D1436769

**kelvin**
colour today

**Contents**

die gestalten verlag

# Preface

"With colour one obtains an energy that seems to stem from witchcraft", Henri Matisse

Everyone has to show their colours at some point, especially painters, cartoonists, graphic artists, illustrators, designers, architects, film directors and fashion designers. In short, colour particularly concerns those who are – in the broadest sense of the word – creative. Because if creatives are too casual with their use of colour, they remain pathetic greenhorns.

Others, like businesspeople, gardeners, traffic planners, the independently wealthy, composers and soccer fans, also intensively occupy themselves with the decisive question about which colour tone suits their respective intentions, environments and moods. There have been innumerable theoretically glorified attempts by professional cultural coffee ground-readers to interpret causal laws into the globally iridescent colour spectrum, but they have only succeeded in nailing colours to an invisible cross of causes and effects. In reality, though, nobody has to wait for the sun to set to see red.

Kelvin refrains from making intellectual speculations. Kelvin is the temperature of colour. And temperatures are first measured when they are perceptible, hence visualised in diverse and masterful ways.

Instead of establishing a hybrid premise that must then be proven in the face of all evidence, Kelvin represents a method of searching and collecting. That which is found establishes objectivity through subjective test drilling deep into the rich soil of a creative global atmosphere. In its eleven chapters, Kelvin brings to light a wide range of top-notch artistic incarnations in the tones blue, red, yellow, green, rainbow, purple, brown, orange, black, white and special colours. The featured pictures, paintings, illustrations, drawings, photographs, graphics, sculptures, furniture, rooms, clothing, books, figures, music recordings and print advertisements make one thing especially clear: they have been created with a uniquely effective use of colour. Because even without a watercolour-proof superstructure, all designers must select their colours with a conscious and deliberate intention. Those shown here experiment with them in such a way that creates magical effects, which defy reproduction with randomly substituted ingredients. A certain "now I get it" experience in the elementary school classroom, when the teacher explains complementary colours for the first time, can't actually hurt anyone working creatively; but every child who plays around with a paint box has already intuitively anticipated that colour should be used deliberately and had the actual experience.

Visible tendencies and trends emerge from an accumulation of applications. Blue most often symbolises cool, reliable objectivity. And even if nobody really knows why, less green books are sold than yellow books; it is the simple truth. The exact formula for the ratio of colour to form, material, context and purpose – the reason for the effect – may remain concealed, but it is still undeniable. It's a must-see.

Because visual codes can always be interpreted differently. They come and go in context. New meanings can be added or ones that have existed for centuries can successively disappear. White is the colour of mourning in China. This fact is not limited, however, to Asia; the same is true for Belgium. Other factors are mixed into this permanent development and create a colourfully mottled connotative tangle. More light! It is true that an English landscape painter from the late 19th century was inclined to paint the grey, cloudy molasses that he saw hanging heavily in the sky when he looked out of the window, therefore providing a one-to-one visual portrayal of his environment. The question that remains is why, for example, do weakly lit lamps cosily but hardly sufficiently illuminate the interiors of many dwellings in dark Scandinavia, while sun-spoiled Italians sit in the glaring halogen shine of their flood-lit kitchens? The cultural mode of action of visual codes is comprehensible – as long as you keep an eye on it.

It's about time that the subject of the effect and application of colours is wrenched away from the antiquated, grey climes of a sluggish, lecturing, visually anaemic reception and exemplarily celebrated in its entire current splendour.

Kelvin brightly highlights groundbreaking and exciting developments in the contemporary handling of colour.

Because even greats like Johannes Itten and Johann Wolfgang von Goethe, whose clever colour theories clearly belong to the educational canon just as Newton's apple does, can no longer lead all artists in the right direction without supplemental support. While their work was absolutely cutting-edge at the time, their skills, measured against today's options, are hardly suitable for every detail, every medium and every nuance. Even this publication cannot and will not claim any colour-related prerogative of interpretation for itself for years to come. But it illustrates associations.

Kelvin invites you to let yourself be visually revelled, inspired and incited by the colours that are the world, and to succumb to their age-old, up-to-date magical effects.

It has been created to visually raise the temperature.

**The Editors**

(opposite page)
**Johann Wolfgang Goethe**
Colour test chart for diagnosing
colour blindness, 1798

# The Colours of Life

**The painter who lost his paints**   Just imagine: a painter whose life is marked by a high proportion of colour experiences, who has spent decades conveying perceptions through colour, suddenly becomes colour blind. This tragic case is a true story. Jonathan I. was 65 years old at the time of his unforgettable car accident. From one day to the next, he saw the world in black and white. "My brown dog is dark grey. Tomato juice is black,"[1] is how he described his new world.

He knew colours well. Over the years he had acquired a differentiated knowledge of their mixing ratios and their effect. Only now they no longer existed. He was not even able to recall them in memory to his inner eye. The "falseness" of his new sensory world horrified him. He felt as though he were living in a world "cast in lead", he reported despairingly.[2] He saw those around him as "living grey statues". Gazing upon his own face in the mirror was equally unbearable.

In contrast to those who have been born colour blind, the painter still had fully functional colour receptors at his command. Following the accident, it was his brain that was unable to further process the eye's correctly registered sensory data into the information "colour" and "colour perception". The painter was first able to abandon the tragic feeling that he had lost his familiar view of the world when he began to reverse day and night. The colours that were swallowed up by the twilight no longer tormented him.

**Errors in colour perception**   In contrast to this unique case of acquired and complete colour blindness, genetically attributed colour-defective vision occurs comparatively often. Red-green blindness or visual impairment affects four to five per cent of the population, almost exclusively males. The genetic information responsible for this is located on the X chromosome. With women, it is improbable that both X chromosomes possess this gene simultaneously. The second X chromosome, therefore, generally guarantees colour vision for women. Besides, the colour blind don't necessarily see only in grey and black and white. The majority of them can simply differentiate fewer colours or occasionally perceive a flickering structure instead. In comparison, hereditary, complete colour blindness and the corresponding complete loss of colour receptors in the eye only occurs in one in five million cases.

Initially, Goethe published a test chart to diagnose colour-defective vision. He determined that two of his students considered different colours to be the same, for example, a pink blossom and a light blue sky. Goethe believed that both of the test subjects that he examined were missing the perception of blue.[3] Simultaneously to Goethe, in 1798, the atomic theorist John Dalton began his self-diagnosis and developed a test series for colour blindness. He thought his own defective vision was due to a blue colouration of his eyes. In his testament, he willed that they be saved for research purposes after his death. The results of their analysis, which was first done in 1995, showed that Dalton's eyes were missing a certain protein in a cone cell, and that he was blind to the colour green.[4]

From an evolutionary point of view, colour blindness is not only presented as a defect. The corresponding genes refer to the nocturnally active eras of our ancestors and are significantly older than those that are "normal-sighted". Consequently, the question to ask is, whether colours exist at all beyond our perception. In any case, Sacks and Weinmann, who publicised the case of the colour blind painter, referred to the brain as the place of origin of colour.

**Visible and invisible light**   Sunlight penetrates the atmosphere and reaches the earth as an electromagnetic wave measuring between 320 and 2,000 nanometres. Humans see electromagnetic waves in a spectrum of 400 to 700 nanometres as colours. The high-energy, short wave ultraviolet light is felt as warmth. How do other living creatures perceive electromagnetic wave spectrums? Which information is provided to animals by the areas of the spectrum invisible to us?

The results of recent investigations showed that birds of prey, for example, can recognise traces of urine from mice under ultra-violet light. This gives them precise information about the rodents' whereabouts in the grass. Songbirds can, in turn, differentiate between green grapes and foliage while in flight with the aid of ultraviolet light. And apparently, in addition to colours, flowers have patterns which are formed in the ultraviolet range on their petals. According to this, what do flowers look like for bees? On the other hand, which evolutionary advantage did colour vision bring to human beings? Was it simply the colourful fruit – successfully found between the foliage by our ancestors – which continually nurtured and developed the ability to see in colour?

This much is certain: colours and their perception are fascinating. Goethe characterised them as "primal phenomena". Surprisingly enough, he attached more importance to his colour theory than to his entire literary work. Prominent natural scientists like Newton, Young and Helmholtz also intensively devoted themselves to the perception of colour.

**Objective and subjective vision of colours**   Newton's observations proved that all colours are contained in white, visible light. He postulated that the tiniest little pieces of matter in various sizes were components of this. Since the 18th century, Newton's mechanistic view of the world has been supplemented by the wave theory. Neither of the two theories was able, however, to explain all of the phenomena of coloured light. Depending upon the design of an experiment, light behaves either according to Newton's corpuscle theory or like an electromagnetic wave. Up until now, not even modern quantum theory has been able to solve the mystery of wave-particle duality.

Goethe, on the other hand, did not believe that colour was quantifiable. He preferred to devote himself to special cases in the area of colour perception. His interest was focused on optical illusions and diseases. His attention was directed more towards the physiological and psychological effects of colour and less towards the physical. "Optical illusions are optical truths", he postulated and researched coloured shadows, after-image effects or, as previously mentioned, colour blindness. While his explanations are often not supportable from an orthodox natural scientific point of view, Goethe did juxtapose the active participation of human perception to Newton's objective-mechanistic view of the world and his comprehension of the human eye as having a passive, receiving role.

Numerous artistic colour theories are based on Goethe's deliberations. The subjective approach of his colour theory directly or indirectly sowed the seeds for the liberation of colour by van Gogh, Gauguin and the Expressionists to beyond the Bauhaus, right up to abstract artists. Goethe's theory of colour provides a classification system along with a variety of differentiated application possibilities. The virulent art utopia of colour as a universal language of the 20th century is a formulation that goes back to the colour theorist Chevreul. But from the practical viewpoint of the artist, Goethe's contribution to a systematic and communicative interaction of colour was extremely productive and is still relevant today.

**Colours and words**   The human eye differentiates the impressive amount of three million colour nuances. In the psyche, they trigger an endless amount of emotional moods. Our words, however, trail behind our perception. As opposed to the optical abundance of visually registered colour, there is a paradoxically small amount of specific colour terms in the individual languages. Most languages manage with five or six colour names.

In view of this discrepancy, the categorisations made give information about the respective culture. They do this specifically because we have limitations with our linguistic ability. The relation of language and colour remains a mystery without specific knowledge of the cultural context. How should one imagine the colour "cuisse

de nymphe émue" (thighs of an excited nymph)? In the 19th century, it described the entire spectrum of pink to purple, even yellow. On the other hand, the colour "Bismarck" described a leathery brown tone.[5] In contrast, the colour concept for the colours "Ice tea" and "Industrial", as well as their thereby intended emotionality, can probably only be comprehended in today's consumer world.

In Greek literature, colour names make noticeably seldom appearances. Instead, terms like "brazen", "wine-coloured" or "dark" are used where today one would, for example, expect blue. "Dewy" or "fresh" replace green. In the Iliad, the word "chloros" (cf. chlorophyll) is not a term for something green, but surprisingly enough it describes honey; in Euripides it even means tears and blood.[6] Therefore, in the 19th century, some classical scholars seriously asked themselves if the people of the ancient world suffered from partial colour blindness and if it was for this reason that colour television was first developed after that time.[7] By today's standards, this theory is considered one of the howlers in scientific research. It clearly illustrates, however, that terms for colour originate in a cultural environment and can only be understood in regard to their context.

**Seeing one's own colours through another's mirror**   Analogous to linguistic research, the actual application of colours in the fine arts of antiquity has been the subject of investigation for 200 years. The fact is that architecture and effigies of the gods were painted extremely colourfully. The Greeks coated the white marble, which we so highly treasure in its original state, with red, blue, green, ochre and pink.[8] Knowledge of the "colourful gods" in their colourful temples received very little approval for a long period of time. The reason for this is the popular image which prevailed in the Renaissance and classical antiquity: pure white architectural columns glowing in the sunlight and pure marble statues shining transcendentally. This image lasted for a long time in the classical educational canon, but

it is nothing other than the projection of the perfect mental image of our culture on another culture. It is still difficult to abandon this seemingly virginal, absolute white of Greek idealism.

The concept of the colourless effigies of the gods corresponds with modern metaphysical ideas. It probably has something to do with Newton's observation that all colours are contained in the white light of the sun. According to a modern point of view, the colour white seems especially suitable to presenting the ideal and totality of the divine. The Greeks freely used the diversity of colour to bestow their gods with absolute vividness and make the divine more topical and real. In a technical sense, they were far from being naive. The synthesis of the ornamental with picturesque illusion, the subtle enhancement of the sculptural effect through the use of colour, is documented for numerous antique sculptures.

We still aren't knowledgeable enough about possible tone-in-tone colour graduation in painting, about the eventual shiny and transparent effects.[9] The colour surfaces of the statues were presumably coated with wax polish, with the coat of colour possibly being more refined or transparent in some places than the modern reconstruction describes it to be. It is certain, however, that the Greeks primarily strived for realism, as did practically all cultures and eras, and not for the transcendence of abstraction that we seek today.

**Colour as a cultural factor**   Through colour, numerous cultures depict heaven and earth with the same immanent immediacy as the Greeks did with their temples and statues of the gods. The people of Bhutan use the signal effect of colour as a reaction to the barren, almost monochrome landscape of the Himalayas. Their clothing, living quarters and furnishings are decorated with strongly coloured and yet finely differentiated patterns. They oppose the brown tones of the mountains during the summer and thwart the colourlessness of the winter landscape. Here, colourfulness stands for a spirited

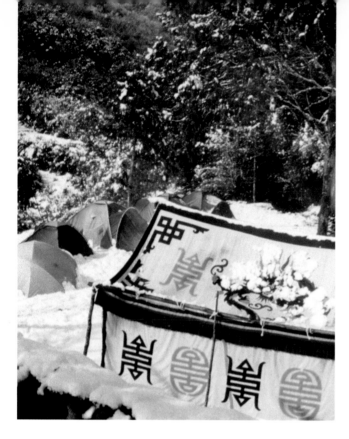

**Dsogchen-Retreat
in Wangdipodrang,
Bhutan 1996**
Photography: Reinhard Gfeller

culture and conscious design. The white tent, with its colourful orna-
ments and motifs, characterises a spiritual location. During Buddhist
indoctrinations it serves as a possible retreat from the cold. Colour-
ful prayer flags on tall poles herald a visibly spiritual presence in the
snow for miles around. Only at a second glance do they reveal how
subtly their colours are integrated into their environment yet how
energetically they assert themselves in front of the backdrop of the
high mountain range landscape.

Presumably, colours have always been considered a vehicle for
culturally connotative signification. Neither dwellings nor cloth-
ing are exceptions to the rule. Earlier, colours were not a question
of mood or fashion, but rather a conscious codification of bodies
and their environments. Red and blue were the most difficult to
acquire, and therefore the most luxurious colours. They were ex-
clusively handled within a traditional dress code. Up until the 18th
century, a patrician bride was wed in red and not white, as is cur-
rently the case. Up until roughly 100 years ago, genteel boys wore
mostly pink clothing and the girls mostly light blue. Girls were con-
sidered to be little Madonnas and were clothed in a weak shade of
blue, the symbolic colour of the Blessed Mother. The boys were little
gentlemen. They were allowed to conceive of themselves as mini-
ature-editions of the nobleman, whose colour was red. Today, colour
assignments are exactly the opposite: blue characterises masculin-
ity; red is the colour of love, eroticism and warmth and is associated
with femininity.[10]

In previous times, colours were not a question of taste or money
but simply affiliation of status. The colour assignments were cor-
respondingly rigid. In our perception of colour today, colour changes
take place more often. They take place under completely different
requirements.

**The liberalisation of colour**      Initially, the development of ab-
straction in art brought the detachment of colour from the object

along with it. Overall, it led to an innovative "autonomy" of colour.
Goethe's subjective colour theory and its successors had a decisive
influence on this development. In addition, objectively seen, colour is
the visible result of abstract magnetic waves. Since the 19th century,
synthetic pigments have made the once elaborate manufacturing
process of colours at least partially redundant. The discontinued
use of natural pigments has also contributed to the fact that the
colour effect is no longer necessarily bound to the materiality or
quality of a specific fabric. Today, advertising especially contributes
to the appellative character of colours. Our culture, like no other
culture before it, is surrounded by an abundance of colours and dif-
ferent colour qualities which influence moods. Creativity seems to be
unlimited. The press of just one key on the computer initiates a cha-
meleon-like change of appearance of the selected area or the entire
picture. This has made colour's availability virtually limitless; colour
is variable and simultaneously immaterial. Colour has forfeited its
exclusive character. But there are still differences between expen-
sive and cheap colours. This depends on the quality of the pigments,
the bonding agents or the style of the coloured object in regard to
fashion and design. Neon colours are often especially expensive,
although their colour pigments are rather temporary.

Analogous to economic and social developments, the increasing
liberalisation of colour application leads to permanent competition
for widespread acceptance. In view of the open system, cultural pes-
simists could postulate the complete arbitrariness and capricious-
ness of colour application. Caution is advised with manipulations for
populist purposes: a Swiss tabloid printed a picture of the Hatshepsut
Temple in Luxor with a metre-long trail of water in the foreground.
The graphic artist coloured the trail red. It conveyed the image of the
blood of the tourists that were assassinated there in 1997.[11]

Digitalised colour generates its own reality here. It suggests
imagery that actually doesn't exist. Only supplemental information
based on facts can protect the viewer against such opportunism.

Because the potential ethics of the designer are not revealed in the creative image, but in the reflective and responsible handling of the colour options we have today.

Text by **Anne Krauter**

Anne Krauter Ph.D. is an art historian who has studied in Stuttgart, Heidelberg and Basel and currently teaches at the University of Applied Sciences in Berne, Switzerland.

1   Oliver Sacks and Robert Wassermann: Der farbenblinde Maler – eine Fallstudie, in: Lettre international, Heft 2, Herbst 1988, pp. 68 – 74.

2   Lettre International, 1988, p. 69.

3   Johann Wolfgang Goethe, Die Tafeln zur Farbenlehre und deren Erklärungen, Frankfurt/M., Leipzig, 1994, Erste Tafel (p. 9).

4   Brockhaus multimedial, 2006, „Farbenfehlsichtigkeit", „Farbenblindheit".

5   John Gage, Kulturgeschichte der Farbe – Von der Antike bis zur Gegenwart, Ravensburg, 1997, p. 206.

6   Arthur Zajonc, Die gemeinsame Geschichte von Licht und Bewusstsein, Reinbek b. Hamburg, 1994, p. 28. Also the source for the story of the colour blind painter (see above).

7   Gage, 1997, p. 11.

8   Bunte Götter – Die Farbigkeit antiker Skulptur, München 2003.
http://www.stmwfk.bayern.de/downloads/aviso/2003_4_aviso_40-45.pdf
http://plato.alien.de/museen-koenigsplatz-glyptothek-farbe.htm

9   I thank the restorer Ueli Fritz, with whom I was able to have many fruitful conversations, for this information.

10  Eva Heller, Wie Farben wirken, Reinbek b. Hamburg, 2005 (2.Auflage), pp. 57 – 61 and p.116f.

11  http://www.rhetorik.ch/Bildmanipulation/Bildmanipulation.html#farbe
http://www.photoshop-weblog.de/?p=444

# Blue

"The sky. The ocean. Blue jeans…
Probably the entire late 19th century can be found
inside this corporate blue suit."

**Blue Notes**   The colour blue. It's everywhere, actually. A favourite colour. There isn't anyone who would want to do without it. The sky. The ocean. Blue jeans. Apparently, there are also people who drive blue cars. And there are blue logos. In the 70s, blue was the corporate colour of 80 per cent of all German companies. You can't count on that today. Nevertheless, the Allianz insurance company has been blue for a very long time and Deutsche Bank actually, too. Probably the entire late 19th century can be found inside this corporate blue suit. The colour of power, as it was understood for many centuries. In the Middle Ages blue was the colour of the divine, transcendent. The Virgin Mary wore a blue robe because she was chosen by God. Later, kings presented themselves in blue in order to demonstrate the divine will of their earthly power.

Although the Old Masters knew very little about psychology, they were knowledgeable about blue. Probably more than we are today. In the old paintings, blue unites heaven and earth, near and far, divinity and humanity.

Today, blue has been put on the defensive. The new dictatorship of emotions is putting cool blue in its place. In communication departments, the order of the day for every job is: "We want a highly emotional presence!" No meaning or understanding is demanded, just lots of emotion. With warm colours we cuddle up very closely to the consumers. Everyone wants to feel good, be happy, trust and preferably not think too much.

Psychologically, blue is worlds apart from red and yellow. Blue seems cold, passive, quiet and serious, while the other warm primary colours are perceived as active, lively and dynamic. That's the reason why many blue companies have started to warm up their colour schemes. To avoid becoming ever more inapproachable and impersonal in a globalised world, they dilute their blues to evoke closeness. Even the familiar classical blue industrial uniform is being replaced with red, green and yellow coveralls.

But this sort of currying favour won't be attractive for long. The enlightened consumer wants to finally have his peaceful environment back. Life again seeks the remote and distant. The depth of the ocean and the vastness of the sky remain the icons of desire that everyone understands. Blue doesn't awaken emotions; blue is an emotion. It's not incidental that blue is the colour of freedom. That's why blue will be back. Rationality will be sexy again, the noisy agitation of communication will subside and the placid clarity of blue will be rediscovered. Since time immemorial one thing is certain: with everything that we constantly change about the colour of logos, products or fashion, there will always be an invariant, that we are true to and that we like – a blue sky will always be a blue sky and that's lovely.

Text by **Achim Heine**

Achim Heine, born in 1955, currently runs an office for product design in Berlin and is co-owner of the graphic art agency Heine/Lenz/Zizka in Frankfurt. He is a professor of experimental design at the Berlin University of the Arts.
www.hlz.de

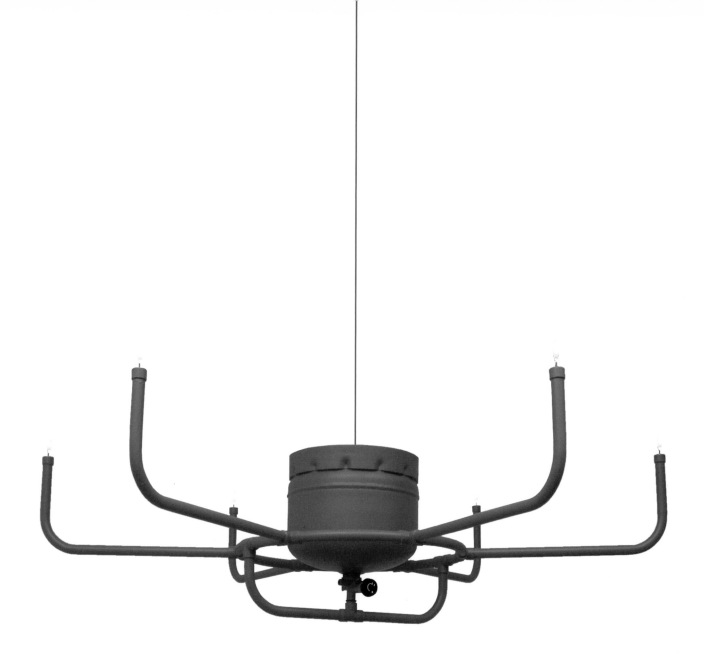

**Chris Kabel**
Big Blue Flames Chandelier
Material: gas pipes and fittings,
limited gas fuelled chandelier
painted in the famous campingaz blue
Size: ø 100 cm, height 35 cm

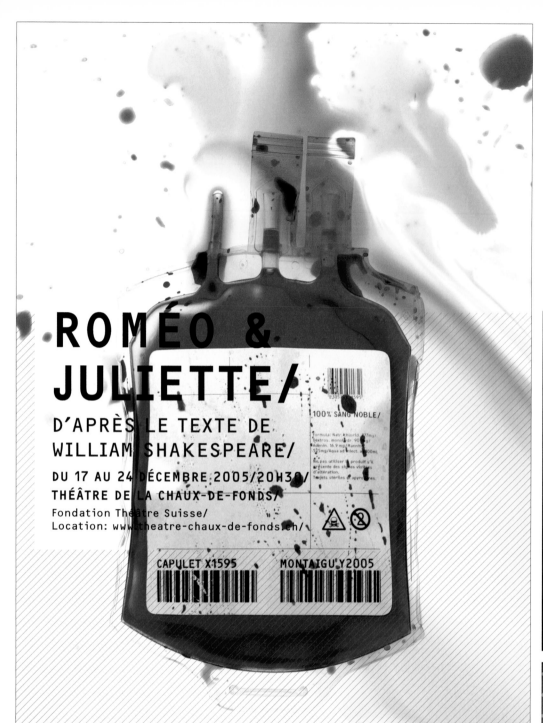

ROMÉO &
JULIETTE/

D'APRÈS LE TEXTE DE
WILLIAM SHAKESPEARE/

DU 17 AU 24 DÉCEMBRE 2005/20H30/
THÉÂTRE DE LA CHAUX-DE-FONDS/
Fondation Théâtre Suisse/
Location: www.theatre-chaux-de-fonds.ch/

100% SANG NOBLE/

CAPULET X1595       MONTAIGU Y2005

1

**1**
**Thibaud Tissot**
Poster made for the play "Romeo and Juliet"
by William Shakespeare
Client: Ecole d'arts appliqués
Format: 89.5 x 128 cm

**2**
**Spin / Joe Burrin**
A series of art magazine adverts to promote
the latest work of Bill Viola being shown at the
Haunch of Venison art gallery in London
Client: Haunch of Venison
Format: 23 x 30 cm

**3**
**TM / Richard Niessen, Esther de Vries**
Stedelijk Museum annual report 2005
Client: Stedelijk Museum Amsterdam

2

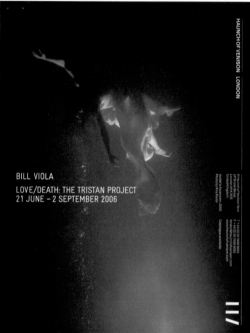

BILL VIOLA
LOVE/DEATH: THE TRISTAN PROJECT
21 JUNE – 2 SEPTEMBER 2006

3

**1**
**Gabor Palotai Design**
The Swedish Architecture and
Design Yearbook 2004
Client: Arvinius Publisher

**2**
**310k**
Versch media party,
Sugarfactory, Amsterdam
Client: Versch
Format: 15 x 21 cm

**3**
**Gabor Palotai Design**
Poster
The Swedish Alcohol Retailing Monopoly

1

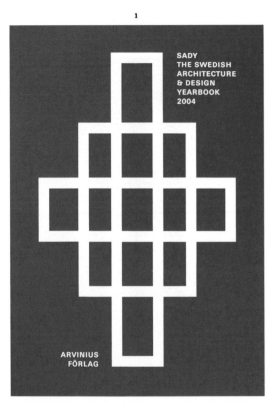

SADY
THE SWEDISH
ARCHITECTURE
& DESIGN
YEARBOOK
2004

ARVINIUS
FÖRLAG

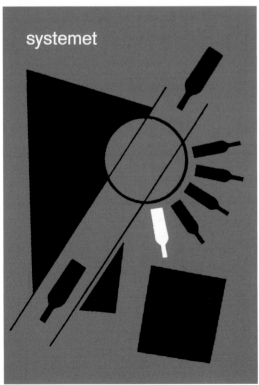

systemet

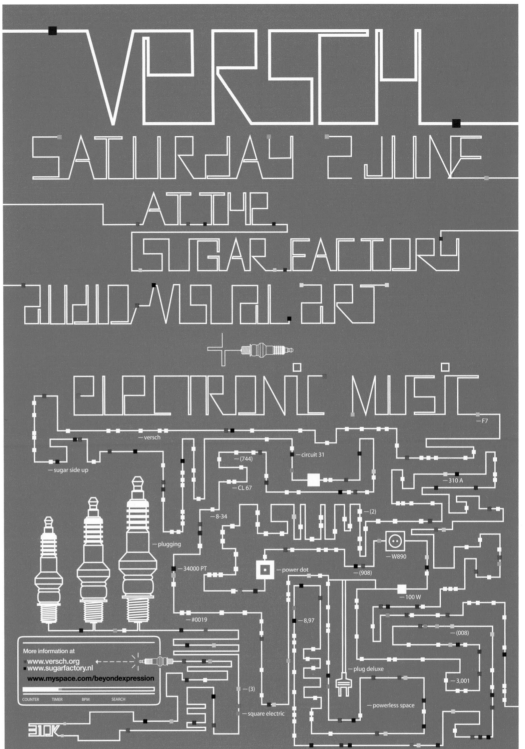

2

**1**
**Novak grafisch ontwerp**
Publication about the Wibauthuis
(Amsterdam) before its demolition.
Bound in cyan linnen. Printed in cyan, black and
partly full colour on shades of grey paper.
Client: Rutten Communicatie-advies
Format: 15.4 x 24 cm

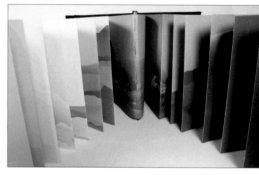

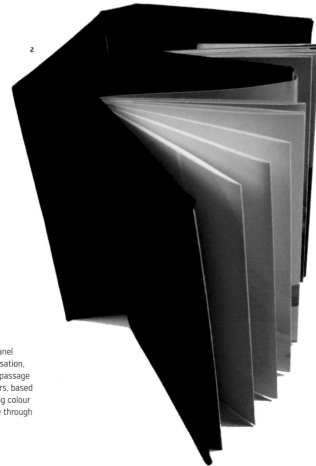

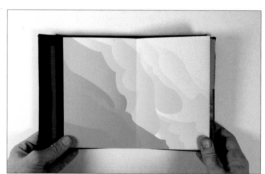

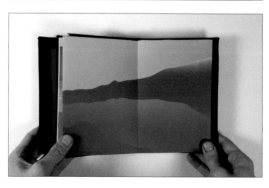

**2**
**Ivor Williams**
"The River"
Handbound book featuring a 4 m single panel
illustration about a river from birth to cessation,
exploring the idea of life as a continuous passage
that expands and changes over many years, based
upon writings by Bertrand Russell. By using colour
as a tool to mark the non-verbal narrative through
a shifting range of blues.
Client: self-initiated
Format: 20 x 400 cm

**1**
**Fons Hickmann / m23**
Posters, cards
Photography: Fons Hickmann
Client: Diakonie

**2, 3**
**Roel Wouters**
A series of invitations for evenings
about media critisism.
Client Infowarroom / deBalie
Format: 42 x 29 cm

Propaganda in the age of mass media control.

During the 90s the late Slobodan Milosevic appropriated Serbian mass media to voice his authoritarian, nationalist and militant regime, both through direct political propaganda as well as through acceptable entertainment formats of a 'turbo-talk' culture.

Snjezana Milivojevic (chairman of the Center for Media Studies, University of Belgrade) will give a keynote lecture on the institutional changes (state control, editorial changes, massive firing of journalists) and the abuse of professional standards (type of news programs, strategies of exclusion and denigration of alternative views) that made the media an instrument to ethnic and nationalist propaganda. Parallel to this dynamic, Milivojevic will analyze the alternative media struggle for independence and the new forms of media literacy emerging among audiences that opposed the propaganda attack.

The keynote lecture will be contextualized by an analysis of the way in which the Dutch media created an image of Slobodan Milosevic as absolute evil and produced a preferred reading of the Balkan wars. A second analysis will broaden the notion of propaganda to include the ideological propaganda that emerges from the media itself: how do commercials, music videos and the evening news manufacture consent and sell their products, lifestyles and biased interpretations through propaganda techniques?

December 14, 2006
start: 20.30 hrs
admission: free
language: english

De Balie
Kleine-Gartmanplantsoen 10, Amsterdam
live webstream: www.debalie.nl/live
www.infowarroom.org

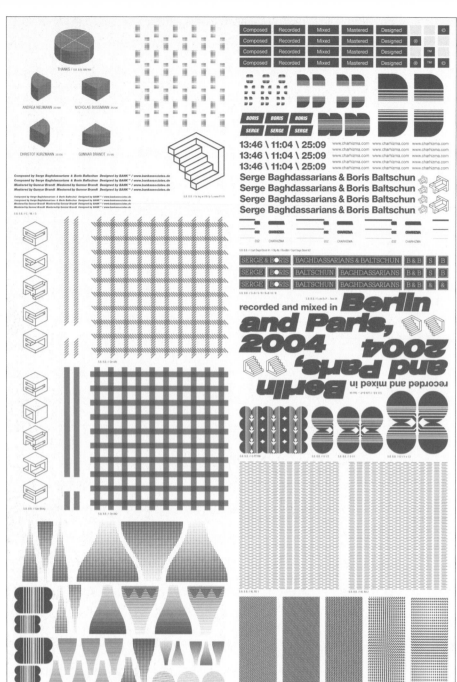

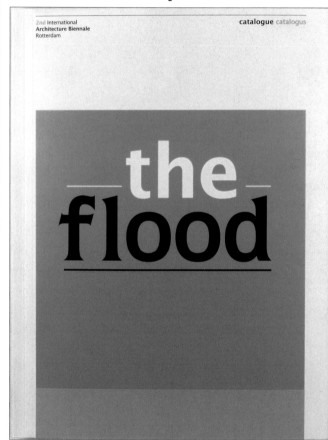

**1**
**BANK™ / Sebastian Bissinger**
Serge Baghdassarians & Boris Baltschun
CD-sleeve (jewel case) with fold-out poster
Client: Charhizma Records
Format: 24 x 36 cm

**2**
**75B**
Catalogue
The identity of this biennale was made by 75B.
Client: 2nd International
Architecture Biennale Rotterdam
Format: 17.5 x 23 cm

**3**
**BANK™ / Sebastian Bissinger**
Serge Baghdassarians & Boris Baltschun
CD-sleeve (jewel case) with fold-out poster
Client: Charhizma Records
CD case: 12.5 x 14 cm

**4**
**BANK™ / Sebastian Bissinger**
Serge Baghdassarians & Boris Baltschun
CD-sleeve (jewel case) with fold-out poster
inner part
Client: Charhizma Records

**1**
**Bo Lundberg**
Personal work
Format: 27.7 x 36 cm

**3**
**Büro Destruct**
Selfpromotion poster
Format: 89.5 x 128 cm

**2**
**Bo Lundberg**
Designer: Staffan Frid
Credit: Woo Agency
Client: Residence Magazine
Format: 22 x 28 cm

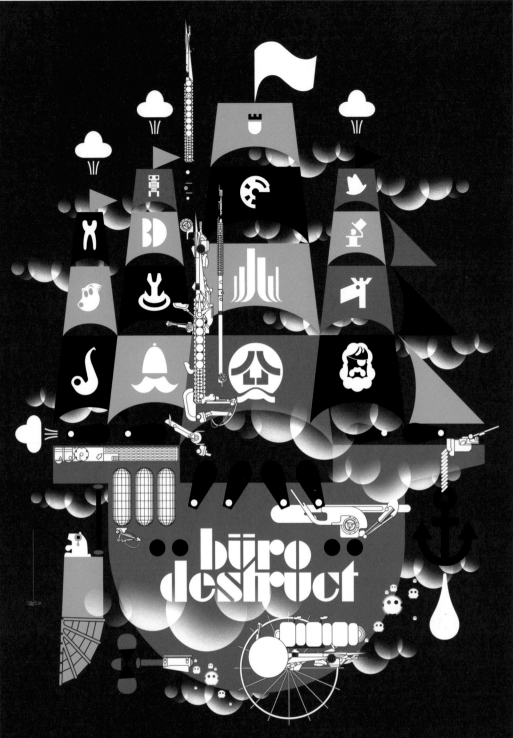

**4**
**Bo Lundberg**
Designer: Bo Lundberg, John Bergdahl, Silla Öberg
Credit: Woo Agency
Client: Apoteket (swedish pharmacies)
Format: 70 x 100 cm

**5**
**Büro Destruct / Lopetz**
Concert poster
Client: Reitschule Dachstock Bern
Format: 42 x 42 cm

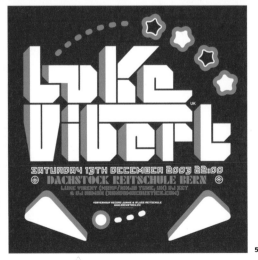

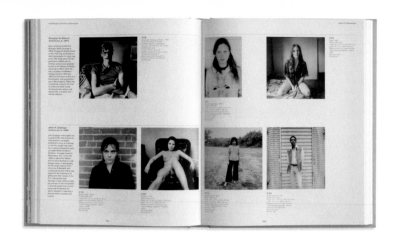

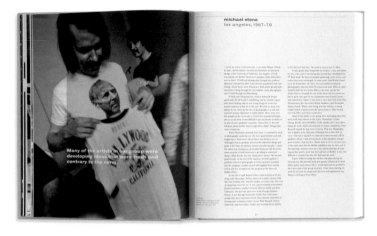

**michael stone**
los angeles, 1967–70

Many of the artists in our group were developing ideas that were fresh and contrary to the norm.

**lewis baltz**
letter to g.w.s.

Everyone who cared about contemporary photography, irrespective of how it was defined, could fit around one large round banquet table at a Szechuan restaurant on West Pico. And did.

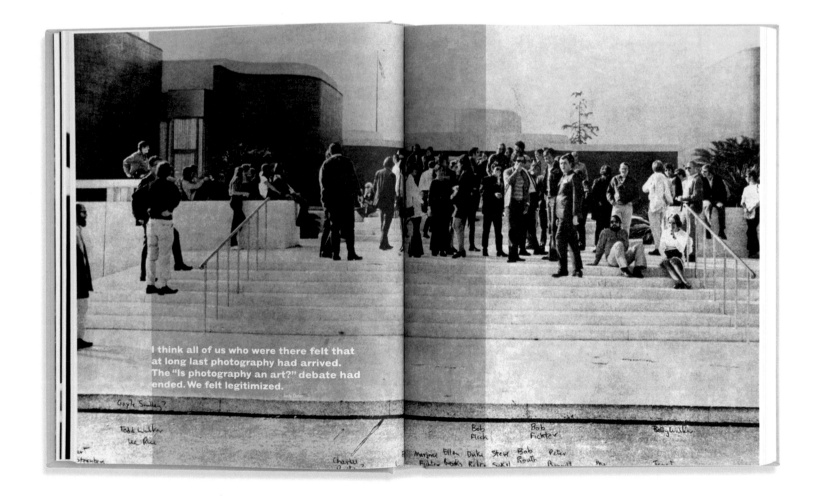

I think all of us who were there felt that at long last photography had arrived. The "Is photography an art?" debate had ended. We felt legitimized.

**Studio Thomson**
Credit: CADS Music Vision Awards 2006
Client: Ballistic
Format: 21 x 29.7 cm

(opposite page)
**Simon Johnston Design**
"The Collectible Moment"
Catalogue of photographs
in the Norton Simon Museum
Cover jacket is a folded poster showing
the complete collection
Client: Norton Simon Museum, Pasadena
Format: 25.5 x 30 cm

ALL THE
SINGER'S
HOLIDAY
PHOTOGRAPHS
COME BACK
TO LIFE

CADS06 Music Vision Awards

In association with MTV
Hammersmith Palais June 8 2006
www.musicweek.com/cads
Tickets: jamess@musicweek.com
Sponsors: AFM Lighting, ONE8SIX, VPL,
Music Mall, ITN Archive, Promo, Music Week,
MVPA, VTR, StudioThomson and CMCS

THE PAVING
STONES
LIGHT UP AS
HE WALKS
DOWN
THE STREET

CADS06 Music Vision Awards

Hammersmith Palais June 8 2006
www.musicweek.com/cads
Tickets: jamess@musicweek.com
Sponsors: AFM Lighting, ONE8SIX,
VPL, Music Mall, Promo, Music Week,
VTR, StudioThomson and CMCS

THE SINGER
WALKS DOWN
THE STREET
TO CAMERA
BUMPING
INTO PEOPLE

CADS06 Music Vision Awards

In association with MTV
Hammersmith Palais June 8 2006
www.musicweek.com/cads
Tickets: jamess@musicweek.com
Sponsors: AFM Lighting, ONE8SIX,
VPL, Music Mall, Promo, Music Week,
VTR, StudioThomson and CMCS

ALL THESE
GIRLS IN
BIKINIS ARE
DOING DIY &
USING HEAVY
MACHINERY

CADS06 Music Vision Awards

Hammersmith Palais June 8 2006
www.musicweek.com/cads
Tickets: jamess@musicweek.com
Sponsors: AFM Lighting, ONE8SIX,
VPL, Music Mall, Promo, Music Week,
VTR, StudioThomson and CMCS

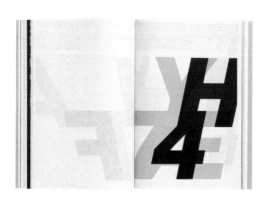

**Anne Denastas, Camille Gallet**

To answer the questions of our environment, numbed in front of our profession, it seemed necessary for us to explain what typography is. To explain in simple ways to a larger audience what our profession is and offer methods to better judge a graphic work. We made this book into an invitation to typography by using nephytes or up-and-coming graphic designers. The texts are easy and concise and the illustrations are there to make the book more attractive. We chose a transparant kind of paper to highlight the typographical grid.

Client: Verlag Niggli AG, Sulgen, Zürich

(opposite page)
**Mode**

Dalton Maag work with design agencies developing custom typeface's, and logotypes for large corporate brands. Mode's identity for Dalton Maag is underpinned by the choice of a distinctive 'duck egg' blue colour that is used extensively from stationery to brochures. The original source of the colour came from a self coloured paper stock, imported from Italy, which was initially used for the Dalton Maag stationery. This particular shade of blue fell in between the range of colours available from UK paper merchants. The colour was chosen to become instantly recognisable as 'Dalton Maag blue', so the identity works on a very basic level where the colour alone identifies and differentiates all of Dalton Maag communications. The use of a consistently applied 'identity colour' has allowed us to be very expressive and experimental with application of the brand langauge, creating an engaging and evolving identity that is rooted by its original choice of colour.

Credit: Phil Costin, Ian Styles, Richie Clarke, Darrell Gibbons, Olly Knight
Client: Dalton Maag

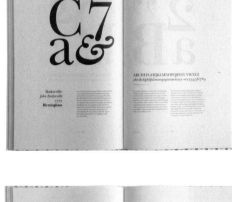

(opposite page)
**Luna Maurer**
Skycatcher, De Balie, The Netherlands,
Website, poster
http://www.sky-catcher.nl
In collaboration with Jonathan Puckey
Client: De Balie
Format: 86 x 124 cm

1

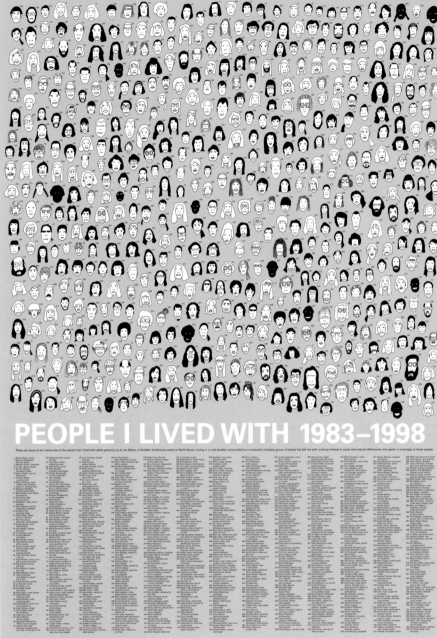

## PEOPLE I LIVED WITH 1983–1998

2

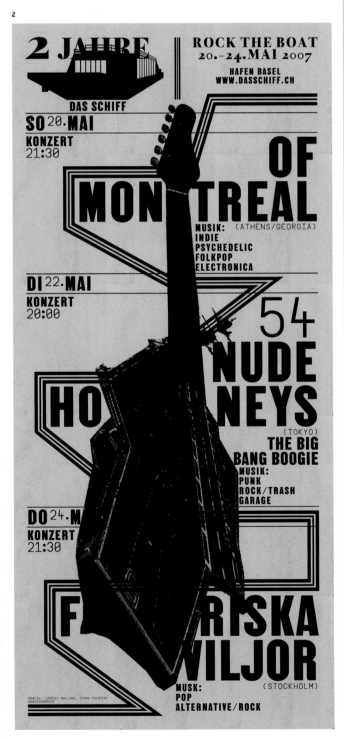

3

1
**Matt Haigh**

2, 3
**Ludovic Balland**
Poster
Client: Das Schiff, Basel
Format: 29.5 x 64 cm

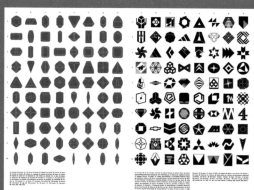

**Ondrej Jób**
Crystallography – both subjective and
objective analysis of a crystal as a visual form
self-commissioned, bachelor project
Format: 18 x 28 cm

(opposite page)
**Seripop**
A tour poster for the band "Ex Models"
Design, printing and layout by Seripop
Photography: Yannick Grandmont
Format: 40 x 70 cm

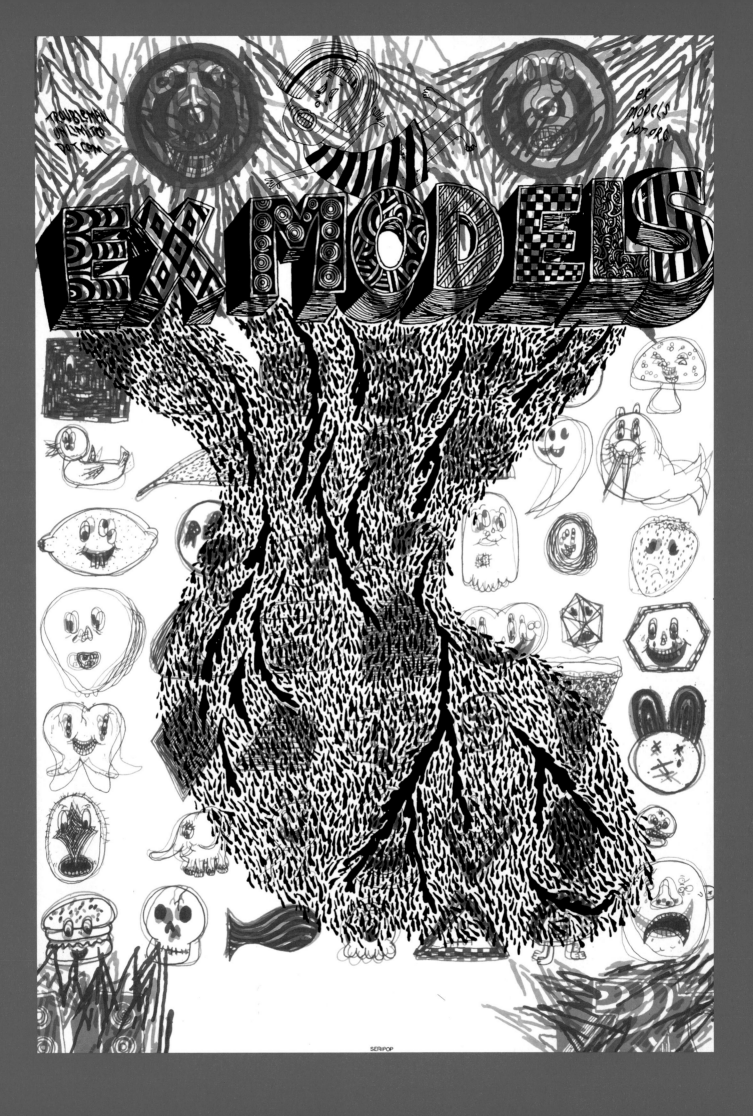

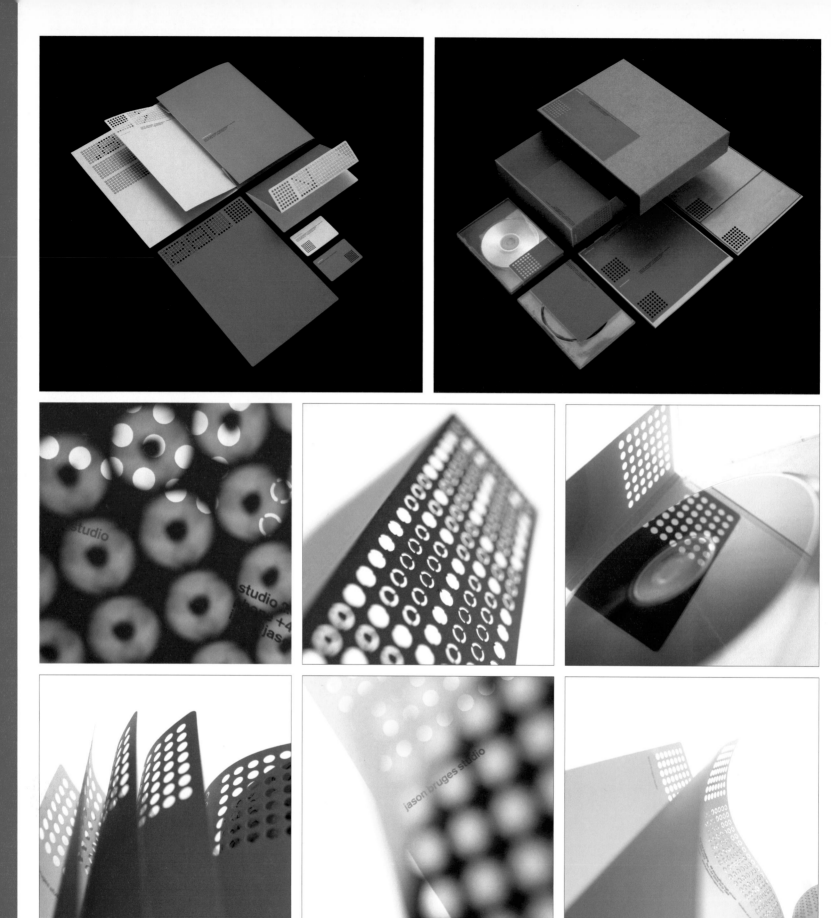

**BB / Saunders**
After creating a new logo, based on an LED grid system, we then worked to apply that across stationery and communications pieces. Business cards had the mark laser-cut, with folders and letterheads having additional holes that could be punched out to provide individual messaging.
Client: Jason Bruges Studio

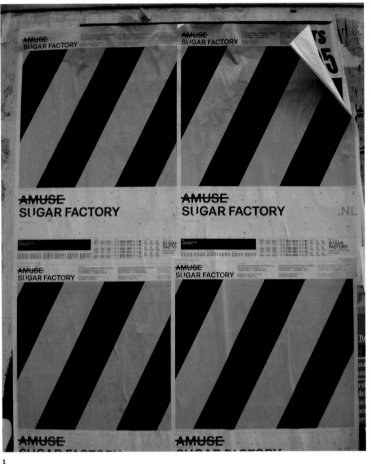

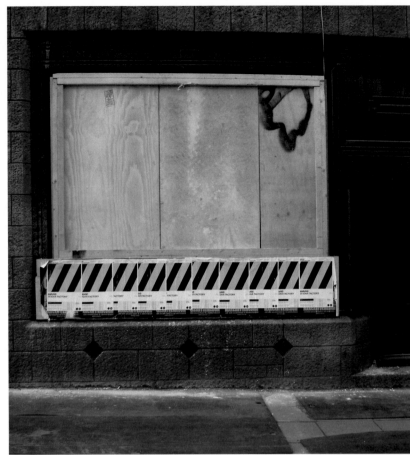

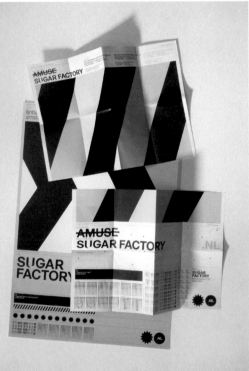

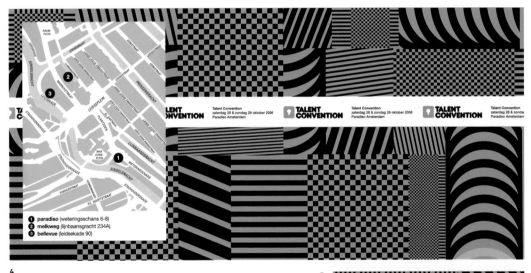

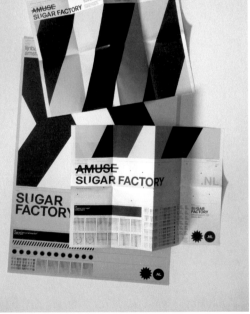

**1, 2**
**310k**
Poster series
Client: Sugarfactory
Format: 59 x 42 cm

**3**
**310k**
Fold-up poster flyer
Photography: Tim Johannis
Client: Sugarfactory
Format: 40 x 70 cm

**4, 5**
**310k**
Invitation
Client: Talent Convention
Format: 10 x 15 cm

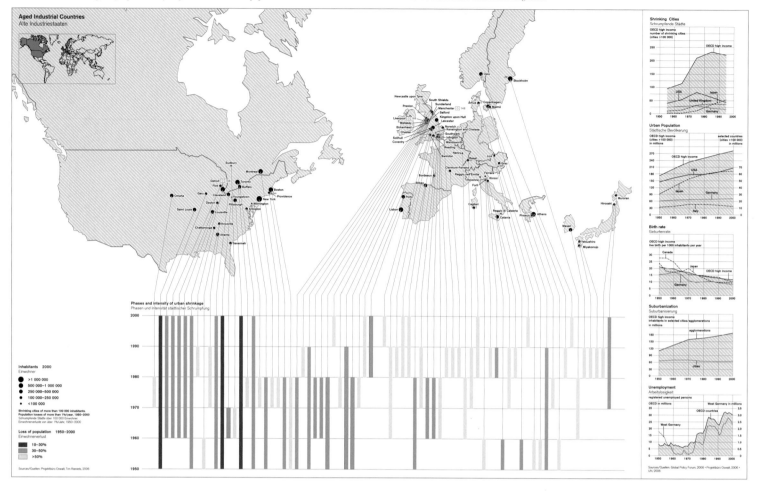

132
Paths of
Development
Entwicklungspfade

**Aged Industrial Countries**

The wealthiest countries on the planet have the highest number of shrinking cities. Roughly half of all shrinking cities are in the G7 states, though they represent only 13 percent of the world's population.

**Alte Industriestaaten**

Die reichsten Länder der Erde haben die meisten schrumpfenden Städte. Etwa die Hälfte aller schrumpfenden Städte liegt in den G7-Staaten, obwohl hier nur 13 Prozent der Weltbevölkerung leben.

Aged Industrial Countries
Alte Industriestaaten

Shrinking Cities
Schrumpfende Städte

Urban Population
Städtische Bevölkerung

Birth rate
Geburtenrate

Suburbanization
Suburbanisierung

Unemployment
Arbeitslosigkeit

Phases and intensity of urban shrinkage
Phasen und Intensität städtischer Schrumpfung

Inhabitants 2000
Einwohner

>1 000 000
500 000–1 000 000
250 000–500 000
100 000–250 000
<100 000

Shrinking cities of more than 100 000 inhabitants.
Population losses of more than 1%/year, 1950–2000
Schrumpfende Städte über 100 000 Einwohner.
Einwohnerverluste von über 1%/Jahr, 1950–2000

Loss of population 1950–2000
Einwohnerverlust

10–30%
30–50%
>50%

Sources/Quellen: Projektbüro Oswalt, Tim Rieniets, 2006

Sources/Quellen: Global Policy Forum, 2006 • Projektbüro Oswalt, 2006 • UN, 2006

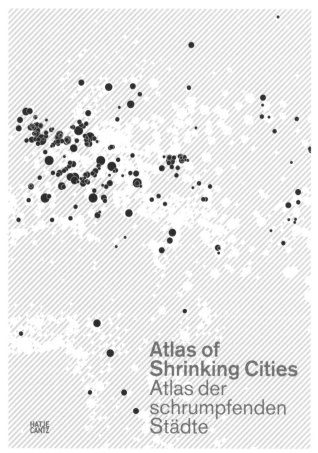

**Atlas of
Shrinking Cities**
Atlas der
schrumpfenden
Städte

HATJE
CANTZ

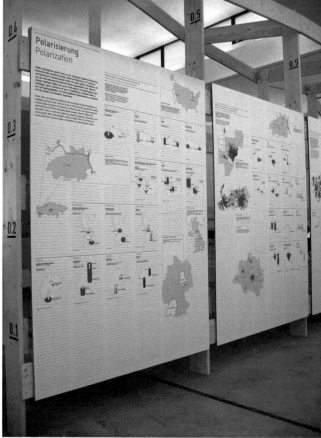

Polarisierung
Polarization

CENTRAL ST MARTINS

A DEGREE IN

GRAPHIC DESIGN

CONQUERING THE MOUNTAIN

NOTES ON YOUR CLIMB

YOU

· Your vision of the top is the greatest asset you have.
· Every step you take you will have to make on your own.
· Your energy alone will carry you to the top.
· You have to start to finish.

YOUR TEAM

· Someone else's weakness could be your strength.
· Everyone has their own approach to their journey.
· Look to those who have faced similar problems on other climbs.
· Together we encourage and inspire each other upward.
· Climbers from different regions each climb differently

YOUR GUIDES

· Your tutors will guide you, not carry you.
· They have climbed the mountain before that is why they are your guide.

**James Musgrave**
An emotive guide to completing a degree
in graphic design at Central St. Martins
Client: Central St. Martins
Format: 21 x 29.7 cm

(opposite page)
**1**
**1kilo**
Doublepage "Aged Industrial Countries"
Client: Shrinking Cities, Philipp Oswalt
Format: 53.4 x 37.5 cm

**2**
**1kilo**
Front cover
Atlas of Shrinking Cities
Client: Shrinking Cities, Philipp
Format: 26.7 x 37.5 cm

**3,4**
**1kilo**
Statistic pannels
Exhibition Shrinking Cities,
Kunstwerke Berlin
Client: Shrinking Cities,
Philipp Oswalt
Format: 1400 x 2000 cm

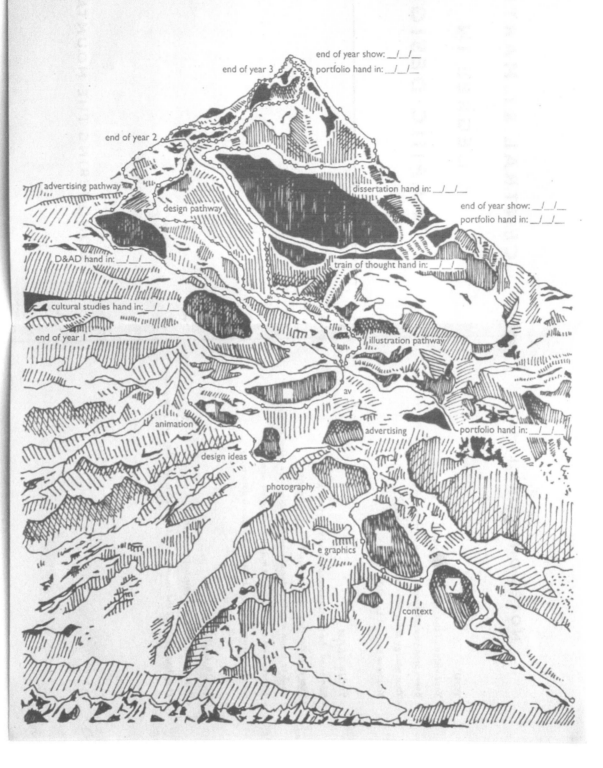

A GUIDE TO YOUR JOURNEY

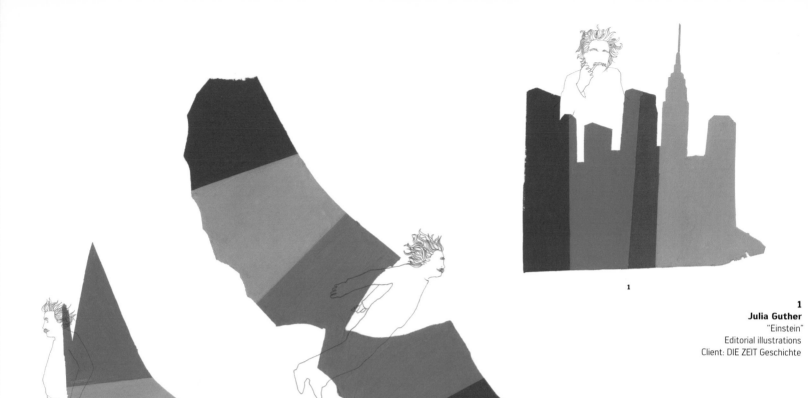

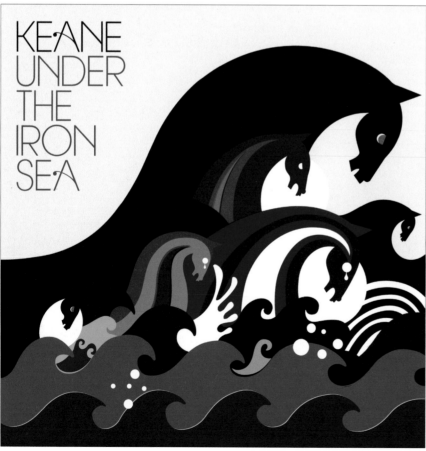

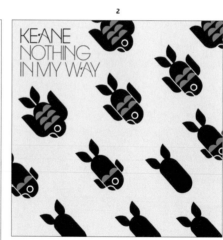

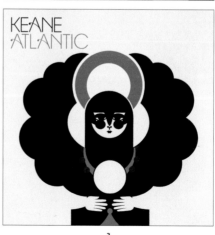

**1**
**Julia Guther**
"Einstein"
Editorial illustrations
Client: DIE ZEIT Geschichte

**2**
**Sanna Annukka**
"Under the Iron Sea"
Client: Universal Island Records
Art direction by
Richard Andrews and Gez Saint
at Big Active
Format: diverse CD sleeves
for the band Keane
Technique: Photoshop

(opposite page)
**2**
**Julia Guther**
"New Birth"
Personal work
Painting,
acrylic and watercolor

**3**
**Julia Guther**
"Among You"
Personal work
Painting,
acrylic and watercolor

**4**
**Julia Guther**
"Sweet Companion"
Personal work
Painting,
acrylic and watercolor

**1**
**Nigel Peake**
preliminary artwork
for a 7" picture disc
Client: Coldcut / Ninja tunes
Format: 30 x 30 cm

1

1

2

3

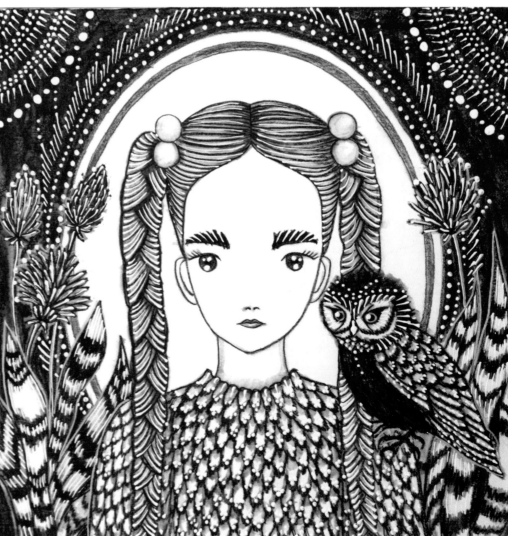

4

**1, 2**
**Rinzen**
Photography by Lyn Balzer and Anthony Perkins
Client: Rooftop Cinema
Format: 42 x 59.4 cm

**3**
**Nacho Alegre**
Patri on her roof

**4**
**Nacho Alegre**
Patri's feet

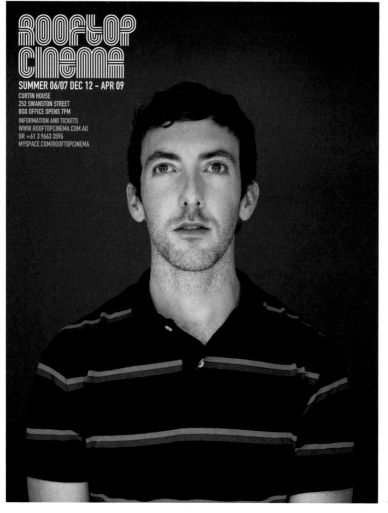

(upper right)
**Nacho Alegre**
Silvia walking in the rocks
after a first fast kiss

(lower right)
**Nacho Alegre**
Irene's kitchen

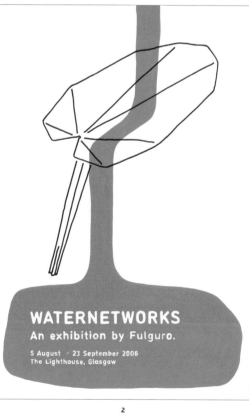

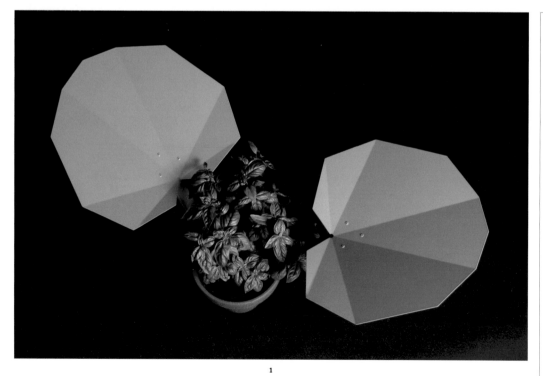

1

**1**
**Fulguro / Yves Fidalgo, Cédric Decroux**
Alluminium leaf to collect rain water
personnal research
Format: 60 x 40 cm

**2**
**Fulguro / Yves Fidalgo, Cédric Decroux**
Poster for our exhibition at the Lighthouse, Glasgow
Client: Fulguro + The Lighthouse
Format: 60 x 42 cm

WATERNETWORKS
An exhibition by Fulguro.

5 August – 23 September 2006
The Lighthouse, Glasgow

2

(opposite page)
**Christian Riis Ruggaber**
Obreiro I, [SIG], 2004, C-Print
Client: SIG

**Jehs + Laub**
Design: Markus Jehs, Jürgen Laub
Photography: Andreas Hoernisch

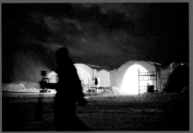

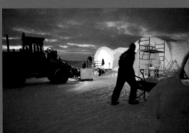

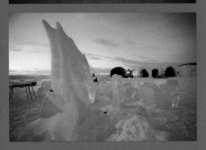

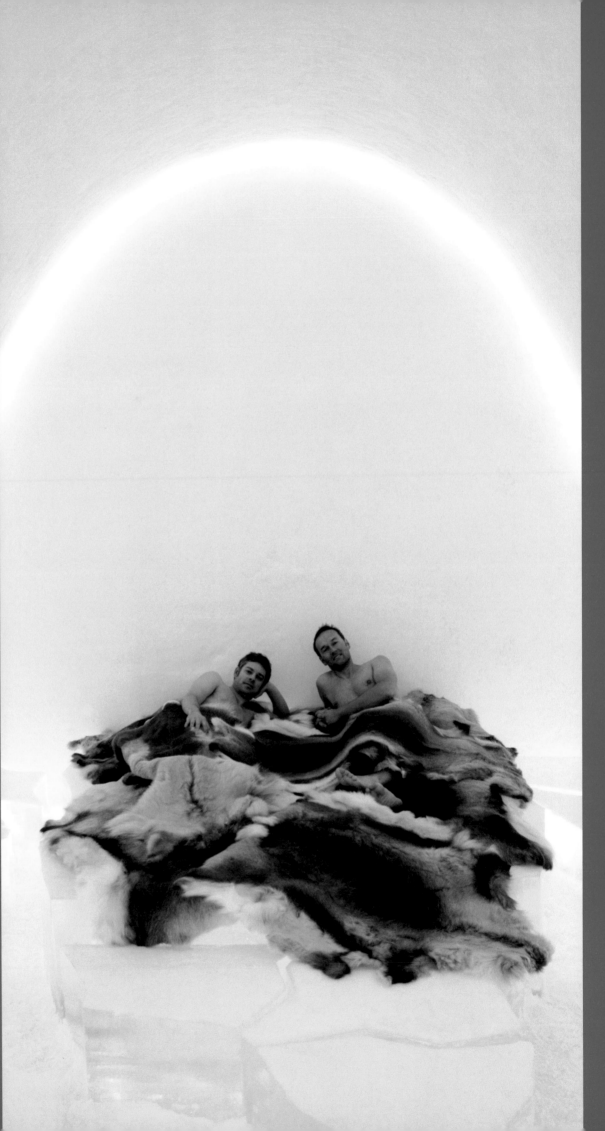

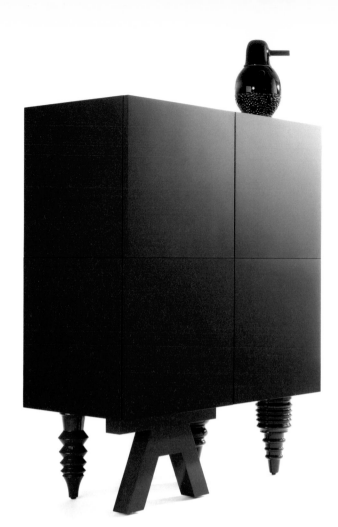

**Jaime Hayon**
Multi-leg cabinet
from the "Showtime" series
Client: BD Editiones de Diseño

**Pixelpunk / Grüner Bereich**
Cover shoots
Credit: Silvan Inderbitzin, Maya Kovats,
Sebastien Kühne, Martin Oberli, Roman Schmid,
Olivier Rossel, Dirk Weiss
Client: The Frank Broccoly Orchestra

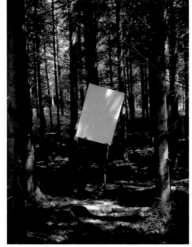

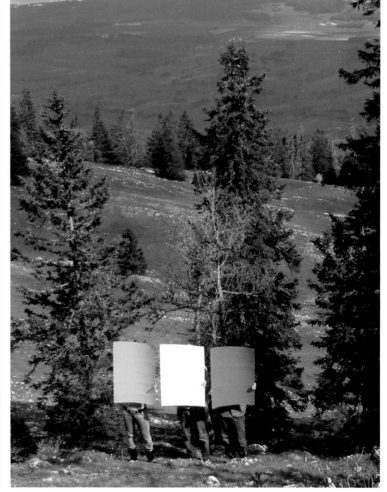

(following pages)
**Space Invasion**
Painters: N&F Hijnen, Rotterdam
Material: Latex emulsion paint,
rolled and sprayed
Photographer: Rick Messemaker
Place: Beukelsdijk, Rotterdam
Client: Borough of Delfshaven

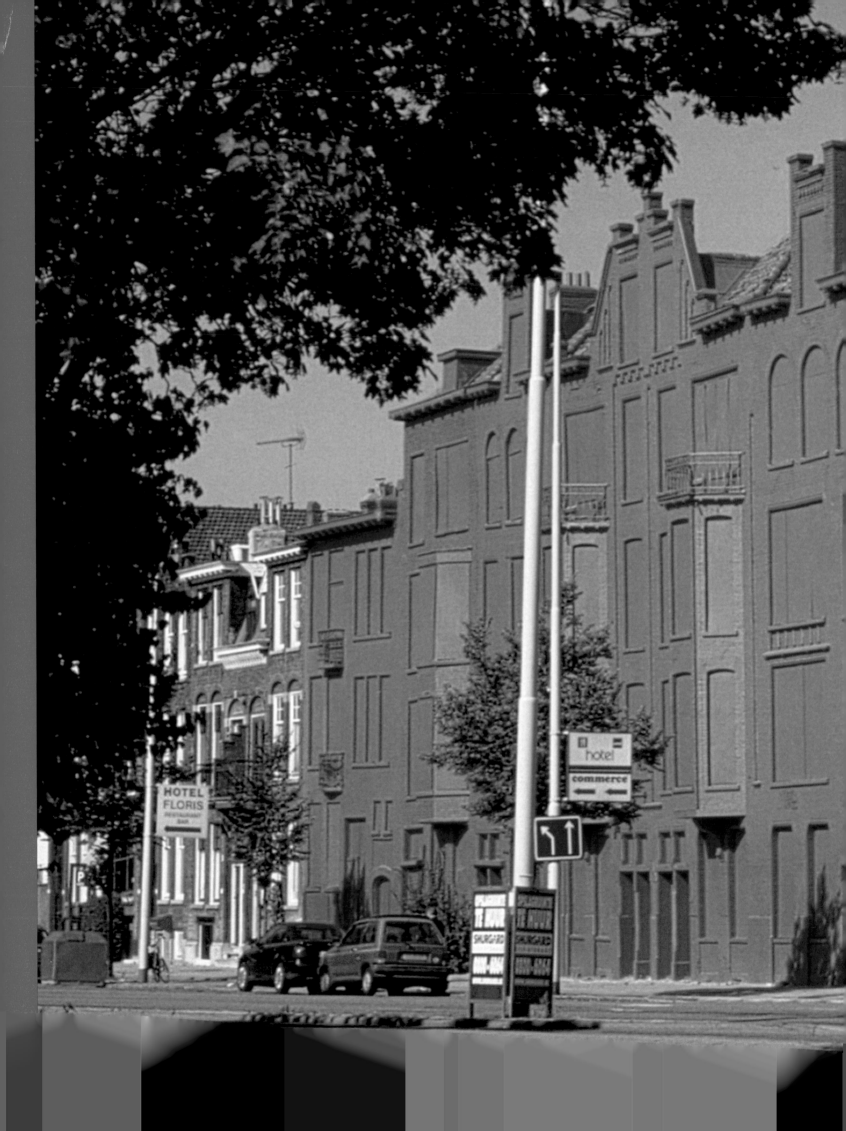

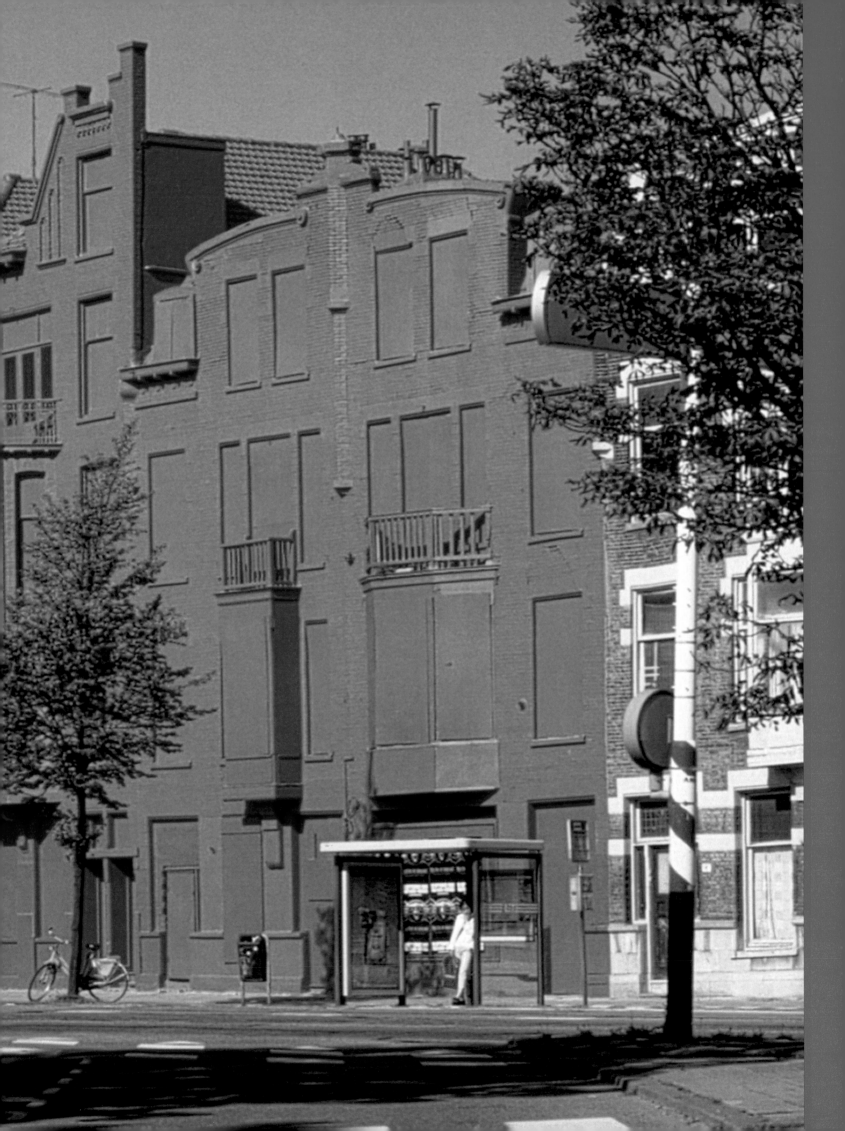

# Red

"If you can't make it good, make it big;
if you can't make it big, make it red!"

Red is the colour of the most elementary experiences. It is the colour of fire and of blood. No other colour is as strongly felt as red. Whether love, joy, hate or desire – they're all red. Equipped with this suggestive power, red has always played an essential role in visual communication.

The designer and Bauhaus instructor Johannes Itten accurately described the propulsive force of red: "It is the drive to achieve results, achieve success. Red is stimulus, the will to conquer and potency ranging from sexual drive right up to revolutionary action." The signal colour red prohibits, warns and draws attention to mistakes. In advertising, red sends out the clear signal "Buy me!". The red pencil gets unsheathed to correct. It makes expensive things reasonably priced, discreet things noticeable, exclusive things attainable for the masses.

Red is experienced particularly intensively within a room. Implemented large-scale, it literally transforms a room into an energy field. It has a stimulating and irritating effect. Large rooms seem theatrically pompous, small rooms can be intimate or even oppressing. Our bodies respond with an immediate reaction: breathing accelerates, the pulse quickens and adrenaline rushes.

The light in the red-light district illuminates the path to eroticism and sexuality. It creates sensual, passionate and seductive beings. Red hasn't been drawing attention to itself only since the discovery of lipstick and nail polish. Since the beginning of time, our secondary and primary sexual organs entice with a range of various red tones.

Red is a power colour. It has been valued by both rulers and modern-day dictators alike. When Otl Aicher created the image of the 1972 Olympic Games, he consciously refrained from using red and gold. The "cheerful games" were meant to politically reposition Germany in the eyes of the global public, and in no way be reminiscent of the propagandising Olympics staged by the Nazis.

Brands that are red attract attention. They have an aggressive, sensual and youthful effect. Ferrari, Marlboro and Coca-Cola, for example, are happy to benefit from these attributes. In the food industry, the appetising effect of red is utilised to convey the impression of flavour, spiciness and intensity. There's a reason why McDonald's presents its golden "M" on a background of ketchup-red.

And yet, red is a potential corporate colour for only a limited number of brands. When it comes to creating one's own Corporate Identity, traditional values like sympathy, integrity and stability are preferred. These can't be believably communicated with red.

Paul Rand coined the phrase: "If you can't make it good, make it big; if you can't make it big, make it red!". The logo that he designed for IBM was blue.

Text by **Robert A. Schaefer**

After studying visual communication, Robert A. Schaefer specialised in the development of effective branding concepts. In his position as Design Director at MetaDesign in Berlin, he advises international companies regarding issues of Corporate Identity. He also holds a teaching position at the Ravensburg School of Design.

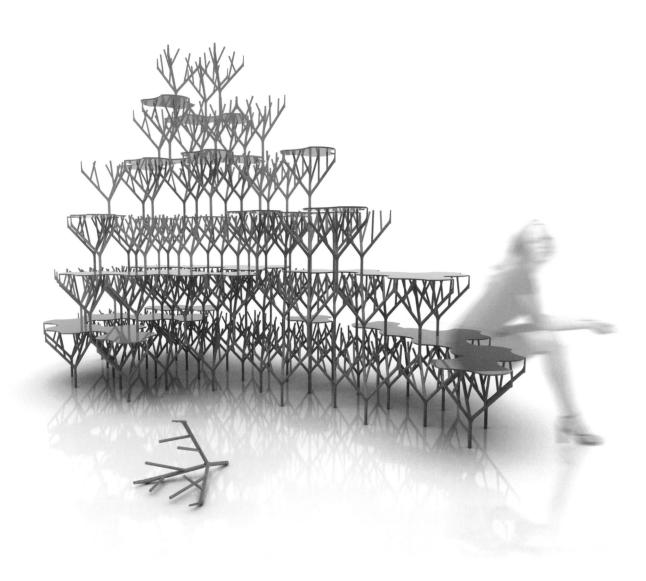

**Unal & Boler Studio**
Photography: Tunc Suerdas

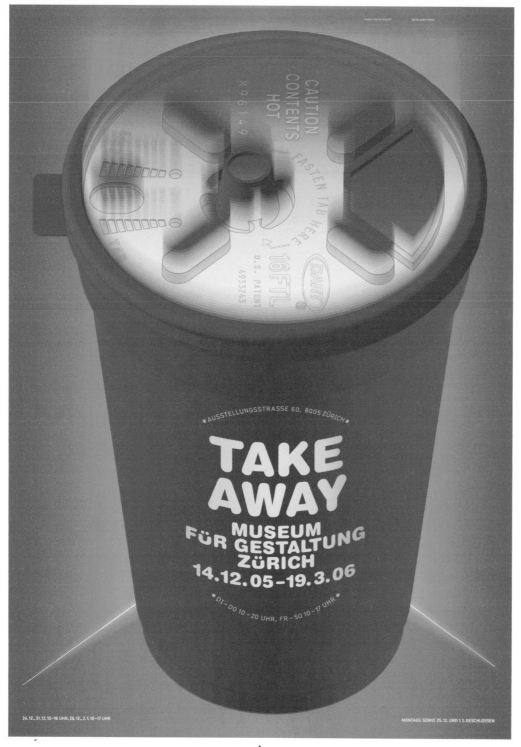

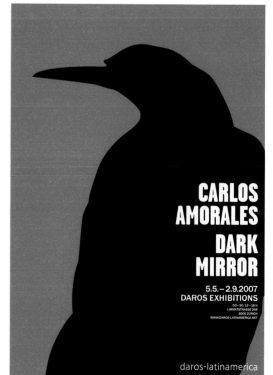

**2**
**Raffinerie AG für Gestaltung**
Exhibition poster
Drawing of bird: Carlos Amorales
Client: Daros Latin America
Format: 89.5 x 128 cm

CARLOS
AMORALES

DARK
MIRROR

5.5. – 2.9.2007
DAROS EXHIBITIONS
DO – SO, 12 – 18 H
LIMMATSTRASSE 268
8005 ZURICH
WWW.DAROS-LATINAMERICA.NET

daros-latinamerica

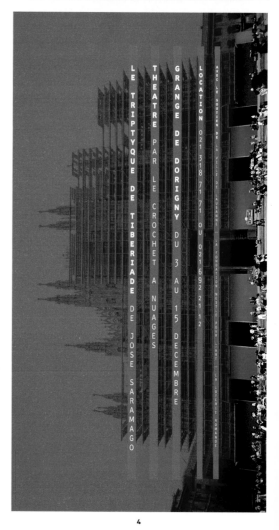

**1**
**Martin Woodtli**
Poster and card
for design exhibition
Client: Museum für Gestaltung,
Zurich
Format: 90.5 x 128 cm

(opposite page)
**Syrup Helsinki /**
**Teemu Suviala,**
**Antti Hinkula**
Illustration
Client: NORD magazine
Format: 19.2 x 27.6 cm

**3**
**BANK™ /**
**Sebastian Bissinger,**
**Willem Stratmann**
Cover, The Sex Issue
Client: Dummy Magazine
Format: 23 x 27 cm

**4**
**André Baldinger**
Theatre poster
Client: Centre Dramatique de
Thionville-Lorraine
Format: 40 x 56 cm

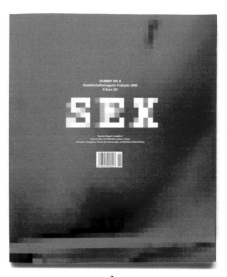

3

4

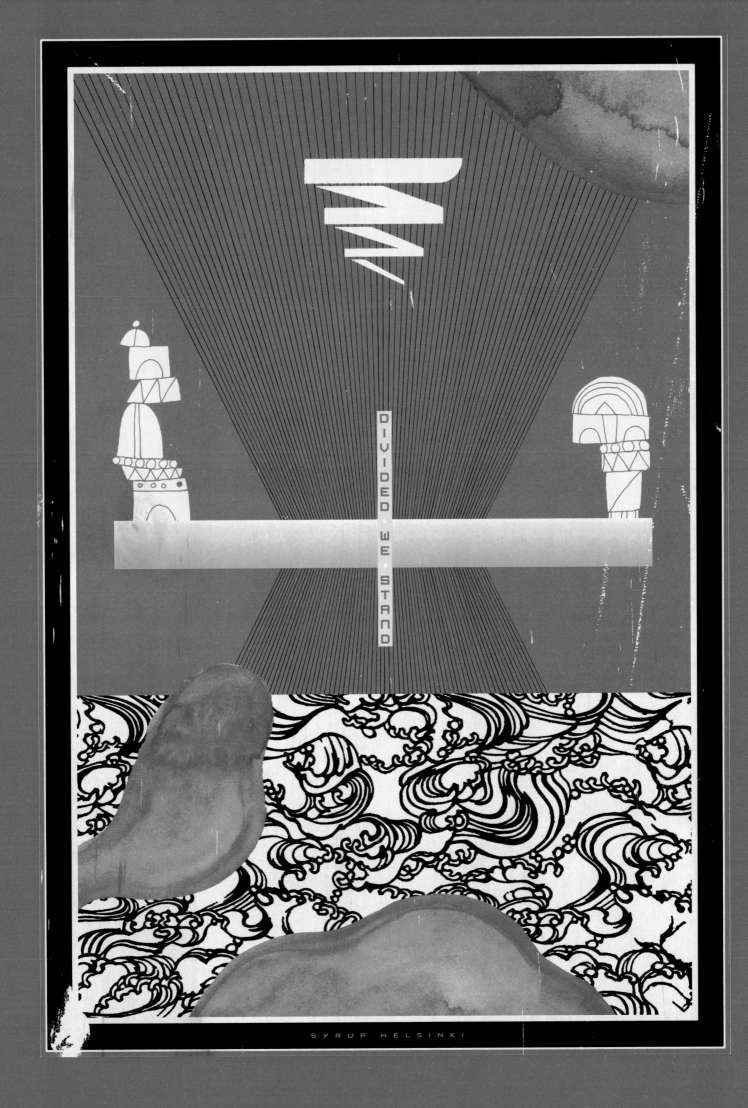

43

1

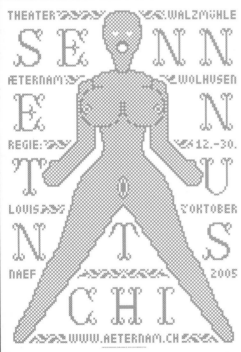

2

3

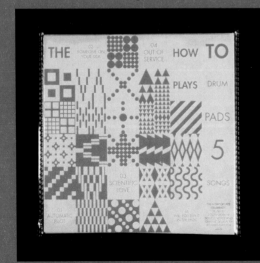

4

1

2

3

(opposite page)

**1**
**Jean-Jacques le Lapin**
Designer: Michel Cotting
Poster, serigraphy
Client: Serge
Format: 35 x 50 cm

**2**
**Emil Kozak**
Poster
Client: Sonja

**3**
**Mixer / Erich Brechbühl**
"Sennentuntschi"
Poster for the Scandalous Play
from the Seventies by Hansjörg
Schneider
Client: Theater Aeternam
Format: 90.5 x 128 cm

**4**
**TM / Richard Niessen,
Esther de Vries**
Drumpads
Client: Howtoplays

---

**1**
**Syrup Helsinki /
Teemu Suviala, Antti Hinkula**
Illustration series featuring the top names in
graphic design and illustration in a fixed colour
palette of black, red and white.
Client: New York Magazine
Format: 17.5 x 11 cm

**2**
**Studio Laucke**
Corporate design, invitation card
Client: Fund "Space For Artists"

**3**
**Koehorst in 't veld, Noemi Trucco**
Periodical
Client: Instituut voor Media & Re/Presentatie
Format: 17 x 24 cm

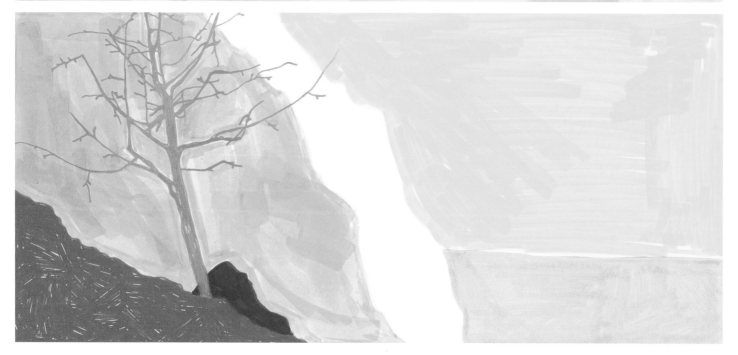

**1**
**Herman van Bostelen**
Poster for a small youth theatre festival
Client: Theater Kikker
Format: 42 x 59.4 cm

**2**
**unfolded**
Poster for theatre piece "White Trash"
Technique: fluorescent adhesive tape
and Letraset
Client: Theater an der Sihl
Format: 29.7 x 42 cm & 84.1 x 118.9 cm

**3**
**Herman van Bostelen**
Poster for a youth-opera
Client: Buffo Operamakers
Format: 42 x 59.4 cm

**4**
**Advance Design, Petr Bosák,**
**Robert Jansa, Václav Havlícek**
Client: Bigg Boss / PSH
Format: 42 x 59.4 cm

(opposite page)
**Brigitte Speich**
Client: Communikation Akoun & Scholten
Format: 21 x 14.8 cm

1

2

3

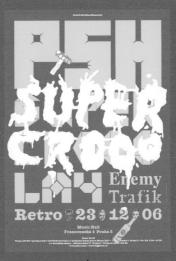

4

**1**
**Gabor Palotai**
Poster
Client: Arvinius Publisher
Format: 70 x 100 cm

**3**
**Raffinerie AG für Gestaltung**
Promotion poster for dance festival
Client: Theaterhaus Gessnerallee
Format: 89.5 x 128 cm

**2**
**André Baldinger**
Promotional poster
Client: Atelier National de Création Typographique
Format: 80 x 120 cm

**4**
**Marcus James**
Menswear print inspired by the flora of Africa
Client: YSL

1

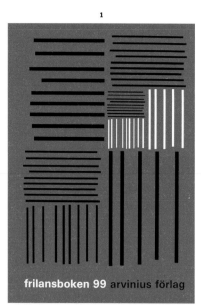

frilansboken 99 arvinius förlag

2

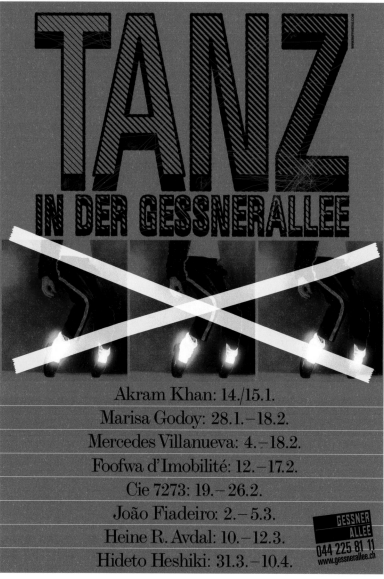

Akram Khan: 14./15.1.
Marisa Godoy: 28.1.–18.2.
Mercedes Villanueva: 4.–18.2.
Foofwa d'Imobilité: 12.–17.2.
Cie 7273: 19.–26.2.
João Fiadeiro: 2.–5.3.
Heine R. Avdal: 10.–12.3.
Hideto Heshiki: 31.3.–10.4.

GESSNER
ALLEE
044 225 81 11
www.gessnerallee.ch

3

4

nottdance06
www.dance4.co.uk

**1**
**Kiosk**
Identity origination and
design of Dance 4's annual
contemporary dance festival,
held in Nottingham, UK
Art direction by David Bailey
Client: Dance 4

**2**
**De Designpolitie**
Poster series
Client: Artis Zoo Amsterdam
Format: 84.1 x 118.9 cm

**3**
**Bodara**
Designs for shirt series
Designer: Tobias Peier
Client: Pö-titi

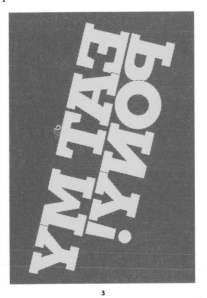

**1**
**Third Eye Design**
Exhibition
Designer: Hector Pottie
Credit: Design Journeys
Client: Six Cities Design Festival

**2**
**Node**
One of two posters for the
Lithuanian pavilion at the
52 Art Exhibition, La Biennale
di Venezia
Client: Contemporary Art Centre
CAC, Vilnius
Format: 70 x 100 cm

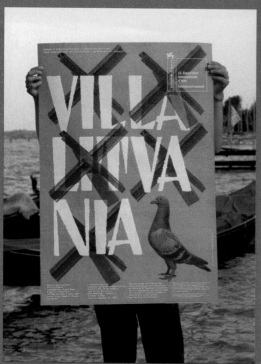

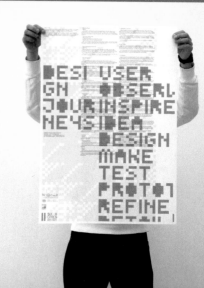

**Stout / Kramer**
Visual Identity, GP04 Fear & Space
Client: Fonds BKVB Amsterdam

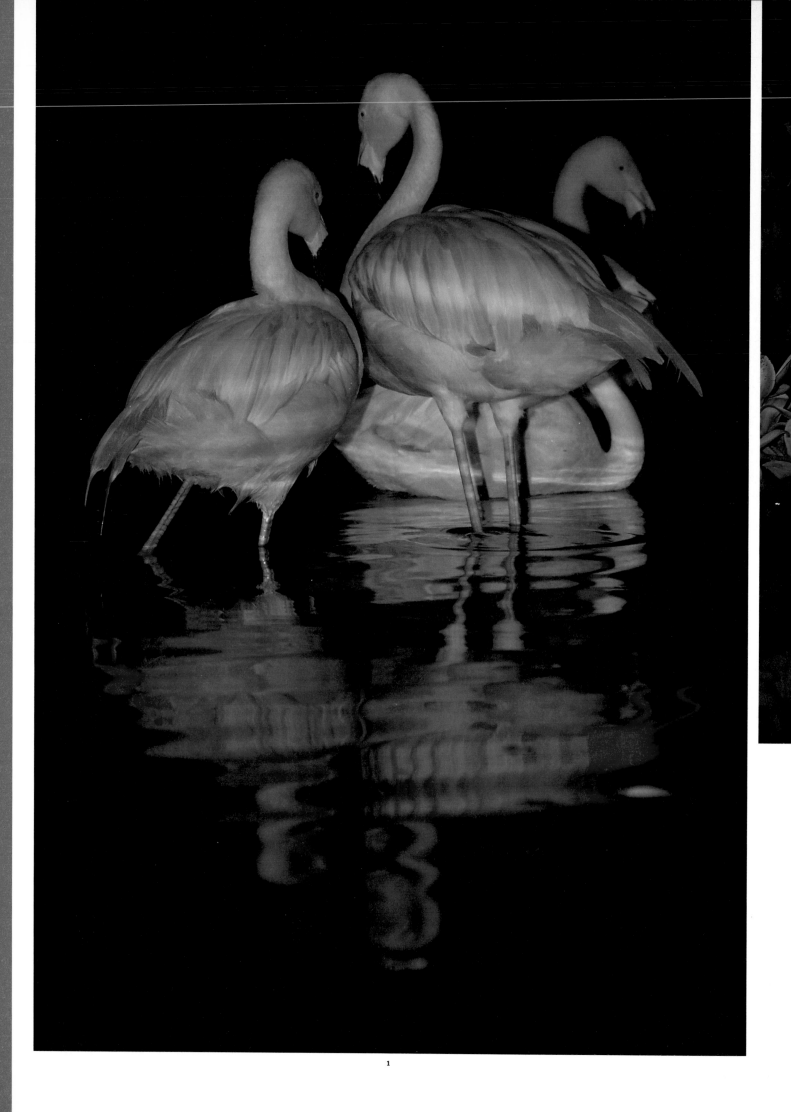

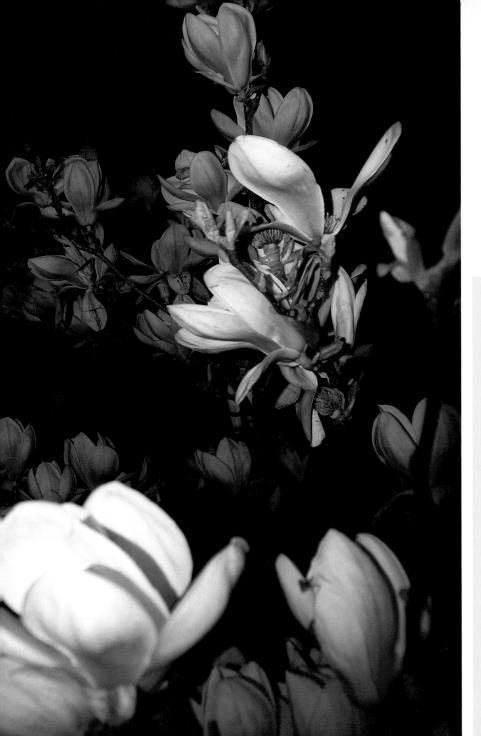

**1, 2**
**Discodoener,**
**Marcus Fischer**
"Printemps, sa roule ma poule!"
Format: 45 x 60 cm

**3**
**Jop van Bennekom**
BUTT Magazine

3

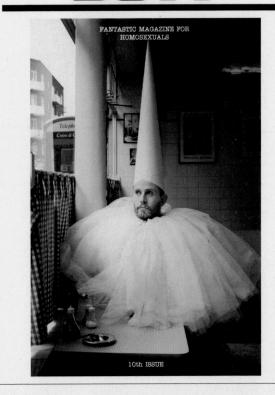

2

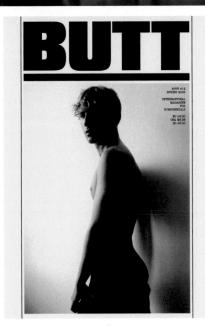

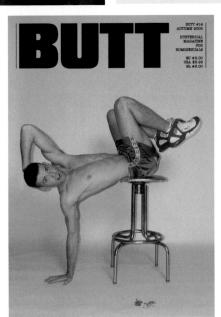

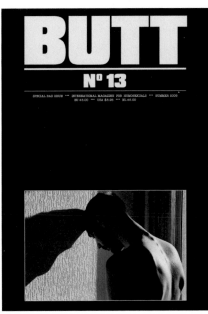

3

3

3

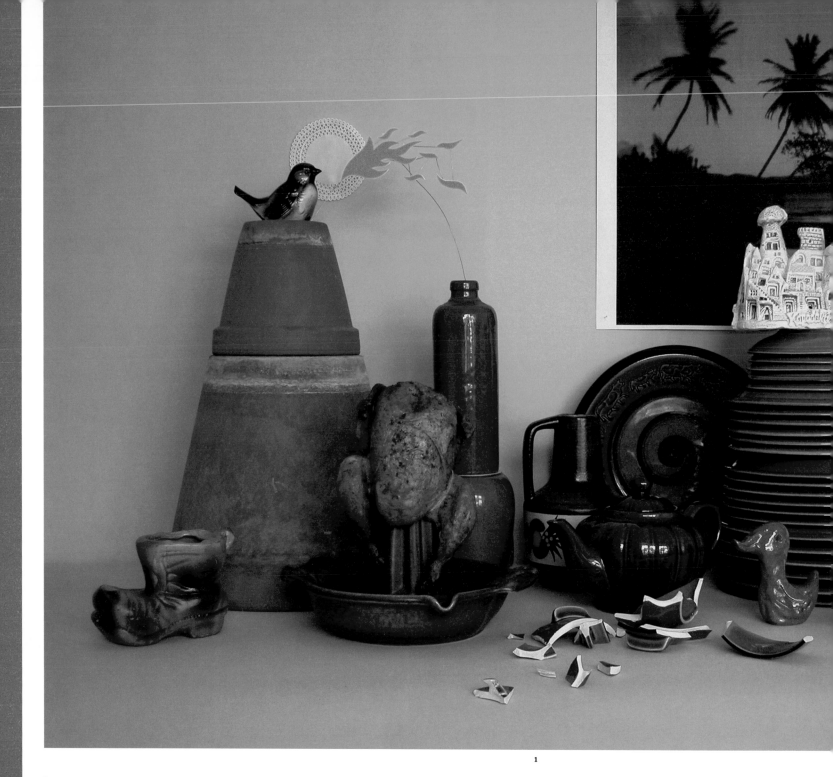

1

**1**
**Superbüro, Barbara Ehrbar**
Invitation poster for the diploma exhibition
of the Ceramic Design Department
Client: Schule für Gestaltung, Bern und Biel
Format: 29.7 x 42 cm

**2**
**Hjärta Smärta**
Editorial about plastic surgery on men
Technique: Papercollage
Client: Diego Magazine

2

**1**
**Fulguro / Yves Fidalgo, Cédric Decroux**
Exhibition design for the results of the contest
"The most beautiful Swiss books 2005"
Each book has its own chair with the title of
the book on it.
Client: Swiss Office for Culture

**2, 3**
**Gilles Poplin**
KD2A Project: Logo as set for TV show
Graphic design and art direction in association
with Sylvia Tournerie
Production Company: Les Télécréateurs
Set designer: Guilain Descayrac Team
Client: France 2

(opposite page)
**1**
**Nacho Alegre**
My Bed

**2**
**Gilles Poplin**
KD2A Project: Logo as Set for TV show
Graphic design and art direction in association
with Sylvia Tournerie
Production company: Les Télécréateurs
Set designer: Guilain Descayrac Team
Client: France 2

**3**
**Gilles Poplin**
KD2A Project: Logo as set for TV show
Graphic design and art direction in association
with Sylvia Tournerie
Production company: Les Télécréateurs
Set designer: Guilain Descayrac Team
Client: France 2

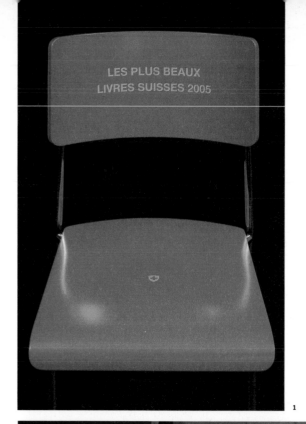

1

2

3

2

3

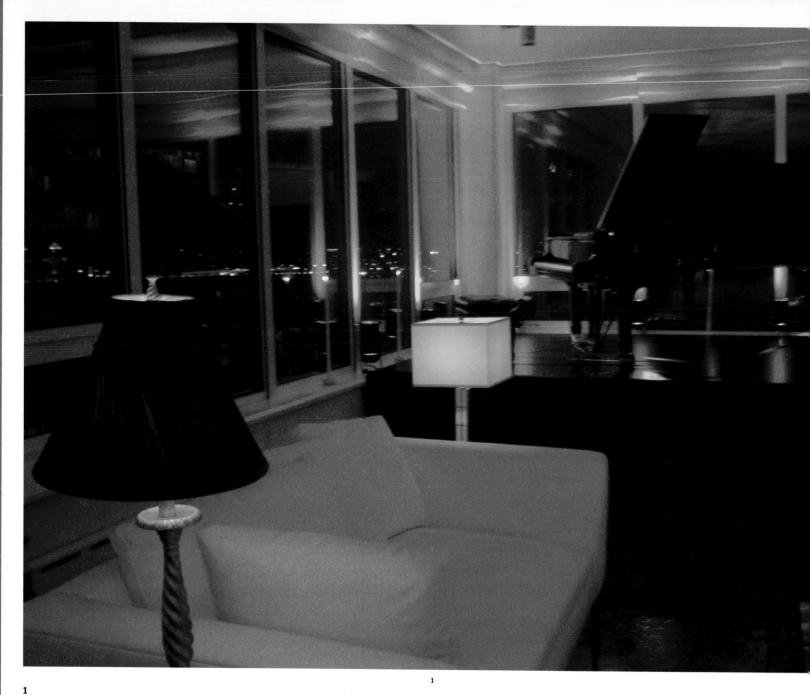

**1**
**Base Design**
Environment
Milk Salon is an intimate classical music venue
and performance series hosted by Milk in
New York City. The hand-delivered invitations to
the first event consisted of a red plexi box
containing 15 red roses. The invitation information
was silkscreened on the box lid. The programme
followed the red theme and featured a red paper
cover with red foil stamping and a red thread
binding. The event environment, likewise, featured
red lighting.
Client: Milk Salon

**2**
**Base Design**
Programme
Client: Milk Salon
Format: 15.5 x 22.5 cm

**3**
**Base Design**
Invitation
Client: Milk Salon
Format: 11 x 20 x 6 cm

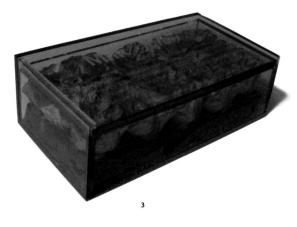

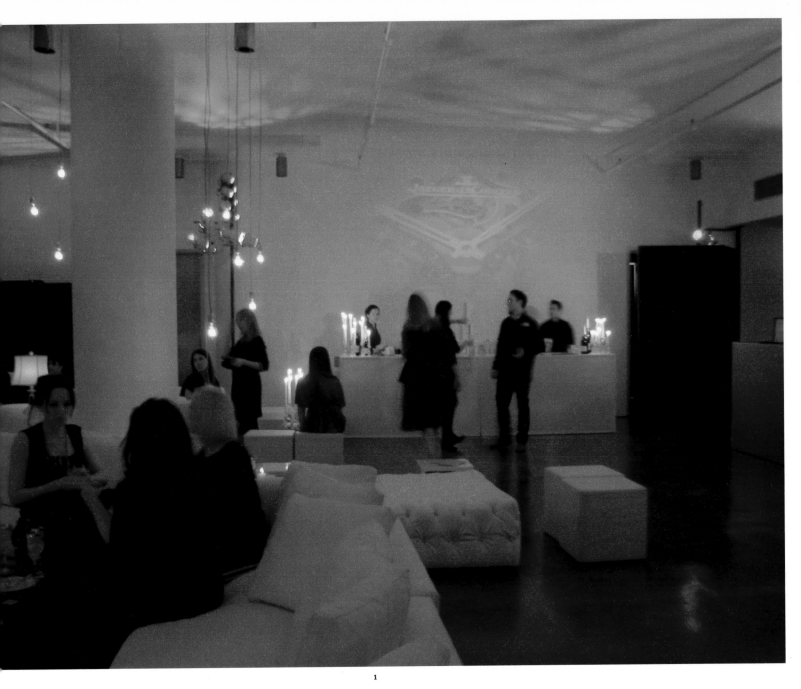

1

(following pages)
**Elias & Saria**
Bathing suit: Sabine Feuilloley
Roof (part of "Falling In Love")
Photo: Elias & Saria
Model: Rachel Hartzog / New York Models
Hair: Melanie Rehfeld
Make-up: Asami Matsuda
Styling: Elias & Saria
Supported by Albright Fashion Library
and in cooperation with Sabine Feuilloley
Retouching: Elias & Saria

3

3

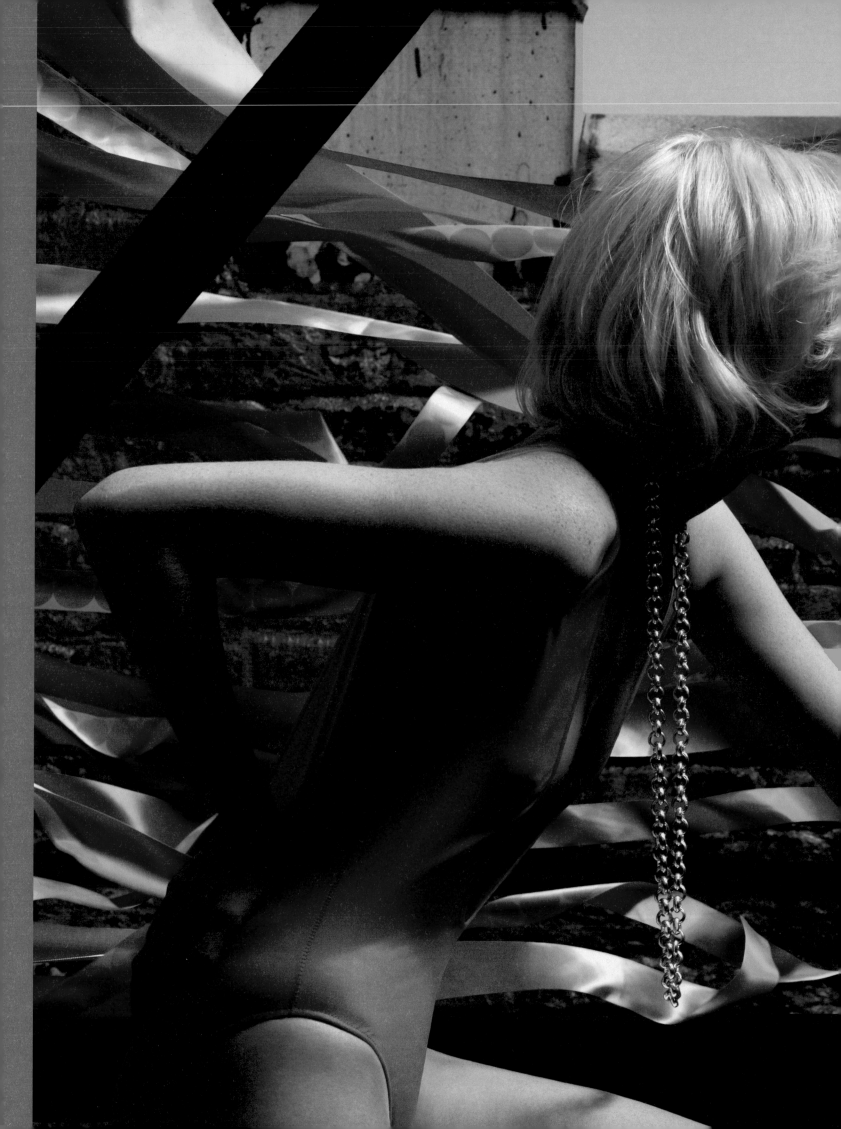

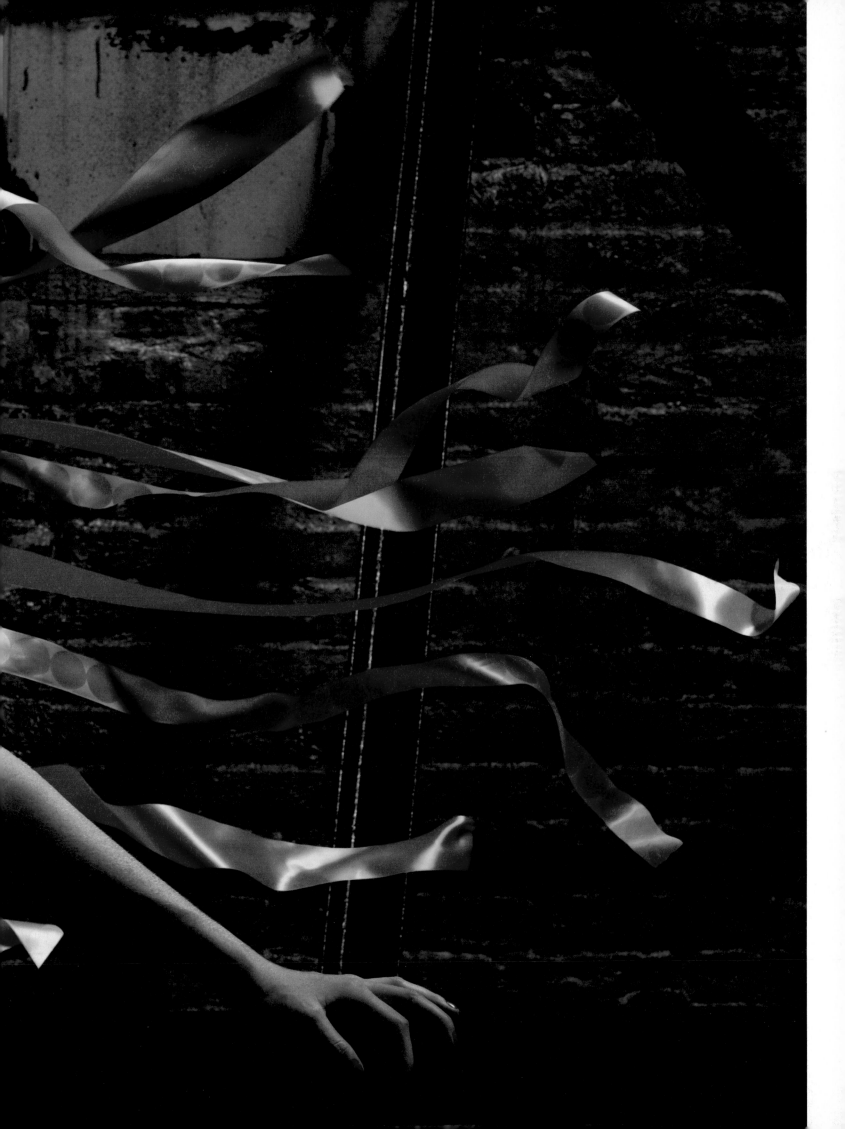

# Yellow

*"To me, yellow is the colour of rebellion.
It's in between green and red on the traffic light. If you feel rebellious,
you start driving when the light turns yellow, not on green."*

When I think of yellow, I think of happy days in the sun or the refreshing taste of lemons. I think of people wanting to be noticed driving yellow Ford Mustangs down LA highways. I think of the colour of the lovely runny egg yolk in the poached egg I have every morning. I think of celebrity gossip in the yellow press; mostly bleach blonde Paris Hilton and her gang's adventures in prison. I think of the difficulty of removing bits of corn stuck in between my teeth at a summer barbeque while trying to chat up a lady. I think about the colour of my brother's wedding ring as it came out of the blacksmith's fire. I think of highlighting words in a factual book. I think of people dressed in yellow clothes, which either show confidence or are an eyesore. But most of all, I think of myself as a teenager stuck in a boring classroom and daydreaming of breaking free of the drudgery of school to do my own thing.

I used to sit next to my best friend J. and her favourite colour was yellow. We used to give each other presents all in yellow. We used to speak with every second word being yellow. We used to look almost crazy while pronouncing our favourite word: Y-E-L-L-O-W. Our faces would contort on "y" and "e" then relax on the "l" before tightening again to savour the "o'" for a few seconds with our tongues out all the way rolling that lovely sound around in the air.

J. and I would have competitions about who had the worst year-end results. We had a great time together and I thought we would be friends forever (as you do when you are young), but after college I moved away and we went separate ways and I almost forgot all about the yellow time we had together until today when I sat down to write this introduction.

To me, yellow is the colour of rebellion. It's in between green and red on the traffic light. If you feel rebellious, you start driving when the light turns yellow, not on green. Yellow is a colour full of energy and freedom. Yellow is the colour of enlightenment. Apparently painting one's study yellow helps with concentration. It's the yellow mustard on a shady hot dog bought – against better judgment – after a boozy night from a New York or London street vendor that makes the sausage digestible and helps fend off the otherwise unavoidable food poisoning.

Yellow was the colour of the pus that came from the splinter that I once got when climbing a fence in order to escape the police that were after me for doing graffiti.

Yellow is the colour of light. In filmmaking, I use it to sculpt my shots in light and shade. It's at the centre of the light spectrum and is the most powerful and clean colour. It's also the colour of my favourite dessert: crème brûlée.

Yellow is associated with happiness and peace as well as jaundice, cowardice and greed.

What makes using colour in art and design so exciting is that we all have different associations and interpretations of each colour and everyone reads slightly different emotions into each colour.

It's exciting to see what everyone else thinks of yellow and how so many talented individuals use yellow in different ways, but, to me, the colour yellow will always be the colour of skipping homework and letting the mind roam free. Now I wish I had skipped homework more often.

Text by **Matthias Hoehne**

Matthias Hoene is a filmmaker who grew up in Berlin and has been living and working in London and Los Angeles for the past 10 years. He has won a Cannes Golden Lion and many other awards for his music videos and commercials. He is currently working on a film project for the relaunch of the renowned British Hammer Horror label.
www.matthiashoene.com

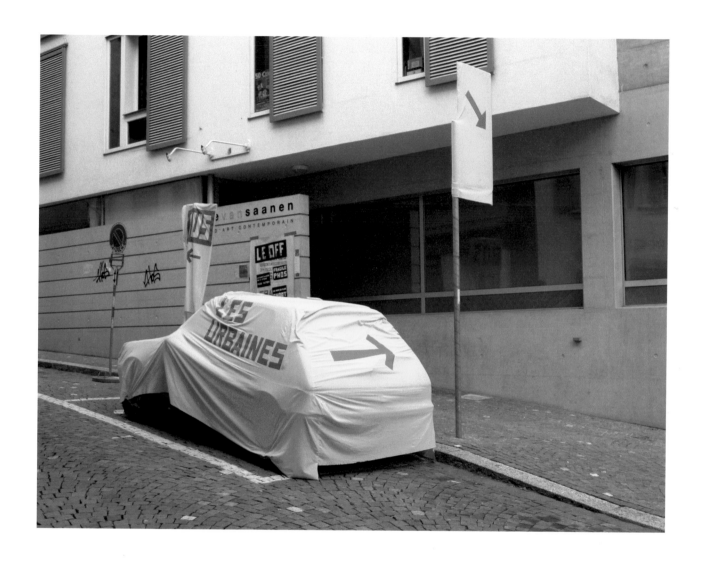

**Fulguro /**
**Yves Fidalgo, Cédric Decroux,**
**Axel Jaccard**
Les Urbaines 2004 Festival des Jeunes Creations
Client: Les Urbaines

**1**
**Norm**
Bruce Lee Poster
Poster featuring Bruce Lee,
Nora Miao, Kareem Abdul Jabbar
and Master Sifu Yip Man.
2 colour silkscreen
Format: 90.5 x 128 cm

**2**
**Fons Hickmann / m23**
Posters, cards
Client: Diakonie

**3**
**Node**
Happy Days Sound Festival 2007
Client: Ny Musikk
Format: 70 x 100 cm

**4**
**André Baldinger**
Cover for the annual
theatre programme
Photo: Graziella Antonini,
André Baldinger
Client: Centre Dramatique
de Thionville-Lorraine
Format: 28 x 21 cm

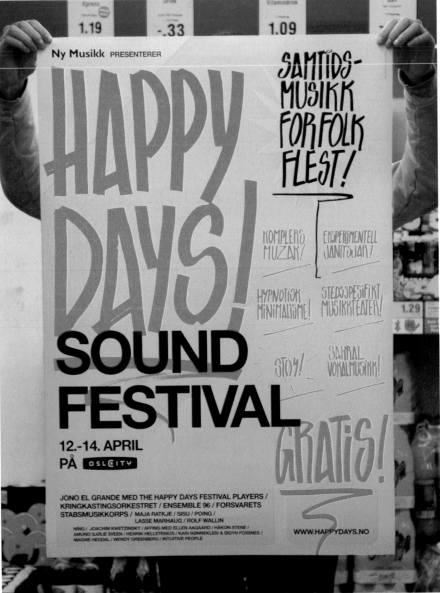

3

1

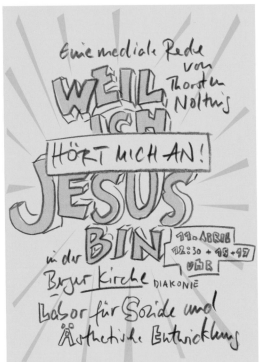

2

4

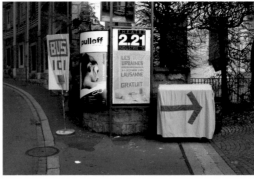

**Fulguro /**
**Yves Fidalgo, Cédric Decroux,**
**Axel Jaccard**
Les Urbaines 2004 Festival des Jeunes Creations
Client: Les Urbaines

LES
URBAINES

FESTIVAL DES JEUNES CREATIONS

3-4 DECEMBRE 2004

LAUSANNE

ABSTRACT   ARSENIC   CIRCUIT   2.21   DONZEVANSAANEN   FÁR   ROMANDIE   SEVELIN 36   SYNOPSIS^M   ZINEMA

THEATRE      DANSE      MUSIQUE       CINEMA      ARTS PLASTIQUES      PERFORMANCE

GRATUIT

WWW.
URBAINES.CH

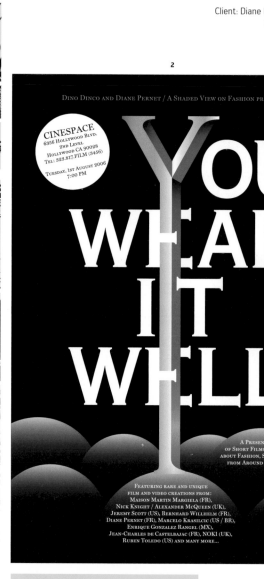

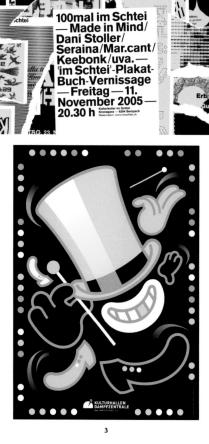

**1**

**Mixer / Erich Brechbühl**
Poster for the 100th event at the
"Kulturkeller im Schtei" in Sempach
Client: Kulturkeller im Schtei
Format: 90.5 x 128 cm

**2**

**Pierre Marie**
"You Wear it Well"
Poster
Client: Diane Pernet, Dino Dinco
Format: 40 x 60 cm

**3**

**Büro Destruct / MBrunner**
Monthly programme poster
Client: Kulturhallen
Dampfzentrale Bern
Format: 89.5 x 128 cm

**4**

**Gabor Palotai**
"Made in Sweden?"
Stockholm Furniture Fair
Silkscreen poster
Client: Designforum
Svensk Form
Format: 70 x 100 cm

**5**

**Atelier Télescopique**
Collection identity
Client: Wassingue™
Format: 21 x 29.7 cm

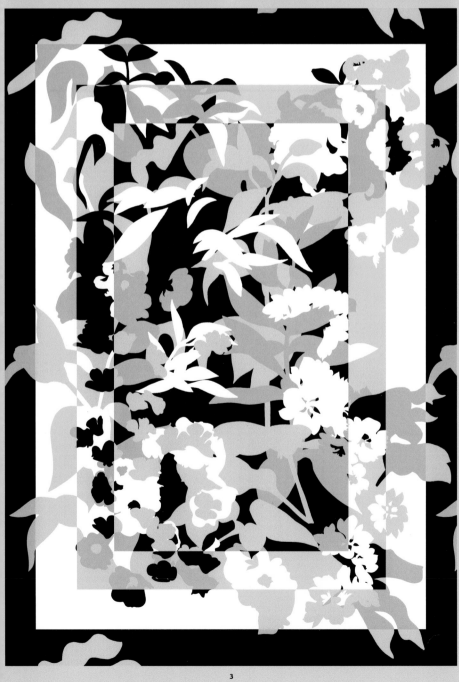

3

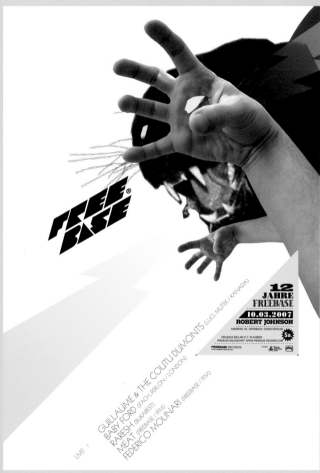

4

**1**
**Dani Navarro**
Client: CCCB,
Centre de Cultura
Contemporània de Barcelona
Format: 10 x 15 cm

**2**
**Newsgroup**
Invitation
Client: W139
Format: 14.85 x 21 cm

**3**
**Marcus James**
Spring Summer 07 Print
Client: Camilla Staerk

**4**
**Bionic Systems,**
**Doris Fürst, Malte Haust**
Promotional poster for the Freebase Records
anniversary night at Robert Johnson, Offenbach.
Client: Freebase Records
Format: 42.2 x 59.6 cm

**BNAKUBUS**

# BNABLAD #04

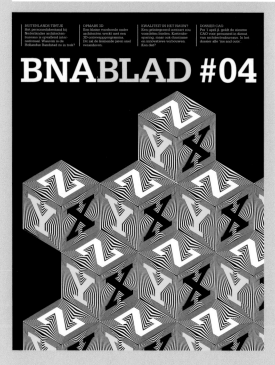

# BNABLAD #02

H₂O

# BNABLAD #01

#1

**Thonik**
Corporate identity
Client: BNA

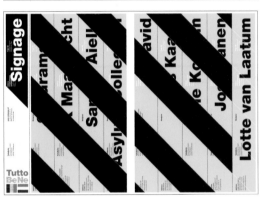

**Lesley Moore, Silke Spinner**
Exhibition design
Client: TuttoBeNe

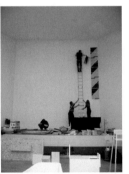

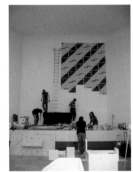

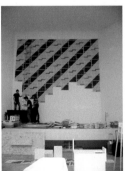

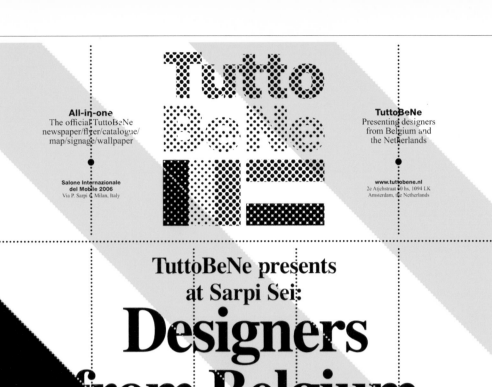

**Umbra + Dor / Dieter Feseke**
8th International Festival for
Silent Film & Music Berlin
Client: The Shoulder Arms /
Steven Garling
Format: 84 x 120 cm

19. — 25.januar
warschau — berlin — hollywood

pola negri

internationales

MADAME DUBARRY · DIE BERGKATZE · DIE FLAMME BARBED WIRE · CARMEN —
LIVEBEGLEITUNG: ALJOSCHA ZIMMERMANN (PIANO) — GRAF V BOTHMER
HANS-GÜNTHER WAUER (KINOORGEL) — ANTONIO PALESANO (PIANO,
ELECTRONICS) CHRISTIAN WEIDNER (SAXOPHON, KLARINETTE) — WILLY
SOMMERFELD (PIANO) — STEVEN GARLING (SCHLAGWERK + ORGANISATION)

festival

für

stummfilm

ROSA-LUXEMBURG-STR. 30        WWW.BABYLONBERLIN.DE        030-2425969

und · musik ·

mitte

im babylon berlin

**Huskmitnavn**
Exhibition "Backjumps –
the Live Issue, Part 3"
Client: Kunstraum
Kreuzberg / Bethanien, Berlin
Format: 60 x 3.5 m

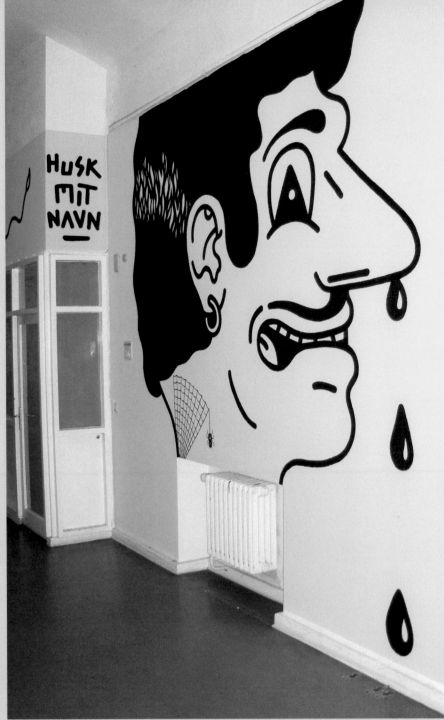

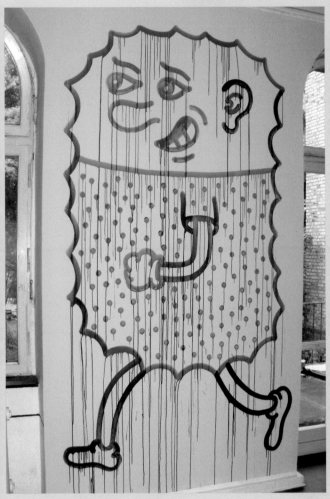

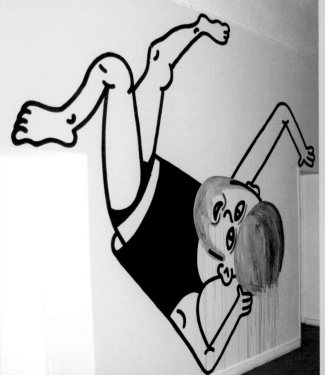

1

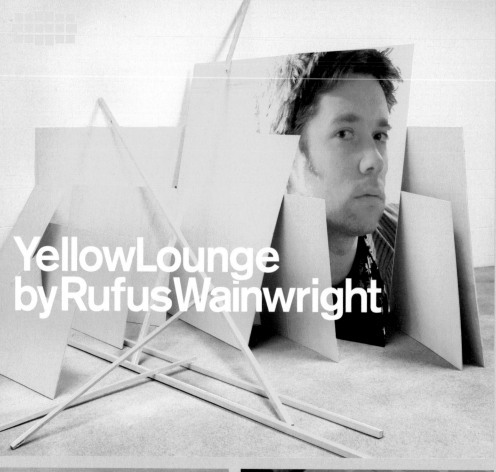

**YellowLounge
byRufusWainwright**

2

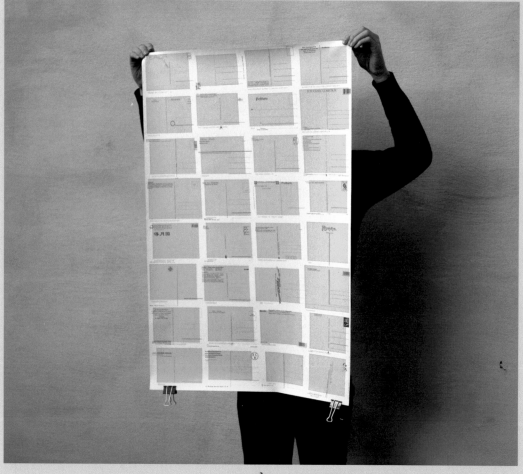

4

3

(opposite page)

**1**
**Borsellino & Co.**
Cover for Locator / Directions 02
Magazine
Client: Design Hotels AG
Format: 17 x 23 cm

**2**
**Dirk Rudolph**
CD for Rufus Wainwright
Client: Deutsche Grammophon

**3, 4**
**Node**
Exhibition organised by:
Berlin China Cultural Bridges
We were asked to take part in
this exhibition in Shanghai.
It focused on Berlin's image
as an open, demanding pop-
cultural metropolis and asked
young graphic and media
artists: "What makes Berlin
addictive?" Our contribution was
a poster showing the backside
of different Berlin postcards
from the last 100 years. Only the
description of the locations
and the basic graphic elements
are visible. By reading the texts,
the viewer has to create his or
her own vision of the German
capital and derives some frag-
ments of the city's modern
history.
Format: 70 x 100 cm

**1**
**Allon Kaye**
Sudden Infant and Ze
Recorded live at a public
lavatory in London
Photo by Martin Holtkamp

**2, 3**
**Allon Kaye**
Printed Wraparound Tracing
Paper sleeve
Photo by Martin Holtkamp

**4**
**Simon Johnston Design**
Book "Colors for Modern
Fashion: Drawing Fashion With
Colored Markers"
Client: Nine Heads Media

2

3

**1**
**Arko**
"Broken Leaves"
Private work

**2, 3**
**Sandra Hoffmann**
"ExSamples"
Exhibition, signage, invitation card,
catalogue, exhibition guide
Client: University of Applied Sciences,
Darmstadt

**4, 5**
**Laura Snell, Katie Waters**
Degree show publicity proposal
Client: University of Brighton

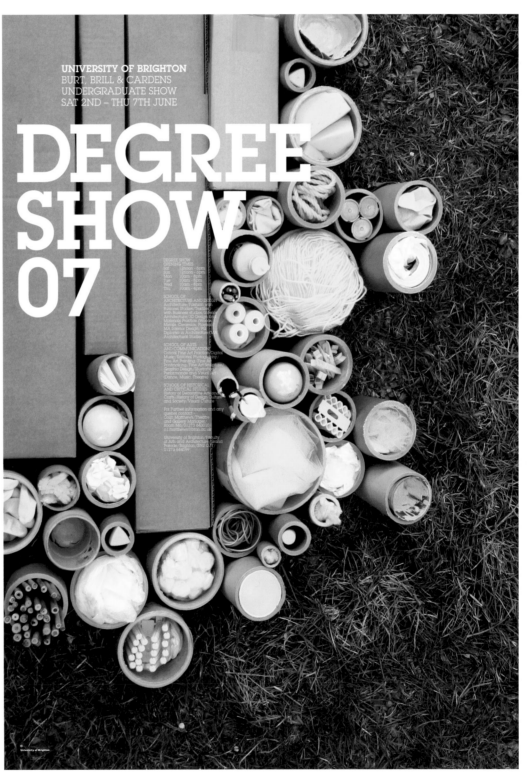

4

5

**Federal Studio**
Summer fashion series "yellow"
Client: Femina fashion magazine
Format: 21 x 29.7 cm

(following pages)
**Elias & Saria**
Bathing suit: Chanel
Slide (part of "Falling in Love")
Photo: Elias & Saria
Model: Isabelle Surmont / Place
Hair/make-up: Stephanie Ruppaner
Styling, retouching: Elias & Saria
Format: 56 x 35.5 cm

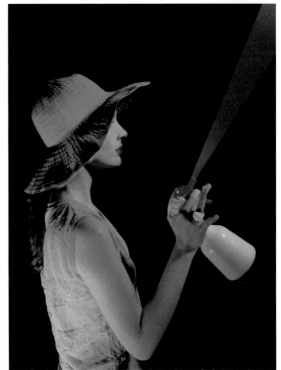

# Green

"But what is 'in our head', when we see green grass?
Runge's blue-green?
And do we have white walls in our head?"

**Runge's Green Not Fuji-Green!** When confronted with the respective phenomena, there is no denying it: grass is green. Spinach is green and so are salad and chives… In a colloquial sense, the term green applies to the fully developed foliage of photosynthetically active terrestrial plants.

But when I started to compare natural colours under daylight conditions with the colour samples of a standardised system, I noticed that the colour that we refer to as "green" is actually different in the countryside. Constantly and over and over, it turns out to be yellow-green there.

Is grass really not green or are all modern colour systems mistaken?

Prior to 1860, Jacob van Ruisdael, Casper David Friedrich and Camille Corot all painted fully-developed foliage in yellow-green. And it looked really naturally green. For Phillip Otto Runge, the colour tone sap green, which the painter used for plants, was known in his colour sphere (1810) simply as "green".

The core meaning of the term green first starts to shift in 1860. Monet wanted to depict the impression itself instead of what triggers it. And in Late Impressionist and Post Impressionist paintings, grass was no longer green (according to Runge) but rather as cool as the blue-green in Runge's colour sphere.

The fact that paintings were presented on white exhibition walls was a novelty. Colour had been liberated in Expressionism and Futurism – out of its natural context, to be exact. The modern colour systems were developed under colour-neutral conditions. While we see medium green from the laboratory – green that, according to Munsell, Ostwald, CIE or NCS, is neither yellowish nor blueish – it does appear to be blue, or at least a cold blue-green outside.

Take, for example, the "signal green" of traffic lights. It's the kind of green that tells us "This is as green as it gets". But not if we put a larger percentage of blue into the chlorophyll; then, it gets bluer. Outdoors, we react extremely sensitively when we depart from the realm of medium vegetative green in the direction of blue. We know exactly that the characteristic vegetative green of photosynthetically active ground covered plants are composed of the green pigments chlorophyll a and b and the yellow pigments carotene b, xanthophyll and xanthophyll-epoxyd. And we have cause to know it and to cherish it because only chlorophyll is able to bind the sun's energy in carbohydrates and enable life on earth. It relaxes us because it guarantees life. In addition, it extracts the carbon from carbon dioxide to develop for its own purpose and leaves us with the oxygen to breathe.

Back when our ancestors hunted and gathered, there was an interest in the ability to effectively differentiate colour in an environment that was dominated by neighbouring shades of yellow; through the colour adaptation, the deviation from the existing predominant colour stimuli makes it more strongly perceived.

But what is "in our head", when we see green grass? Runge's blue-green? And do we have white walls in our head?

If we abandon the internalised presentation room as designers and enter the real world as architects or landscape planners, we should take the blinders of white reference from our eyes. We should also generate a coloured environment to serve as a more realistic background for our designs, in which the buildings would eventually be perceived. Then, we would be able to see again that grass is green.

Runge's green not Fuji-green!

Text by **Berthold Hering**

Born in Darmstadt in 1961, Hering received his diploma in Free Art from the Academy of Fine Arts, Hamburg in 1989. He currently lectures on the topic of colour in an outdoor environment and has published diverse works on the topic, i.e. "Symphänologie der Farben" in the botanical journal Tuexenia, Goettingen, 2007. In that year, he also created the video "Der Zauberer der Zeiten". www.bertolt-hering.de

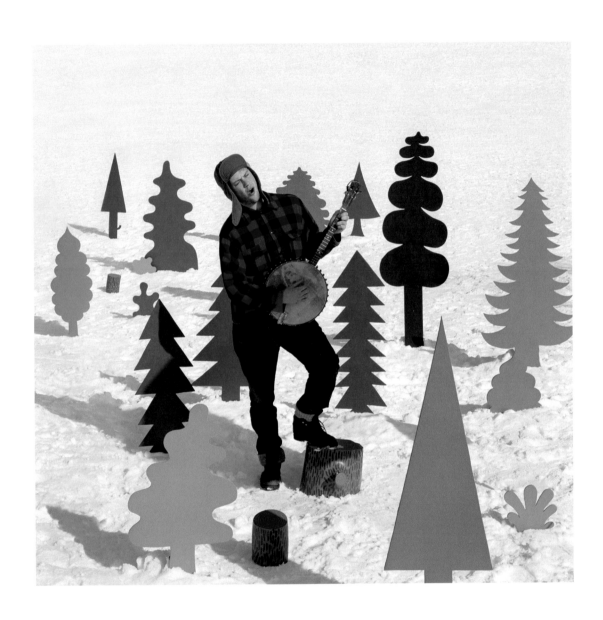

**Yokoland /**
**Espen Friberg, Aslak Gurholt Rønsen**
Artwork for the compilation record
"The Great American Brainkiller"
Client: Metronomicon Audio
Photograpy: Jørgen Gomnæs
Assistant: Marianne Nilsen

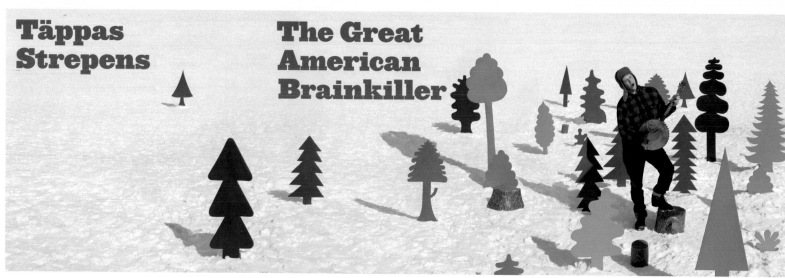

# Täppas Strepens — The Great American Brainkiller

1. **Various Angry Ramblings**
2. **Yeller Cab**
3. **Radio Europe**
4. **Ketchup & Wrestling**
5. **Janet Jacksons Nipple**
6. **They Speak in Slogans**
7. **Slaves of the Scenery**

(C) & (P) 2005 Metronomicon Audio
All wrongs reversed
www.metronomiconaudio.net
MEAU.0022.CDR

1

2

2

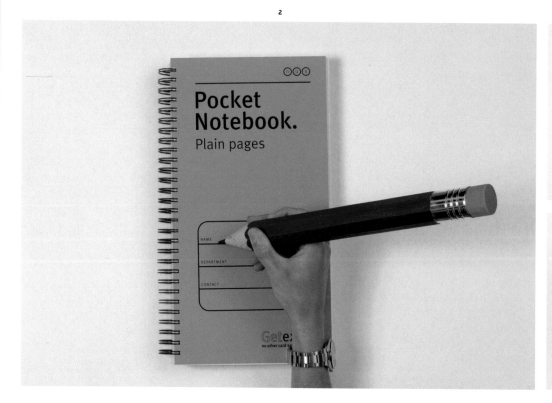

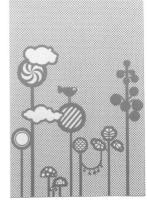

round /
**Michaela Webb, Suzy Tuxen**
Identity for childrens clothing label
Client: Big by Fiona Scanlan

(opposite page)
**1**
**Yokoland /**
**Espen Friberg, Aslak Gurholt Rønsen**
Artwork for the compilation record
"The Great American Brainkiller"
Client: Metronomicon Audio
Photograpy: Jørgen Gomnæs
Assistant: Marianne Nilsen

**2**
**Public / Nicholas Jeeves**
We were briefed by the NUS PR agency
with the task of creating a press pack for
the National Union of Students' new package
– NUS Extra. The word 'gimmick' has any
number of sickly undertones – but a good
and simple one, we believe, is always welcome
and these giant notebooks and pencils were
very well received by both journalists and
(just as happily) their children.
Client: National Union of Students
Format: 17 x 30 cm

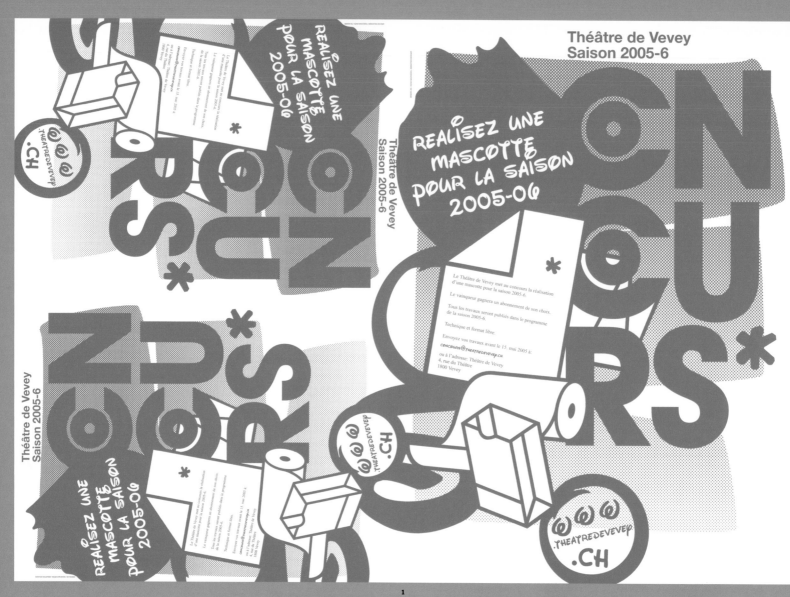

1

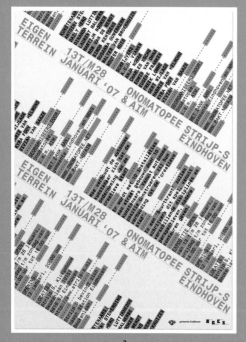

2

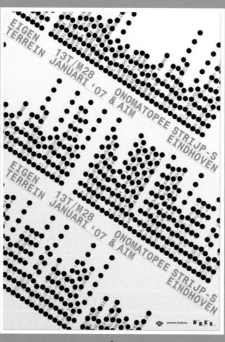

2

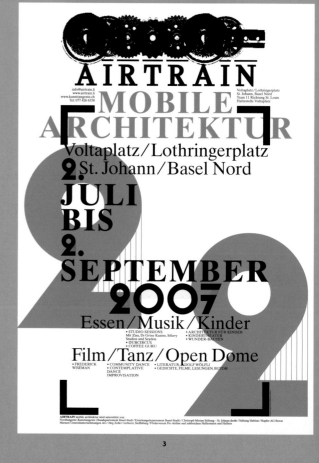

3

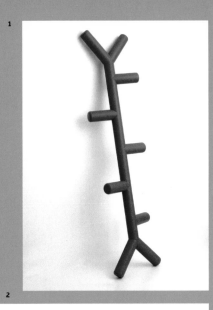

MyHome SIEBEN
SEVEN EXPERIMENTE
EXPERIMENTS FÜR EIN NEUES
FOR CONTEMPORARY
LIVING Interventions WOHNEN Interventionen
by: von:

Jurgen Bey, Ronan & Erwan Bouroullec,
Fernando & Humberto Campana,
Hella Jongerius, Greg Lynn,
Jürgen Mayer H., Jerszy Seymour

AN EXHIBITION EINE AUSSTELLUNG
AT THE IM
VITRA DESIGN MUSEUM
14. JUNI–
16. SEPTEMBER
2007

Vitra Design Museum

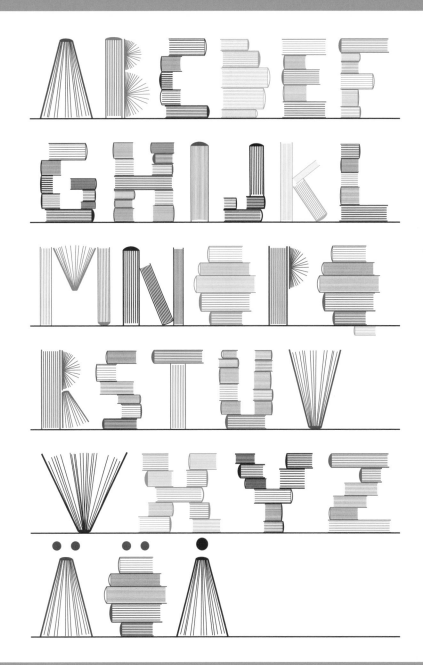

(opposite page)

**1**
**Welcometo.as /**
**Adam Machacek, Sébastien Bohner**
Poster
Client: Théâtre de Vevey
Format: 128 x 89.5 cm

**2**
**Onomatopee /**
**Remco van Bladel**
Invitation / flyer for the exhibition "Eigen Terrein"
Self published
Format: 21 x 29.7 cm

**3**
**Ludovic Balland**
Poster
Client: Airtrain
Format: 29.7 x 42 cm

**1**
**Emanuelle Jaques**
Ramo is a ladder inspired by a branch of a tree.
Sculptural as well as functional, the shape allows
different uses for outdoor or indoor, as a ladder or
as a wardrobe.
Client: Serralunga
Height: 170 cm

**2**
**Ludovic Balland**
Poster
Client: Vitra Design Museum
Format: 89.5 x 128 cm

**3**
**Bygg Studio / Hanna Nilsson,**
**Sofia Østerhus**
Book Club font, green version
Format: 21 x 29.7 cm

**4**
**Madame Paris**
Poster / programme
Client: Le Bourg
Format: 40 x 56 cm

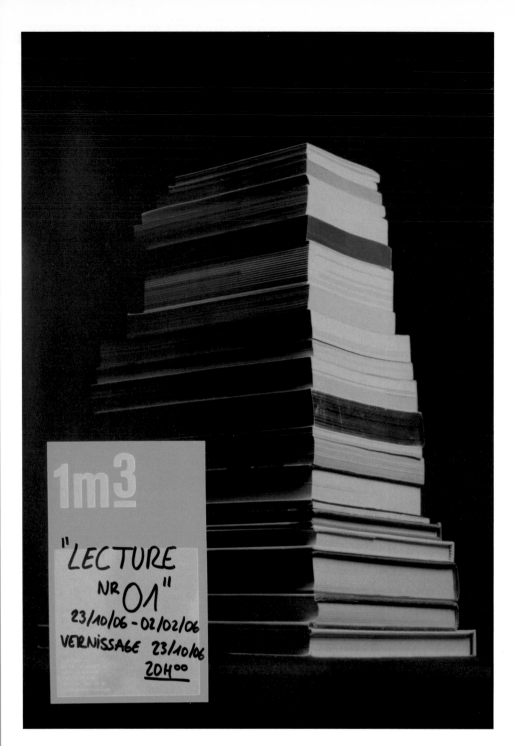

**Fageta**
Poster
Screenprinting: Lowrider
Client: Galerie 1m³
Format: 42 x 59.4 cm

**Fageta**
Corporate Identity
Screenprinting: Lowrider
Client: Galerie 1m³

**Fageta**
Poster booklet for a young artists festival in
Lausanne, Switzerland. The poster also works as
flyer, programme and signage to guide the public
through the different exhibition places in the city.
Client: Les Urbaines Off Festival
Format: 29.7 x 42 cm folded in 14.8 x 21 cm

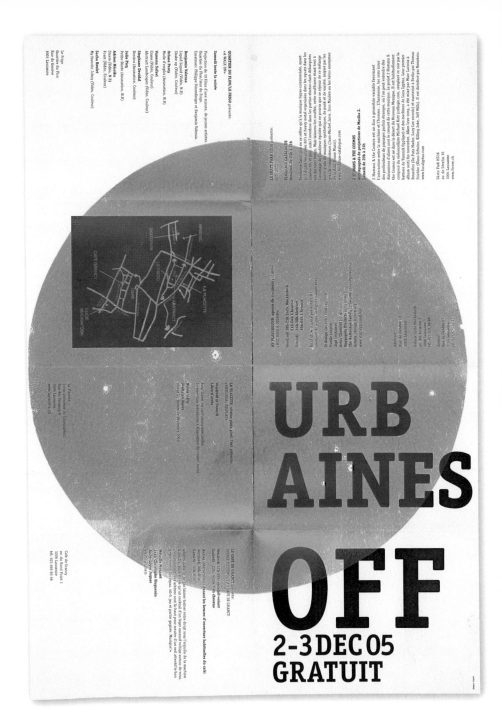

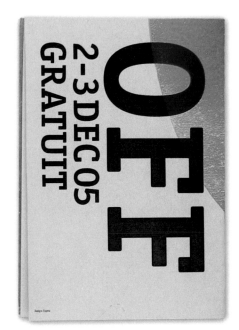

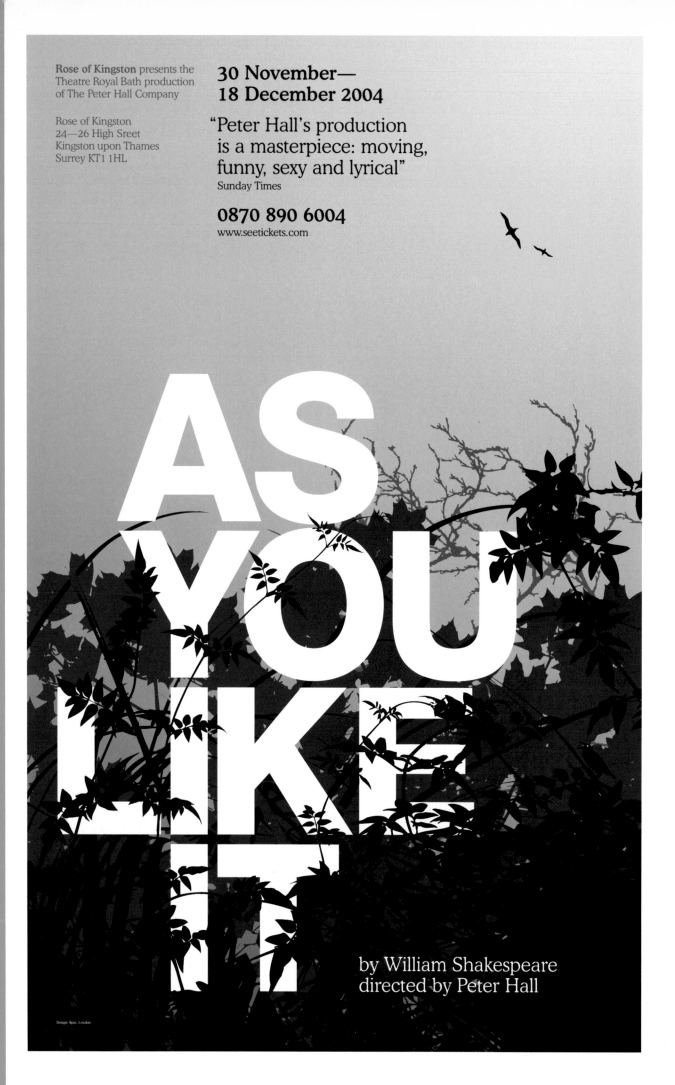

Rose of Kingston presents the
Theatre Royal Bath production
of The Peter Hall Company

Rose of Kingston
24—26 High Sreet
Kingston upon Thames
Surrey KT1 1HL

30 November—
18 December 2004

"Peter Hall's production
is a masterpiece: moving,
funny, sexy and lyrical"
Sunday Times

0870 890 6004
www.seetickets.com

AS YOU LIKE IT

by William Shakespeare
directed by Peter Hall

Design Spin, London

**Spin**
Promotional poster
Designer: Patrick Eley, Joe Burrin
Client: Rose of Kingston
Format: 76.2 x 152.4 cm

(opposite page)
**1**
**Onomatopee**
Poster for music / art
Collective Sonido Gris
Designer: Remco van Bladel
Self published
Format: 49 x 64 cm

**2**
**No Office**
Identity, concept, design for
"Remi", an exhibition and art
project about adoption
Designer: Dirkje Bakker,
Nelleke Wegdam
Client: Stichting Entree
(arts foundation)
Format: 59.4 x 84 cm

**3**
**Patrick Lindsay**
Hommage au peintre Cézanne
Client: Cézanne 2006

1

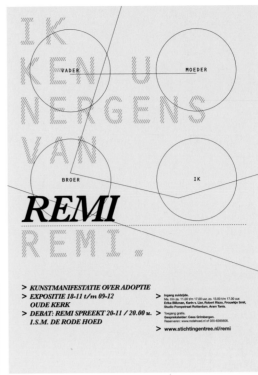

IK KEN U NERGENS VAN

VADER          MOEDER

BROER          IK

# REMI

REMI.

> KUNSTMANIFESTATIE OVER ADOPTIE
> EXPOSITIE 18-11 t/m 09-12
  OUDE KERK
> DEBAT: REMI SPREEKT 20-11 / 20.00 u.
  I.S.M. DE RODE HOED

> Ingang zuidzijde.
  Ma. t/m za. 11.00 t/m 17.00 uur, zo. 13.00 t/m 17.00 uur.
  Erika Blikman, Karin v. Lier, Robert Rizzo, Frouwkje Smit,
  Studio Pompstraat Rotterdam, Aram Tanis.
> Toegang gratis.
  Gespreksleider: Cees Grimbergen.
  Reserveren: www.rodehoed.nl of 020-6385806.
> www.stichtingentree.nl/remi

2

3

3

3

3

1

1

> UNDER FIRE.2
> JORDAN CRANDALL
>
> THE ORGANIZATION
> AND REPRESENTATION
> OF VIOLENCE.

2

**1**
**Kummer & Herrman**
Book cover
Photography: Mick Salomons
Client: BAK, Basis voor Actuele Kunst
Format: 11.4 x 16.5 cm

**2**
**Kummer & Herrman**
Book cover "Under Fire 2, The Organization
and Representation of Violence"
Photography: Mick Salomons
Client: Witte de With, Center for Contemporary Art
Format: 17 x 24 cm

**3**
**spin / Joe Burrin**
64 page book to celebrate the work and
innovation on display in the UK pavillion
at the Aichi Expo 2005 in Japan.
Client: British Foreign Office
Format: 22 x 28 cm

(opposite page)
**A Practice for Everyday Life**
Poster
Client: Scarlet Projects/
Victoria and Albert Museum, London

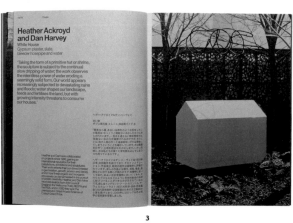

3

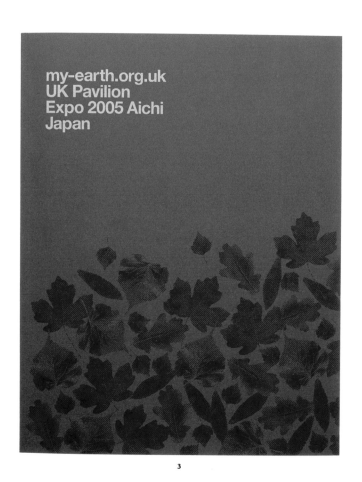

3

# Village Fete 2005

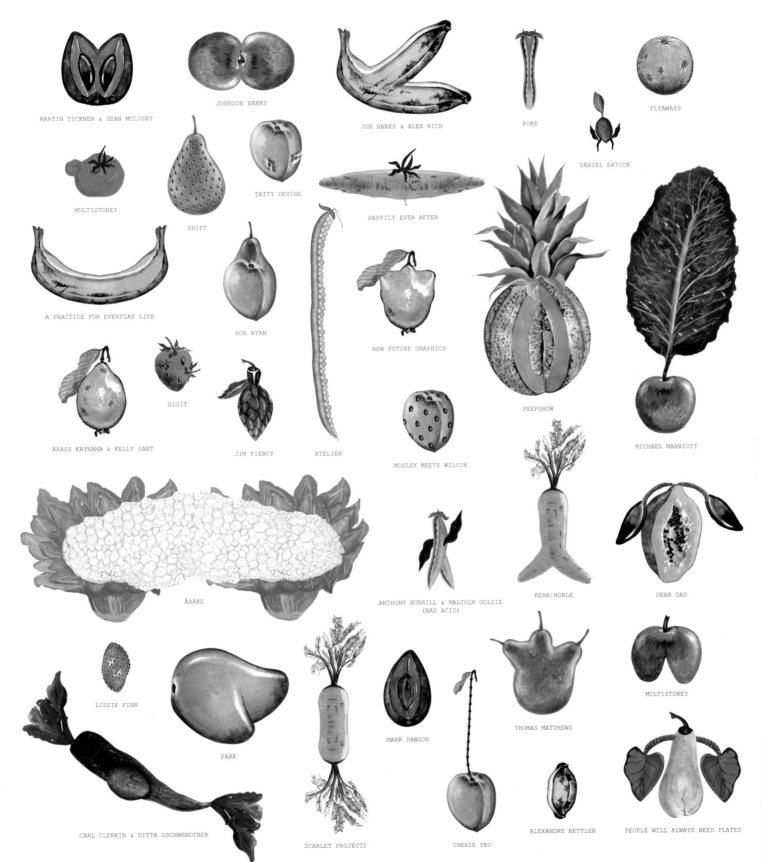

MARTIN TICKNER & SEAN MCLUSKY

JOHNSON BANKS

JON HARES & ALEX RICH

POKE

FLYAWAYS

DANIEL EATOCK

MULTISTOREY

TATTY DEVINE

SHIFT

HAPPILY EVER AFTER

A PRACTICE FOR EVERYDAY LIFE

ROB RYAN

NEW FUTURE GRAPHICS

PEEPSHOW

MICHAEL MARRIOTT

DIGIT

ARASH KAYNAMA & KELLY SANT

JIM PIERCY

ATELIER

MOSLEY MEETS WILCOX

ÅBÄKE

ANTHONY BURRILL & MALCOLM GOLDIE
(BAD ACID)

KERR|NOBLE

DEAR DAD

LIZZIE FINN

PARK

MARK PAWSON

THOMAS MATTHEWS

MULTISTOREY

CARL CLERKIN & GITTA GSCHWENDTNER

SCARLET PROJECTS

CHERIE YEO

ALEXANDRE BETTLER

PEOPLE WILL ALWAYS NEED PLATES

DESIGNED BY A PRACTICE FOR EVERYDAY LIFE (APFEL)

**1, 2, 3**
**Begin Begat Begun /**
**Mari J. Hovden**
Concert Poster
Client: Truls and the trees
Format: 29.7 x 42 cm

**4**
**Stout / Kramer**
Visual Identity
Client: The municipal administration of Rotterdam,
Department of the Arts and Culture

1

2

3

4

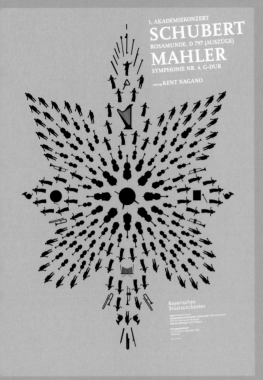

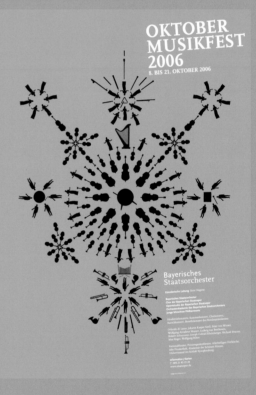

**Fons Hickmann / m23,**
**Barbara Bättig, Fons Hickmann**
Poster series
Client: Bayerische Staatsoper
Format: 59.4 x 84.1 cm

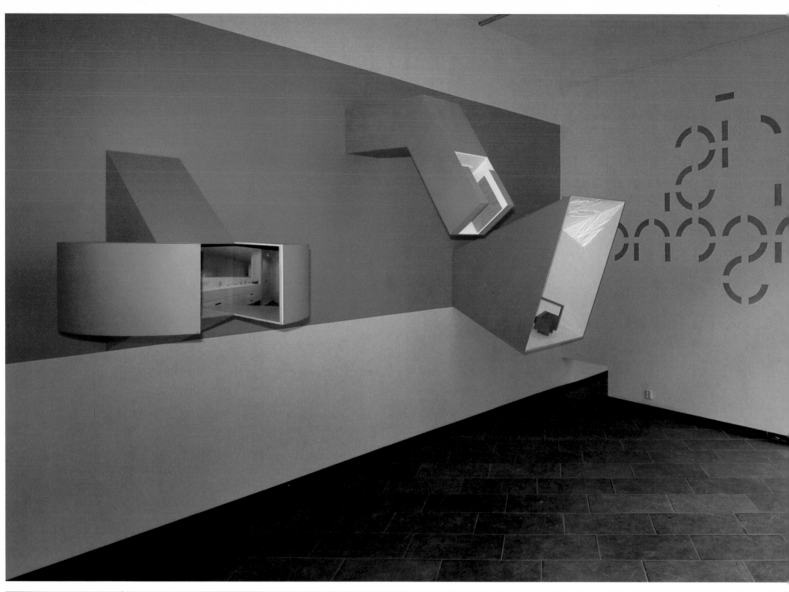

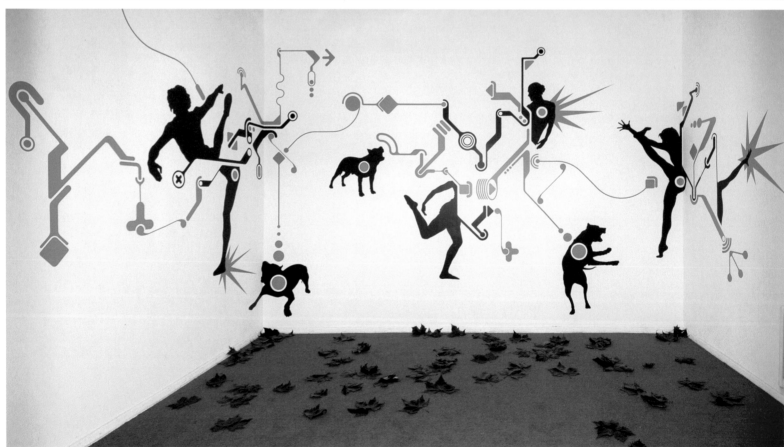

2

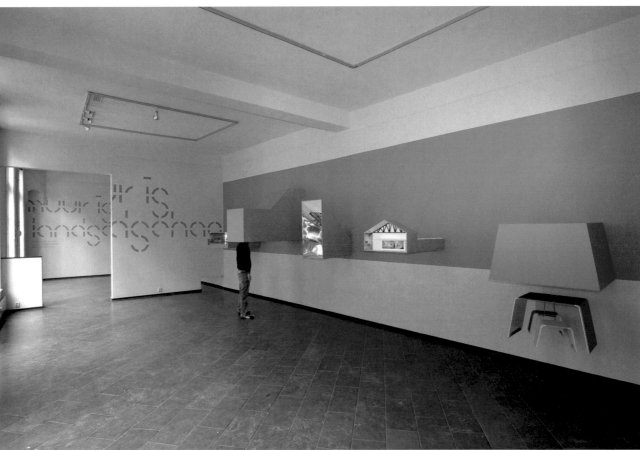

1

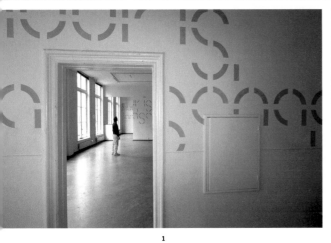

1

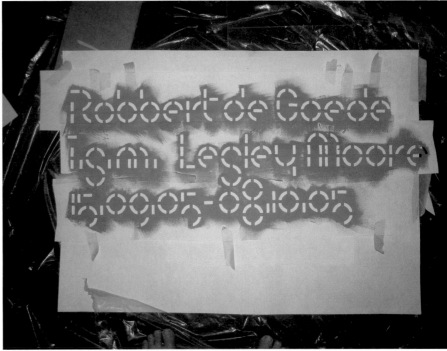

1

**1**
**Lesley Moore**
The exhibition shows the work of interior designer Robbert de Goede.
For the exhibition Lesley Moore designed a custom-made font based on the designer's working method in which modules play a big part.
The font itself consists of just two modules – one straight and one curved – with which every letter is made.
Using a cut-out stencil system, the entire lettering was painted with just these two parts.
Client: HKU Gallery / Robbert de Goede

**2**
**ASH / Victor Ash**
Installation for Backjumps
Kunstraum Bethanien, Berlin
"Dogs and Dancers"
Client: Backjumps 2
Format: 500 x 400 x 400 cm

(following pages)
**Big Active / Kate Gibb**
Spring / Summer 2002
Catalogue
Client: Dries Van Noten

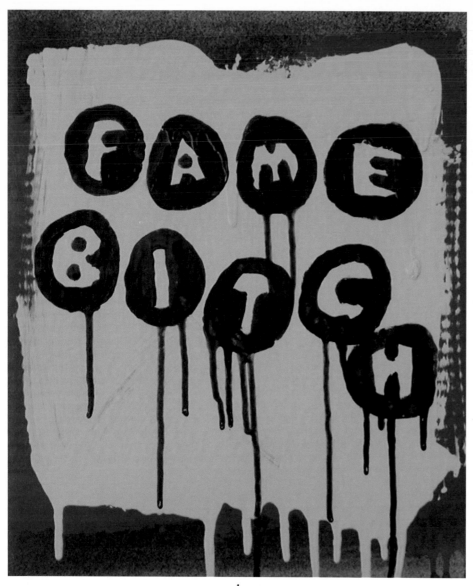

**1**
**Pixelpunk**
Illustration for one of Radio
Dadio's electro-dub mixes
Client: Radio Dadio
Format: 30 x 36 cm

**2, 3**
**Pixelpunk / Fuente Y Fuente**
Illustration for Swatch's Instant
Store in Barcelona
Credit: Luca Manes / Thilo Fuente
Client: Swatch Instant Barcelona

**4, 5**
Pixelpunk
"The Clash"
From a series of 5 pictures
Format: 30 x 40 cm

1

2

3

**1**
**Rinzen**
Special irish poster edition for Rinzen's
presentation at Sweet Talk Dublin
Client: Candy
Format: 59 x 42 cm

**2, 3**
**Pixelpunk**
"The Clash"
From a series of 5 pictures
Format: 30 x 40 cm

**www.vintageplant.net** **www.vintageplant.net** **www.vintageplant.net**

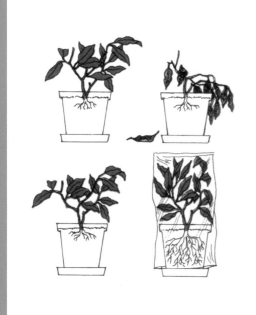  

**www.vintageplant.net** **www.vintageplant.net** **www.vintageplant.net**

**bygg studio /**
**Hanna Nilsson, Sofia Østerhus**
Business card for second-hand shop
and network of pot plants
Illustration by Ebba Schultz
Client: Vintage Plant
Format: 5.4 x 8.5 cm

(opposite page)
**Sulki & Min Choi**
Poster for the gayageum concert "Bubbles"
by the Korean musician Koh Jiyeon
Client: Mul
Format: 59.4 x 84 cm

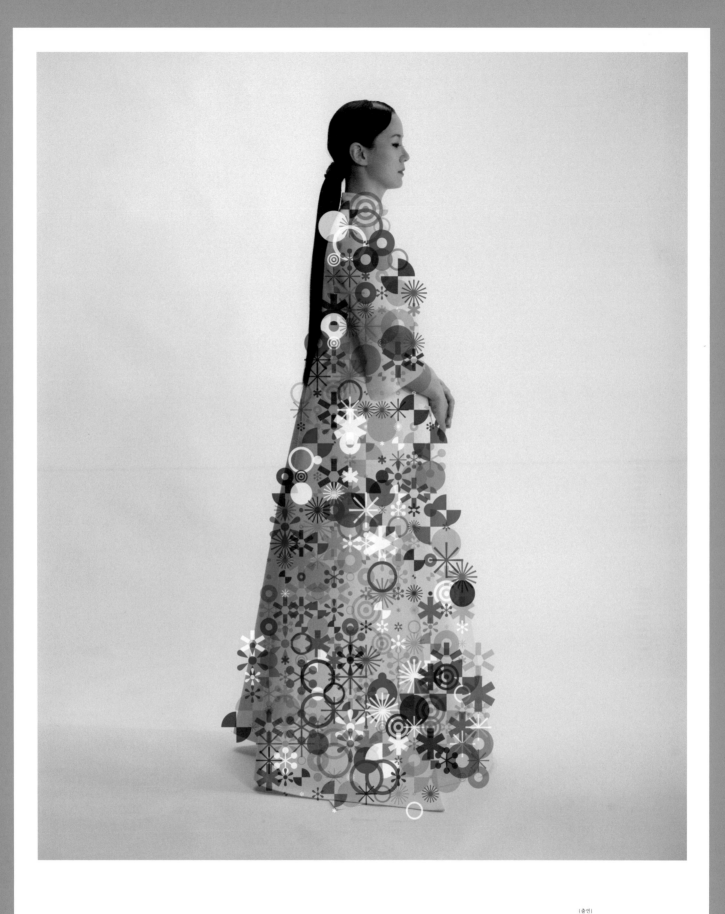

[주최]
물기획

[후원]
서울문화재단
예술의전당

[협찬]
고흥곤 국악기 연구원
담연

[입장권]
일반석 30,000원
학생석 20,000원

[예매처]
티켓링크
T: 1588-7890
www.ticketlink.co.kr
www.sac.or.kr

[공연 및 단체 관람 문의]
T: 02-3446-0620

# {기 포}

예술의전당 자유소극장
2007·5·15·화·8pm

고지연 가야금 프로젝트

[출연]
고지연
김용식
나원일
이병훈
정은혜
강지은

[프로그램]
사랑은 어디에
별과 시(詩)
한오백년
저녁노래 4
Please Touch Me
신(新)춘향
기포

가야금 프로젝트 그룹 물:
강윤·김도원·박미아·박은경·박정은·손승희·
이수정·임은미·최현영·김현승·박소라·백승희·
송정아·이승아·장민혜·정은선

[특별 출연]
안은미 현대무용가
이정우 미술평론가

(opposite page)
**Martin Woodtli**
Sureface
Client: soDA
Format: 220 x 270 cm

**1**
**Homework / Jack Dahl**
Invitation
Client: Copenhagen Fashion Week

**2**
**Izumi Nogawa**
"Lotus Green"
Client: Lotus

1

1

**1**
**Discodoener /**
**Marcus Fischer**
"Cherry-Moon"
Credit: Enrique y Judita
Format: 45 x 60 cm

**2**
**Emanuelle Jaques**
Design for an exhibition
Client: Collective INOUT
Format: 140 cm (ø 80 cm)

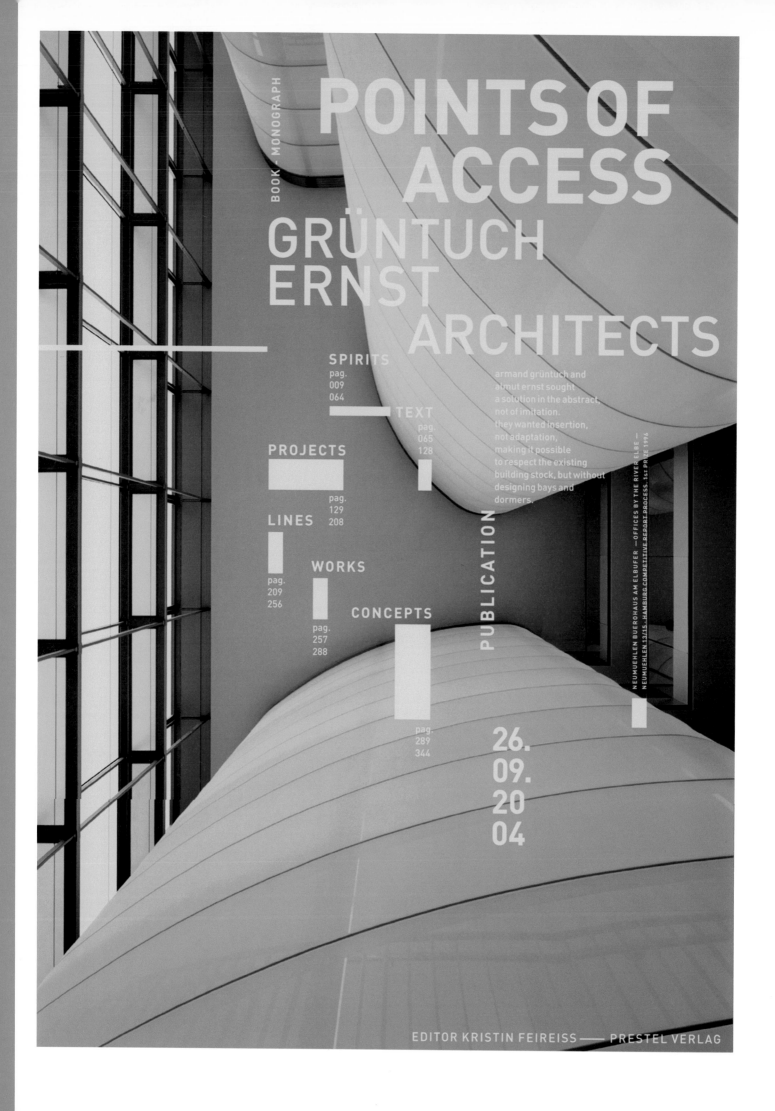

BOOK - MONOGRAPH

# POINTS OF ACCESS
# GRÜNTUCH ERNST
# ARCHITECTS

armand grüntuch and
almut ernst sought
a solution in the abstract,
not of imitation.
they wanted insertion,
not adaptation,
making it possible
to respect the existing
building stock, but without
designing bays and
dormers.

NEUMUEHLEN BUEROHAUS AM ELBUFER — OFFICES BY THE RIVER ELBE —
NEUMUEHLEN 13/15 - HAMBURG COMPETITIVE REPORT PROCESS. 1st PRIZE 1996

PUBLICATION

26.
09.
20
04

EDITOR KRISTIN FEIREISS —— PRESTEL VERLAG

106

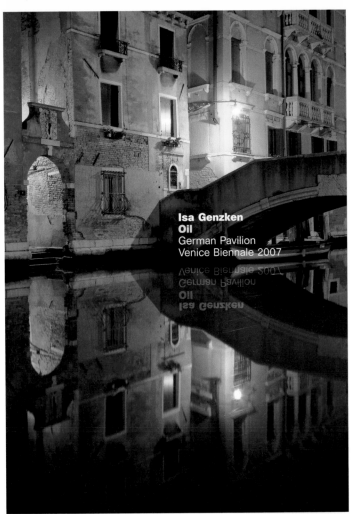

**Isa Genzken**
**Oil**
German Pavilion
Venice Biennale 2007

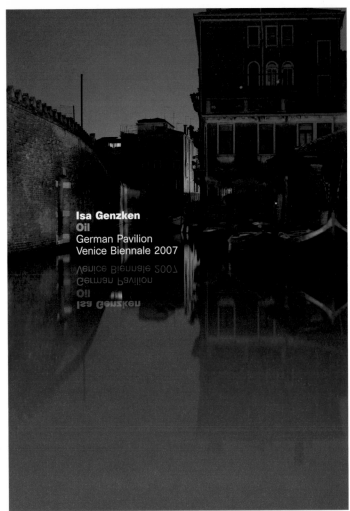

**Isa Genzken**
**Oil**
German Pavilion
Venice Biennale 2007

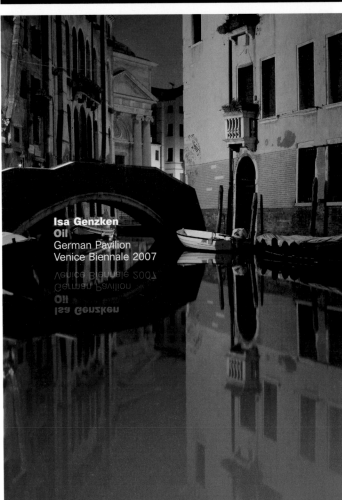

**Isa Genzken**
**Oil**
German Pavilion
Venice Biennale 2007

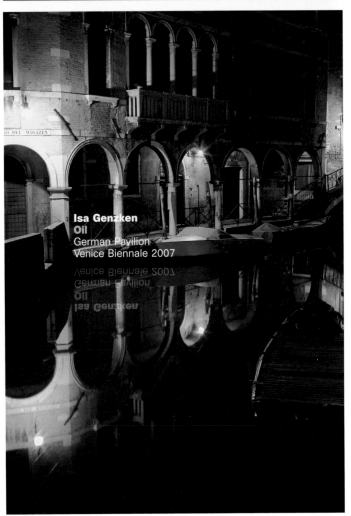

**Isa Genzken**
**Oil**
German Pavilion
Venice Biennale 2007

1

1

1

(previous pages)

(left page)
**Umbra + Dor /**
**Dieter Feseke, Kerstin Baarmann**
Image poster for book release
Photography: Grüntuch Ernst Architekten
Client: Grüntuch Ernst Architekten, Berlin
Format: 84 x 120 cm

(right page)
**Surface / Markus Weisbeck**
German Pavilion, Venice Biennale 2007
The graphic idea of the mirrored Venice reflects
one main work of Isa Genzken realised in the
German Pavilion.
Photography: Jörg Baumann
Client: Auswärtiges Amt
der Bundesrepublik Deutschland
Format: 70 x 100 cm

**1**
**Margot Zanni**
Terrace
Installation, books, video,
photography
Client: Galerie o.T., Lucerne

**2**
**Tina Frank**
Still image
Personal work
Format: 20 x 20 cm

2

1

# Rainbow

"In the beautiful vortex of blackness in the universe we cherish this world as it is defined by colour, shading and how light affects all of it."

**Riding the Rainbow**   Each colour has a special vibration and emotion attached to it. When I think about a rainbow, the first thing that I feel is an array of emotions all happening at the same time. It triggers my taste buds first as I think of red delicious apples and sour apple green candy; it inspires me as I think about plastic yellow raincoats, the baby blue skies. I get really inspired at the combination of all these possibilities as I begin to explore the magical prism of light and love.

There are so many things that rainbows represent in their mystique and magic.  A rainbow is one of the most fanciful optical illusions that everyone in the world can experience.  I think the idea of real magic is something that people are starving to explore in our society. We know so much about the rules and what is accepted in our world that I think the inkling of evolving ourselves and our understanding of the magic in our world is expanding daily. And the most exciting thing is that it's here. IT is all around us. We are delving into inner and outer space more and more these days, as well as parallel dimensions and exploring the limitations of our own perception. Can we see the rainbow? And, if we can see it, then what else is out there? Somewhere over the rainbow. It's a very exciting new frontier for all of us.

The rainbow is becoming more and more popular for a growing and intrinsic spiritual hunger inside of people. I think it is a great visual way of saying I am free and I love it. I believe that's why it was first adapted as a symbol for one of the newest and most modern civil rights battles of the gay pride movement. But I think all people hunger for this expression. It's a pure representation of light and what light provides us. In the beautiful vortex of blackness in the universe we cherish this world as it is defined by colour, shading and how light affects all of it. A super blast of rainbow colours directly affects your emotions. We are not even sure of why or how. But it is as important as love or any of our inexplicable senses. We are all the rainbow people and we want love in our life and will show the world with our many colours. We will do this by incorporating rainbows into our clothing and all consumer products that represent us. We will do this by mixing together and combining races and religions and information. And, once we see all the colours of the rainbow and our information bridge is complete, then we will truly shine throughout the universe.

I think the explosion of rainbows in our present visual culture is more prevalent due to the explosive feeling of love that we as a people need to express. We have been starving for colour as we begin this technological journey into new information systems and as we force the human heart into the cold technological tundra that is still completely unexplored and  in its infancy. We will create our own images and universe both here and in the Wired. Now we need rainbows and the power of the light more than ever. We will create a revolution of love, and more and more people will join in the rainbow adventure. Thank you for your participation and please help to spread magic, luck, and friendship.

Text by **FriendsWithYou**

FriendsWithYou (FWY) is an artist collaborative founded by the two Miami-based artists Sam Borkson and Arturo Sandoval III.  Since its conception in 2002, FWY has continued to promote the two artists' common message of magic, luck, and friendship through its popular designer toy line, public art installations, new-form playgrounds, published works, live performances, and various animation, motion picture, and multimedia projects.
www.friendswithyou.com

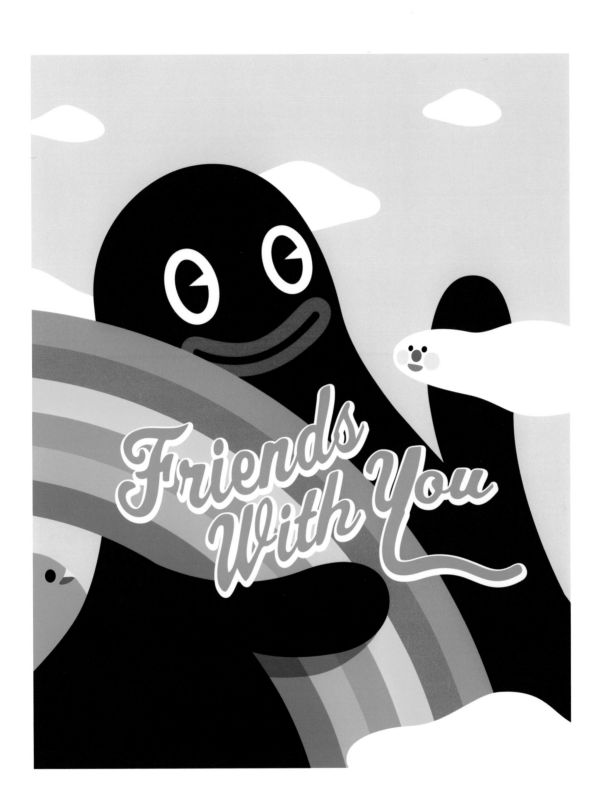

**FriendsWithYou**
Book
Publisher: Die Gestalten Verlag

1

# AbsoluteTheatre
www.absolutetheatre.nl

zeeland 28 aug t/m 8 sept 2007
nazomerfestival.nl

theater op locatie
festivalhart Abdij Middelburg

start voorverkoop 25 juni
vraag de brochure aan via nazomerfestival.nl
of bel 0900 33 000 33 (0,45 p/g)

Indien u de brochure vorig jaar ontvangen heeft, dan krijgt u die dit jaar vanzelf weer toegezonden.

3

**Fertility**
Fertilité

Birthrate
Taux de fertilité

**Migration**
Migration

IETM's 30th
Autumn Annual
Plenary Meeting,
Utrecht

30ème Réunion
Plénière de l'IETM,
Utrecht

Emigration and immigration
Emigration et immigration

**Borders**
Frontières

Number of borders per country
Nombre des frontières par pays

ODAN

ODAN

1 SYMBOLS 8.35
2 FACTS 6.04
3 FEELING 5.40

FREMDSPRACHEN: EIN VIELSEITIGES PRODUKT ZU EINEM VERNÜNF-TIGEN PREIS Wer eine neue Sprache lernt, lernt nicht nur neue Vokabeln und eine neue Grammatik, sondern lernt eine neue Kultur kennen, eine neue Mentalität, ein neues Land mit all seinen Gebräuchen und Ausdrucksformen. ■ So einfach wie jetzt kommen Sie nie wieder zu so umfassenden Kenntnissen in Fremdsprachen und ihrer Kultur! ■ Sprachkurse für Erwachsene beschränken sich in der Regel auf die reine Vermittlung der Sprache, finden meistens abends statt und sind sehr teuer. KOMPETENZEN IN FREMDSPRACHEN SIND KOMPETENZEN OHNE VERFALLDATUM: SIE BLEIBEN EIN LEBEN LANG AKTUELL UND KÖNNEN JEDERZEIT ERNEUERT, ERWEITERT UND PERFEKTIONIERT WERDEN Auch bei längerem Nichtgebrauch: Sprachliche Kenntnisse können in kurzer Zeit reaktiviert und aufgefrischt werden. KENNTNISSE IN MEHREREN SPRACHEN ZU HABEN IST EINE SCHLÜSSELQUALIFIKATION FÜR DAS STUDIUM UND FÜR DAS GANZE BERUFSLEBEN Kompetenzen in mehreren Fremdsprachen erhöhen die Mobilität während des Studiums und im Beruf. ■ Angesichts der sprachlichen und kulturellen Vielfalt der Schweiz und Europas (und der ganzen Welt) ermöglicht das Beherrschen von Fremdsprachen die Zusammenarbeit auf wirtschaftlichem, politischem und kulturellem Gebiet. MEHRSPRACHIGKEIT HAT EINEN MARKTWERT Wer über ein reichhaltiges Sprachportfolio verfügt, hat ein Mehr an Qualifikation und erhöht seine Chancen auf dem Arbeitsmarkt. JEDE SPRACHE ÖFFNET EINE TÜR IN EINE ANDERE WELT, ERWEITERT BUCHSTÄBLICH DEN HORIZONT, SCHAFFT ZUGANG ZU EINER ANDEREN KULTUR, ERMÖGLICHT UND FÖRDERT NEUE SICHTWEISEN Der Gotthard sieht von Norden oder von Süden her betrachtet nicht gleich aus. ■ Sprachen lernen heisst, auch neue Kulturen kennen lernen, andere Mentalitäten und andere Wertvorstellungen. ■ Neue Sichtweisen führen zu grösserer geistiger Flexibilität. VERSCHIEDENE SPRACHEN UND KULTUREN KENNEN, HEISST SICH ÜBER GRENZEN HINWEG VERSTÄNDIGEN KÖNNEN: IM ZENTRUM DES FREMDSPRACHENUNTERRICHTS UND -ERWERBS STEHT DIE KOMMUNIKATION Grammatik ist nicht Selbstzweck, sondern Voraussetzung für kommunikative Kompetenzen. ■ Der moderne Fremdsprachenunterricht legt grosses Gewicht auf die kommunikativen Fähigkeiten: Hören, Sprechen, Lesen, Schreiben, Gesprächsverhalten. ■ Die im Unterricht gelernten kommunikativen Kompetenzen stehen im Einklang mit den Kriterien des Europäischen Sprachenportfolios und werden dort dokumentiert. ■ Es besteht die Möglichkeit, ein internationales Sprachdiplom zu erwerben. SPRACHLICHE KOMPETENZEN WERDEN IN DER AUSEINANDERSETZUNG MIT INHALTEN ERWORBEN Texte, Filme, Musik etc. aus dem jeweiligen Sprachraum vermitteln Kenntnisse in Kultur und Mentalität. ■ In der Auseinandersetzung mit Inhalten wird die Fähigkeit gefördert, Texte zu analysieren und auf die wesentlichen Informationen zu reduzieren, systematisch und in Zusammenhängen zu denken. ■ Zum Fremdsprachenunterricht am Gymnasium gehört auch die Lektüre und Diskussion von literarischen Texten. ■ In der Auseinandersetzung mit literarischen Texten suchen wir nach Antworten auf die Grundfragen der menschlichen Existenz: «Who is it that can tell me who I am?» (King Lear) DER SPRACHUNTERRICHT FÖRDERT DIE FÄHIGKEIT, WESENTLICHES VON NEBENSÄCHLICHEM ZU TRENNEN, INHALTE AUF DAS WESENTLICHE ZU REDUZIEREN, FAKTEN UND GEDANKEN IN KLARE WORTE ZU FASSEN UND WEITERZUGEBEN

Das Gymnasium Burgdorf bietet folgende Sprachen und Kurse an: WWW.GYMBURG.CH
GRIECHISCH ■ LATEINISCH ■ FRANZÖSISCH ■ ITALIENISCH ■ ENGLISCH ■ SPANISCH ■ RUSSISCH ■ JAPANISCH

**1** (opposite page)
**Herman van Bostelen**
Postcard and poster for a theatre festival
Client: IETM, international network for contemporary performing arts
Format: 10.5 x 14.8 and 420 x 592 cm

**2** (opposite page)
**Herman van Bostelen**
Advertisement and festival image for the Zeeland Nazomerfestival
Client: Theaterproductiehuis Zeelandia
Format: 21 x 29.7 cm

**3** (opposite page)
**Herman van Bostelen**
Cover and graphics for a program for IETM's plenary meeting 2005
Every colour represents one of the particpating countries.
Client: IETM, international network for contemporary performing arts
Format: 17 x 24 cm

**1**
**Arran Lidgett**
Front and back cover of promotional sleeve designed for the
electronic music artist, Odan. The artwork was designed for 12 inch
format and also as a CD sleeve, both printed on coated stock.
Client: Right Angle Records

**2**
**Lorenzo Geiger**
Client: Gymnasium Burgdorf
Format: 29.7 x 42 cm

**1**

**Alexandre Chapus**
Diploma 2005. Production of a series of books that are identical in format but different in content and the experimental principle that they are about. The goal of those books is not to give a set of rules, not to be a user's manual, but to show the reader how each book is different and how this brings about a real pleasure in its design and the reception of it's details.

**2**

**Sam John Mallett**
A self initiated typographic project enabling me to explore the colour model CMYK in its most basic sense, from how the colours interact with each other to how the words / letters are said.
Format: 59.4 x 42 cm

**Studio di progettazione grafica, Renato Tagli**
Study of colour-form-relationship
Format: 21 x 29.7 cm

There Today

Real Soul LED

# THE FREELANCE HELLRAISER

Want You To Know

Pound For Pound

# THE FREELANCE HELLRAISER

Waiting For Clearance

# THE FREELANCE HELLRAISER

You Can Cry All You Want

# THE FREELANCE HELLRAISER

Waiting For Clearance

Album Sampler

**Big Active, Mat Maitland**
Album and singles for Freelance Hellraiser
Record label: Brightside / Sony BMG / 2006

1

**1, 2**
**Urs Lehni**
Graduation catalogue, invitation card,
exhibition signage
This graduation catalogue for the department of visual
communications at the School of Art and Design Zurich consisted
of 13 DIN A5 booklets, one for each graduate. The booklets featured
excerpts from the diploma projects as well as short biographical
information.
Client: HGKZ School of Art and Design Zurich

**3**
**Lehni-Trüb**
Late Shift,
Exhibition poster, invitation cards

3

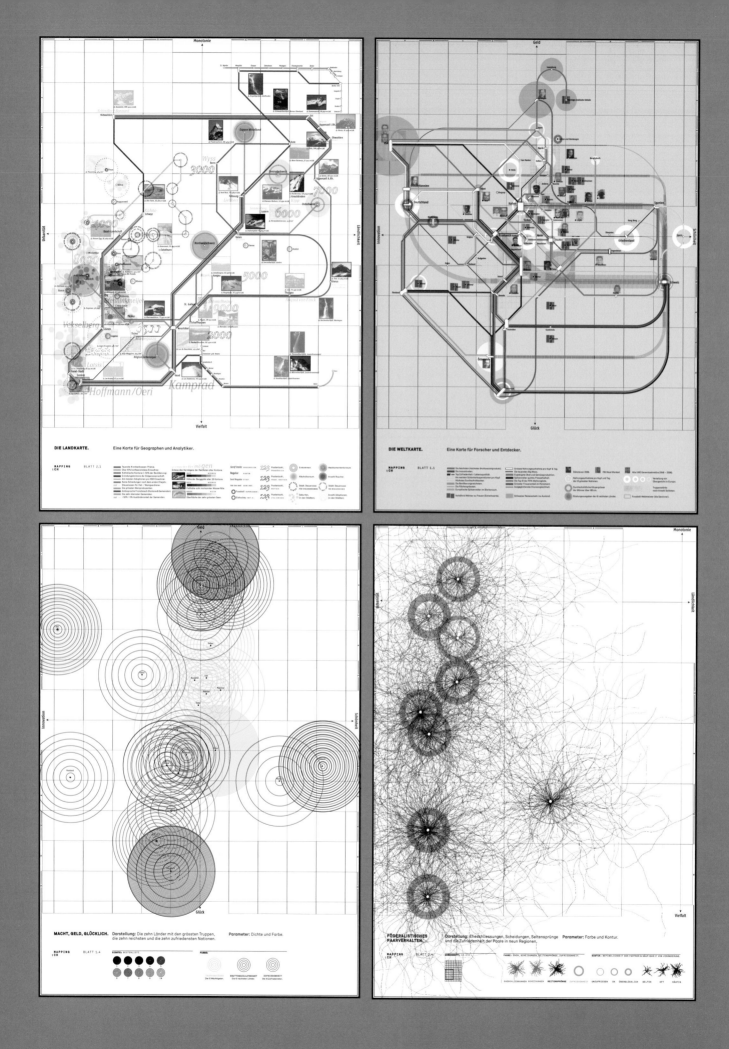

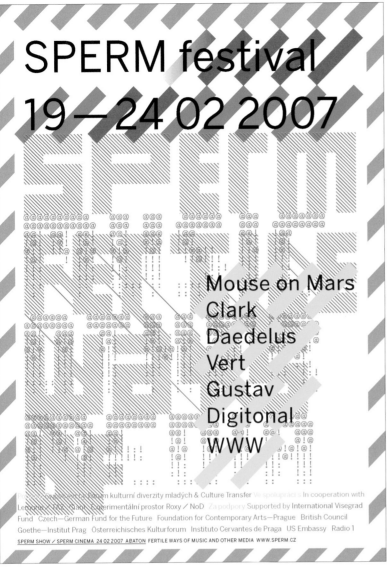

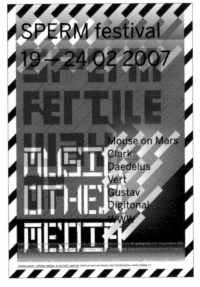

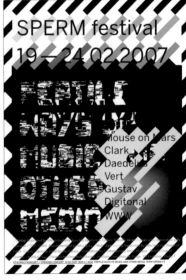

(opposite page)
**Lorenzo Geiger**
MAPPING:CH is a collection of twelve maps
(3 main maps complemented by 3 x 3 detail maps)
which invite the reader to travel through an
imaginary statistical landscape of Switzerland.
Graduation work at the University of the Arts
Bern, 2007
Format: Lambda-print 70 x 100 cm, mounted in
light boxes

**Advance Design,**
**Petr Bosák, Robert Jansa**
Visualisation of Sperm, a festival featuring
electro, hip hop, indie, breakcore, dubstep and
other music. In every work for the festival we
tried to maintain a diversity of styles using fonts
created especially for Sperm and as a unifying
element we chose the diagonal / slash. A sign
that separates and unites at the same time.
Client: Sperm festival
Format: 14.8 x 21 cm

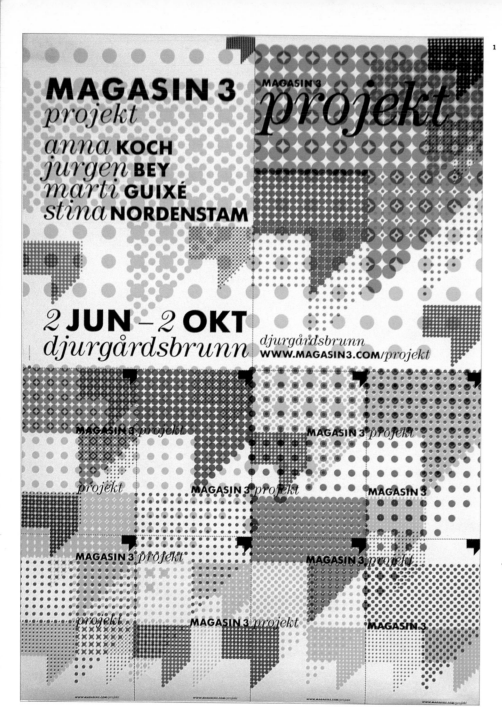

2

3

1, 2
**Kristina Brusa,
Anna Lena von Helldorff**
Summer art project
Client: Magasin 3 Stockholm

3
**Kapitza**
Map of the world, illustration for
'Extreme Sleepover', a feature
on futuristic hotels
Client: Futurespacemag
Format: 44 x 30 cm

(opposite page)
1
**Onomatopee, Remco van Bladel**
Onomatopee 01,
Playword 7" record cover, poster
Onomatopee invited Machinefabriek, Jan van
den Dobbelsteen, Erwin van Looveren and
Freiband to make four soundpieces with a
poem of Freek Lomme as a starting point
Words by Freek Lomme
Music by: Machinefabriek, Jan van den
Dobbelsteen, Erwin van Looveren and
Freiband
Format: 27 x 55.5 cm

2
**Human Empire, Jan Kruse**
LP for Isan
Client: Morr Music

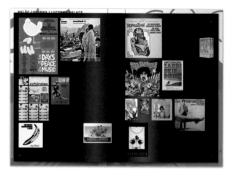
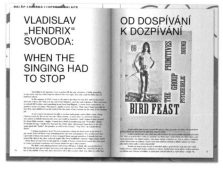

(opposite page)
**Welcometo.as,**
**Adam Machacek,**
**Sébastien Bohner**
Spread from the
exhibition catalogue
"The Pope Smoked Dope"
Client: City Gallery Prague
Format: 16.6 x 23 cm

**1**
**Seripop**
CD packaging for band
MSTRKRFT
Photo: Yannick Grandmont
Client: DKD / Universal
Format: variable dimensions

**2**
**Materia,**
**Jacques Magiera**
Illustrations for T-shirt prints
("drawing like painting")
Client: Graniph Japan
Format: 9 x 19 cm

1

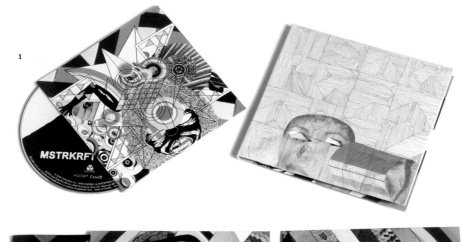

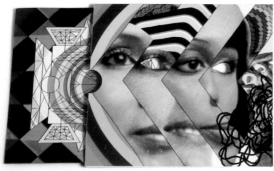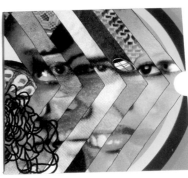

2

**Patrick Lindsay**
10 years of the festival
Client: Festival Métissons

124

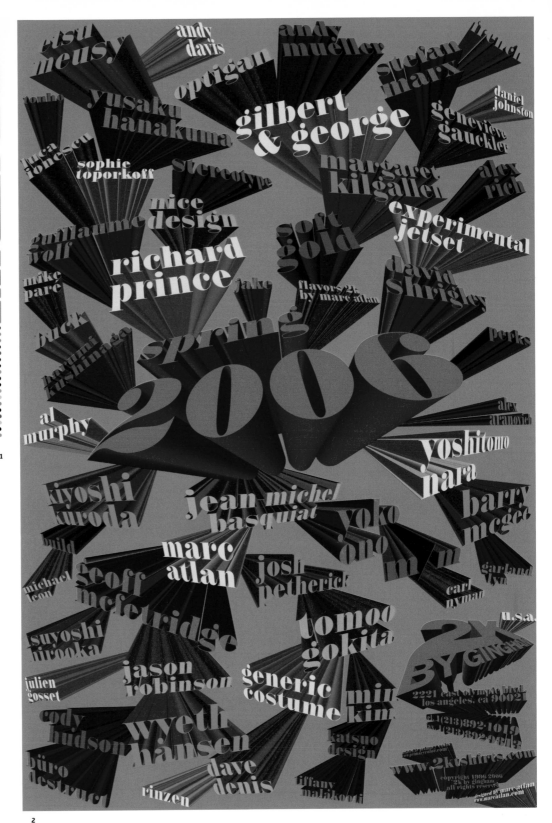

**1**
**Herman van Bostelen**
Poster for a series of performances
Client: 't Barre Land
Format: 84 x 118.8 cm

**2**
**Marc Atlan**
Poster and ad campaign for 2K T-shirts
Client: 2K

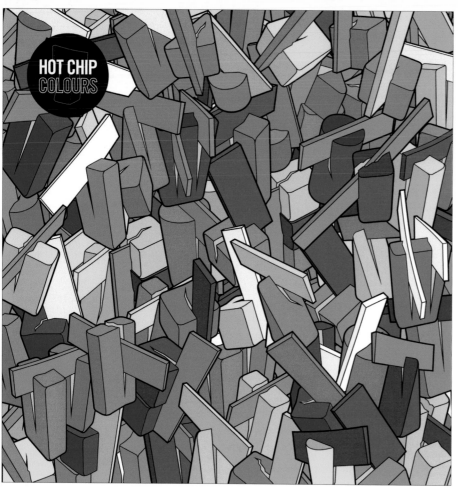

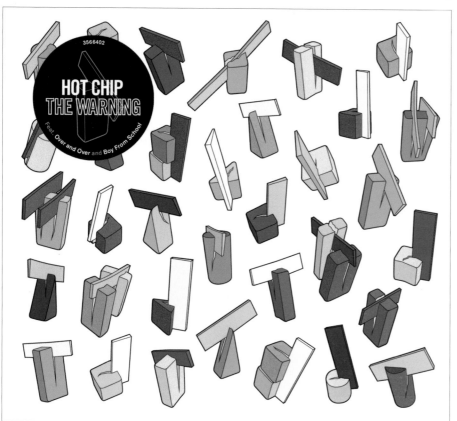

1
Wallzo, Darren Wal
12" for Hot Chip
Client: EM

2
Wallzo, Darren Wal
CD for Hot Chip
Client: EM

126

heterogeneous substances
ingenious pursuits
lavoisier
dispatches
e... quilibrium
mutti
interacting massive particles
natural history of creation

thomas strønen
pohlitz

7 033662 020515

1

2

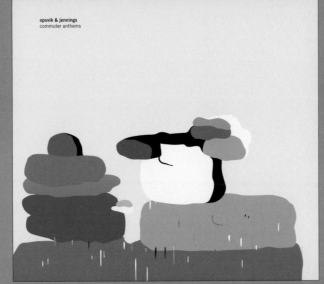

opsvik & jennings
commuter anthems

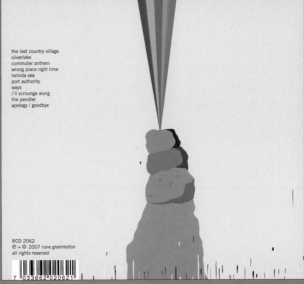

the last country village
silverlake
commuter anthem
wrong place right time
lorinda sea
port authority
ways
i'll scrounge along
the pendler
apology / goodbye

RCD 2062
℗ + © 2007 rune grammofon
all rights reserved

7 033662 020621

3

**1**
**Kim Hiorthøy**
CD for Thomas Strønen
Client: Rune Grammofon

**2, 3**
**Kim Hiorthøy**
CD for Opsvik & Jennings
Client: Rune Grammofon

**No Office, Dirkje Bakker, Nelleke Wegdam**
Identity, concept, design for art festival in Amsterdam
Client: City counsel Amsterdam, Stadsdeel De Baarsjes
Format: 59.4 x 84 cm

**Kim Hiorthøy**
CD for Diskaholics
Client: Smalltown Superjazzz

**Kim Hiorthøy**
CD for Mats Gustafsson and Yoshimi
Client: Smalltown Superjazzz

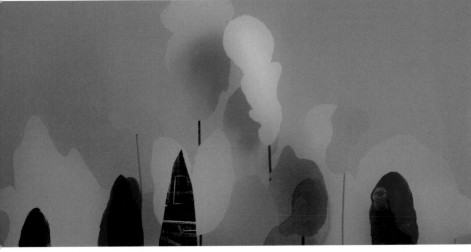

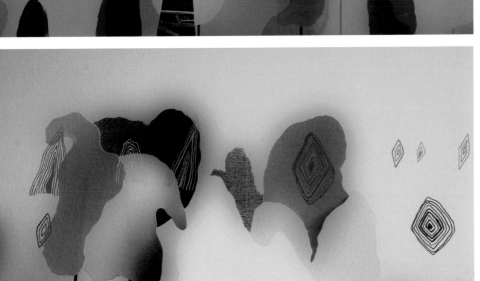

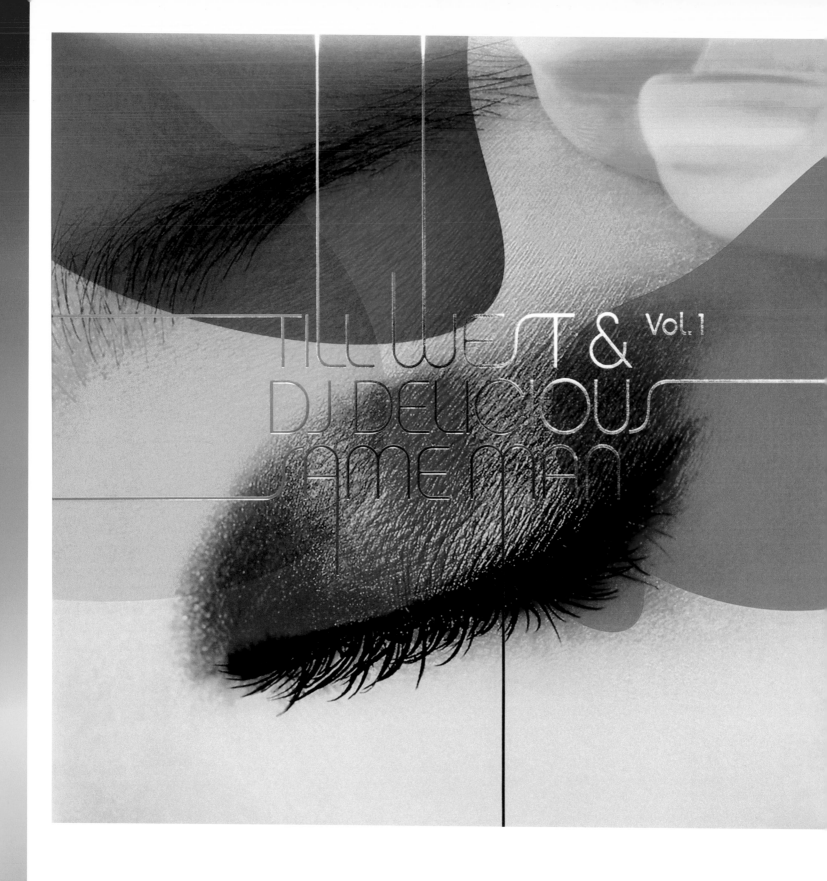

TILL WEST & Vol. 1
DJ DELICIOUS
SAME MAN

**Zion Graphics, Ricky Tillblad**
Till West and DJ Delicious: Same Man
Client: Refune

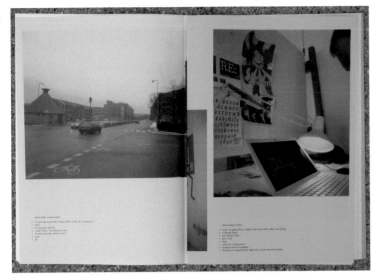

**1**

**Ondrej Jób**
Slovak-Danish, a book about the exchange student experience, comparing Slovak and Danish culture and facts by short real dialogues made with instant messengers and large photograps. Printed black on colour papers, no stiching, with the photographs overlaping from Danish to Slovak part and vice versa
Format: 21 x 29.7cm

**2**

**Public, Nicholas Jeeves**
Workshop Information: Logo, 57 pieces of print, website and signage were commissioned for stage one of this brief. The LMC specifically requested that the identity avoided all echoes of 'alternative, new-age' services.
Client: The London Massage Company
Format: 14.8 x 21 cm

*Travelling*

DJ's Cinnaman &
All Out K

KLIP
DRIFT
DICHTERS
DANSEN
NIET

Serge van Duijnhoven
& Fred de Backer

Nw'A'DAM

**1**
**Newsgroup**
Invitation for Ballroom Blitz
Client: Patta
Format: 10.5 x 14.85 cm

**2**
**Newsgroup**
Flyer for Travelling
Client: Rushhour
Format: 10.5 x 14.85 cm

**3**
**Herman van Bostelen**
Bookcover for a book of poems
Client: Nieuw Amsterdam publishers
Format: 15 x 20 cm

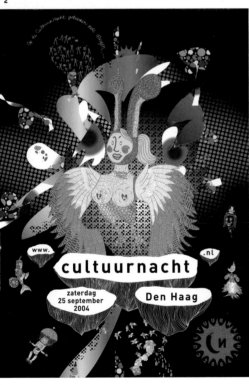
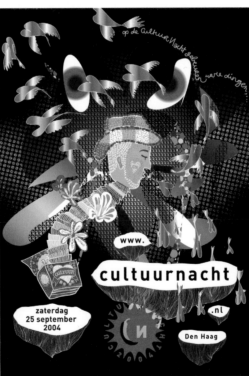
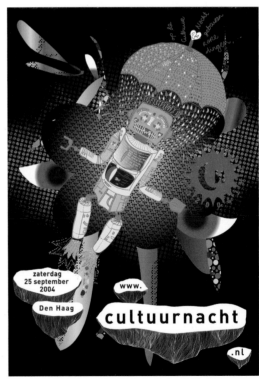

**1**
**Saiman Chow**
Diesel 50th anniversary book project
Format: 59 x 37 cm

**2**
**NLXL**
Visual communication for "CultuurNacht", a yearly cultural event
in the city of The Hague
Client: The Generator

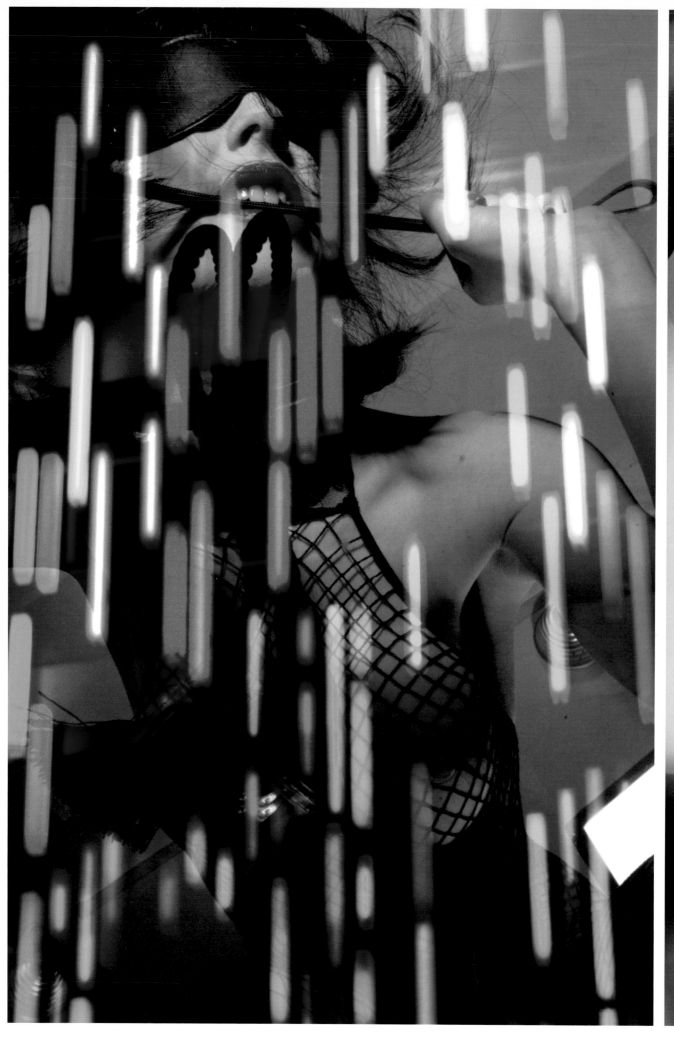

**Discodoener, Marcus Fischer**
"Lap Dancer"
Client: LoveAcademy
Format: 60 x 45 cm

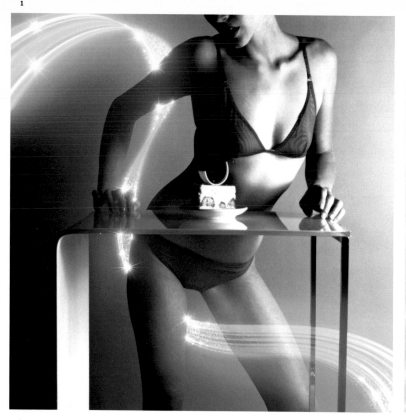

**1**
**ZIP Design, David Bowden**
Cicada Deliverables, CD and 12" formats,
advertising, promo, tour visuals
Photography: James Pfaff
3D illustration: Mat Dartford
Client: Critical Mass Recordings
Format: 31.4 x 31.4 cm

**2**
**Discodoener, Marcus Fischer**
Boutique CD
Model: Ina Müller / Fischercasting
Client: Koochi
Format: 60 x 45 cm

(opposite page)
**Elias & Saria**
Slide (part of "Falling In Love")
Bathing suit, shoes: Chanel,
Model: Isabelle Surmont / Place,
Hair / make-up: Stephanie Ruppaner,
Styling, photo, retouching: Elias & Saria,
Format: 28 x 35.5 cm

(previous pages)
**1**
**Petter Törnqvist**
Photography: Annika Aschberg
Client: Emma Borgström

**2**
**Petter Törnqvist**
System for creating music out of images and images out of music
Photography: Rasmus Norlander
Client: 1:2:3

(opposite page)
**Alexandre Chapus, Emmanuel Pevny, Vincent Vernet**
Signage system that attracts the attention of the visitor when he enters and which leads him through the works. From the right point of view the anamorphosis informs one about the possible routes that one can take, visible in coloured lines when one deviates.
Twelve colours for twelve projects: twelve colours for twelve tracks that leads to turns, surprises and quotes, twelve free 'tours' made out of adhesive tape on the floor.
Photography: Sandrine Marc
Management: sp Millot
Client: Baubourg, centre Georges Pompidou

**Maurer United Architects [MUA]**
Space Invasion
Client: Showroom MAMA, Rotterdam

**William Hundley**
Friends series 2007

142

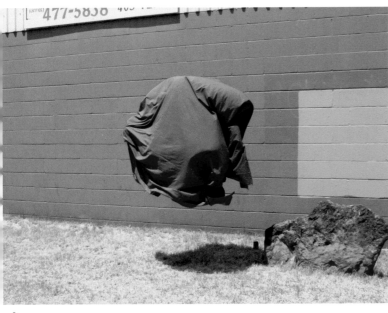

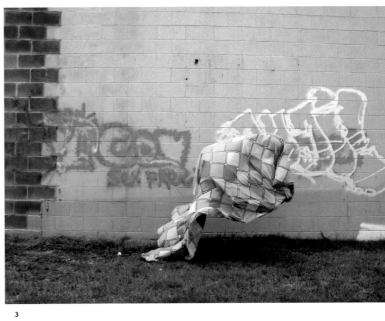

**1**
**William Hundley**
Red Bomb 2007

**2**
**William Hundley**
Meteor 2006

**3**
**William Hundley**
Checkers 2006

143

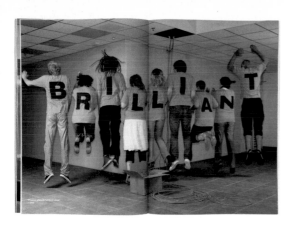

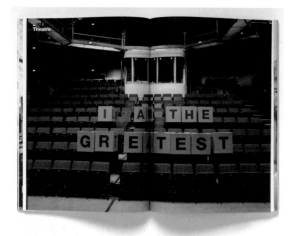

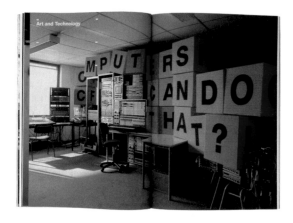

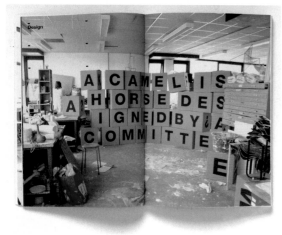

**De Designpolitie**
Education Guide
Client: Utrecht School of Art
Format: 21 x 29.7 cm

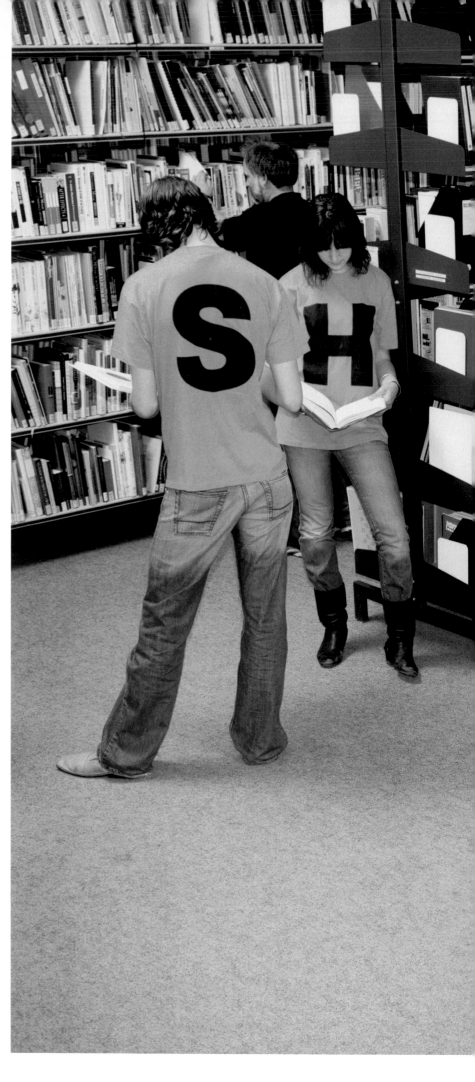

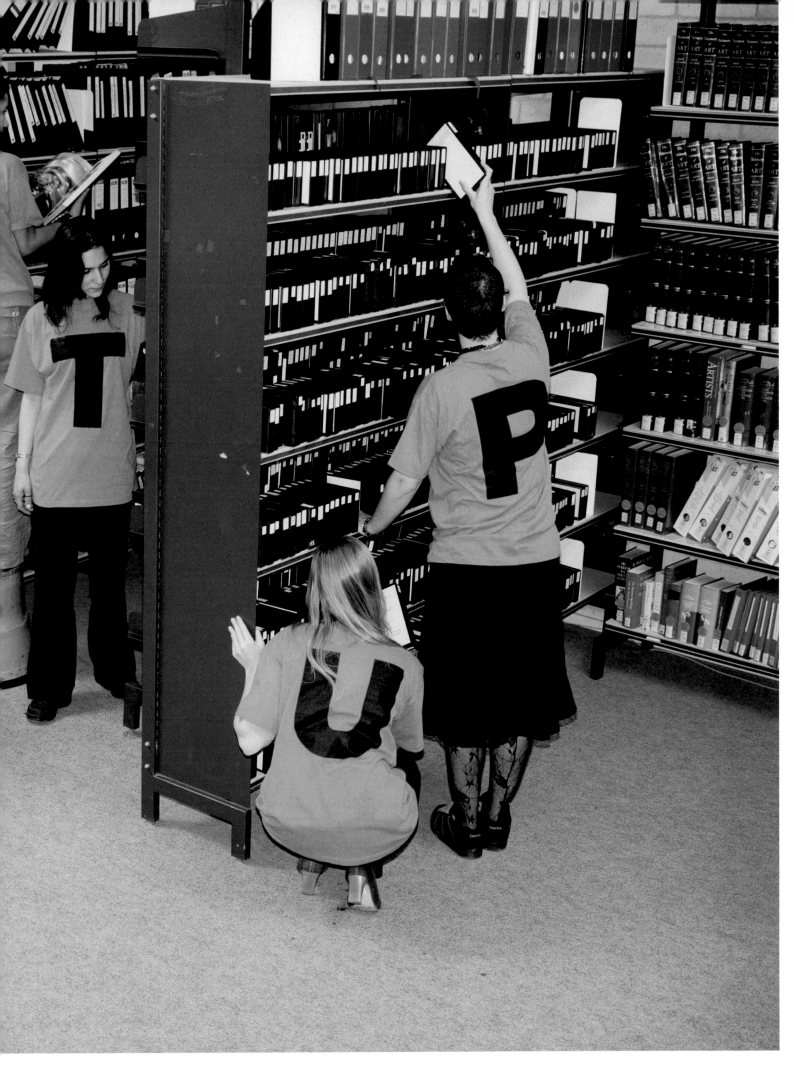

# Purple

"Purple is synonymous with the sexiness of power, and it is a well-known fact that this is not to be underestimated."

Caution when using purple in the bedroom! At least that's what is recommended by one of the innumerable self-proclaimed colour experts in the Web, who rant about the ineaxhaustible theme of colour psychology. Purple colour tones, she warns, repress sexual desire since they have a heightened spiritual, even holy character, which is reminiscent of repentance and Lenten sermons as well as funeral services. This concern is probably unfounded among contemporaries, who are less conscious of Catholicism. When they think about purple, their thoughts drift to lilac-coloured lace lingerie on white skin or high-class tarts in purple velvet and silk.

That is less contradictory than it seems. In antiquity, purple was pure luxury: thousands of purple Murex snails had to die to produce one gram of pigment. In just one of the ancient production facilities located on the Turkish coast, archaeologists found the shells of an estimated sixty million marine snails. And even today, the price for a gram of real purple pigment costs almost 3,000 Euros. And so, it came to be that the colour was reserved for the mighty: from senators and emperors in ancient Rome right up to present-day bishops. Purple is synonymous with the sexiness of power, and it is a well-known fact that this is not to be underestimated.

We owe it to virtuous little flowers like violets or lavender that purple not only stands for magniloquence and gaudiness, but also for virtue and modesty. In the Middle Ages, the violet was the symbol for being single, and an essence of old maid still lingers on in this variation of purple. The Women's Movement of the 20th century interpreted it as the colour of female independence – today, some only associate it with prudish women's liberationist practices. At the same time, purple is homosexual, and that has allegedly been the case since Sappho wrote poetry among her circle of lovers on the island of Lesbos. In Poland, the purple character Tinky Winky from the toddler's TV series "Teletubbies" recently received the honour of having the highest level of the Polish national government debate about whether he/she is gay and therefore liable to be a corruptive influence on children.

Whether or not purple in the bedroom is dangerous, is debatable. There are, however, some precarious associations concerning its use as an element of design. This is certainly the reason why only a few design eras dared to use the colour, which men view with especial scepticism. It was probably exactly this ambivalent, extravagant, mysterious, hidden aura of purple that the Art Nouveau movement so appreciated, and they dyed their glass and fabrics accordingly. Then, purple had its revival in the sixties with cult-designers like Verner Panton or Joe Colombo – the latter of whom presented a purple sleeping-landscape (!), the futuristic interior "Visiona I", at the Cologne Furniture Fair in 1969.

It took another good twenty years until the remembrance of the ensuing feminist-eco-hippie phase faded away. Now it's finally happening: the current favourite colours of fashion designers are mauve, lilac, lavender, amethyst, aubergine, puce and heliotrope. Christian Lacroix used purple seats to give the French TGV train system a lounge-like atmosphere; women's magazines are bursting with photos of celebrities in purple satin dresses. Apparently, the colour corresponds to a period of time that yearns for heightened stimulation, while remaining cool and aloof within. It even fits to the currently raging ornamental playfulness, to the passion for glamour and hedonism. And, it is so widespread, that it's possible to catch a glimpse of a man or two – who are not intimidated by controversy – wearing a purple shirt or sweater.

Text by **Claudia Gerdes**

Claudia Gerdes is a freelance author and editor of the design magazine PAGE. She lives and works in Hamburg.

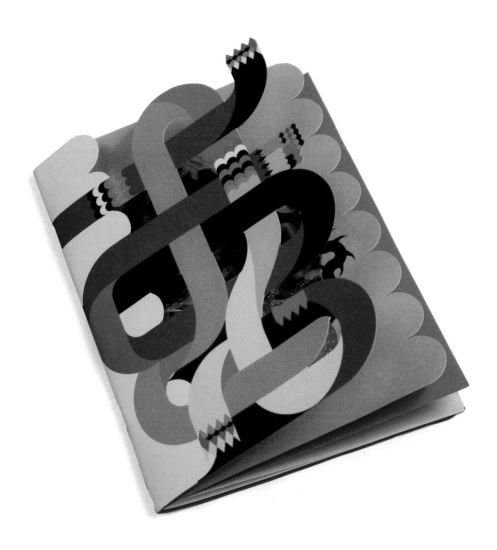

**Antoine+Manuel**
"39", Christian Lacroix's
Fall / Winter 2006 / 2007
haute couture checklist brochure
Client: Christian Lacroix

147

## Space Calculated in Seconds – The Music of Edgard Varèse and Beyond

19th November 2006 8.00pm
West Road Concert Hall, Cambridge

Daniella Ganeva
– Marimba

with
Anglia Sinfonia

Paul Jackson
– Conductor

Varèse
Hyperprism;
Déserts;
Poème Électronique

Plus new works for
percussion, electronics
and live images

Julio d'Escriván
La Revolcón;
Canción Americana,
Juguete y Sueño con
Ranitas

Orestis Karamanlis
Ataxia

Jonathan Gilmurry
Heavy Plant Crossing

Tickets
Un-numbered – £10
Concessions – £7
Student Standby – £3

Available from Corn Exchange
Box Office – 01223 357 851

World-renowned marimba
player Ganeva joins Anglia
Sinfonia for the visionary music
of Varèse. Arguably the world's
first multimedia piece, Poème
Électronique was written for
World Expo in 1958. Here
artists from Anglia Ruskin make
a new realisation of the images
to go with this classic work.

This concert is presented as
part of the Cambridge Music
Festival.

**1**
**Public, Nicholas Jeeves**
Poster template for classical concerts
Client: Anglia Sinfonia
Format: 42 x 59.4 cm

**2**
**Raphaël Garnier**
LP cover "Une véritable histoire", Audrey
Client: Cuicui Muisic

**3**
**Raphaël Garnier**
12" cover "La vie de Château", Tutu Pointu
Client: Cuicui Muisic

**1, 2**
**Boros / Ingo Maak**
Poster for an exhibition of the artist
Florian Slotawa
Client: Kunstverein Solothurn, Switzerland
Format: 90.5 x 128 cm

**3**
**Hi / Claudio Barandun & Michel Steiner**
Poster for the exhibition "2. Zeit"
Client: Kunstmuseum Luzern
Format: 128 x 98.5 cm

**4**
**Jens Schildt**
Poster in dutch and english, for the
preparatory course at the Gerrit Rietveld
Academie in Amsterdam. A2 format perforated
and folded down to A4 with application forms.
Fonts: Cookie and Akzidenz Grotesk
Credit: Ian Brown for fixing the Cookie font!
Client: Gerrit Rietveld Academie
Format: 42 x 59.4 cm

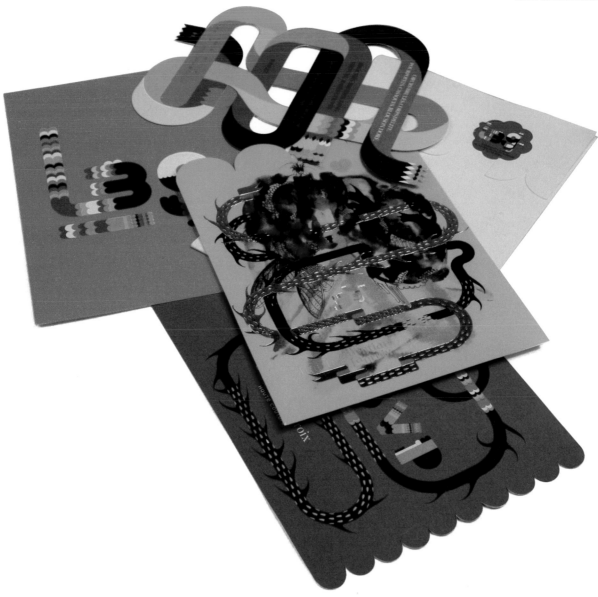

**Antoine+Manuel**
"39", Christian Lacroix's
Fall / Winter 2006 / 2007
haute couture invitation
Client: Christian Lacroix

(opposite page)

**1**
**Richard Robinson**
1 x 10" of a 3 part set
Client: Tirk Records
Format: 10" Record

**2**
**Richard Robinson**
CD Promo
Client: Tirk Records
Format: CD

**3**
**Richard Robinson**
Commercial CD release with die-cut front panel
Client: Tirk Records
Format: CD

**4**
**Spin, Joe Burrin**
Indian art specialists Amrita and Mallika required
an identity to launch their service to the art
collecting community. The aim was to reflect the
vibrancy of the art in question with a
contemporary feel.
Client: Amrita Jhaveri and Mallika Advani
Format: 21 x 14.85 cm

**5**
**Spin, Joe Burrin**
Client: Amrita Jhaveri and Mallika Advani
Format: 21 x 9.9 cm

**6**
**Spin, Joe Burrin**
Client: Amrita Jhaveri and Mallika Advani
Format: 8.5 x 5.5 cm

FUJIYA

Amrita Jhaveri & Mallika Advani
Invite you to cocktails to
celebrate a new partnership
and the launch of

Amrita
&Mallika

An independent art consultancy for
collectors of modern and contemporary
Indian art

Wednesday
21st September 2005
5.30—8.30pm

Hazlitt Gooden & Fox
17 East 76th Street, New York City

RSVP info@amartindia.com
Enquiries +1 212 772 1950

Consultants in Modern
& Contemporary Indian Art

Amrita Jhaveri
Tel +91 9820069479
Email amrita@amartindia.com

By appointment
Tel +91 (0)22 2369 3630
Email info@amartindia.com
www.amartindia.com

Amrita
&Mallika

1

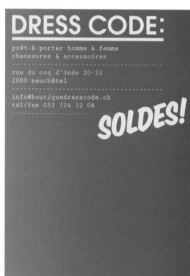
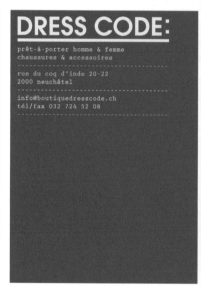

2

**1**

**Vance Wellenstein**
Jerome / McKnight Foundation Fellowships
application form and reminder postcard
Client: Minneapolis College of Art and Design
Format: 76.2 x 22.9 cm (19.1 x 22.9 cm trim size) /
15.2 x 20.3 cm

**2**

**no-do**
Every season, the colors of the store changes
and the flyers picture this concept. The sales
being a transition in between two seasons.
Client: Dress Code
Format: 10.5 x 21 cm

(opposite page)
**Dani Navarro**
Designer: Dani Navarro
Client: ADG-FAD
Format: 16 x 21.5 cm

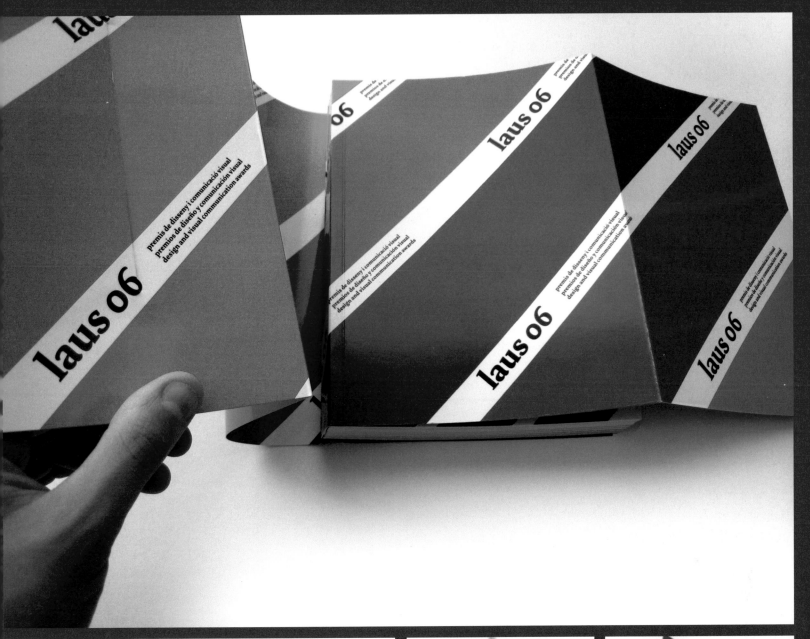

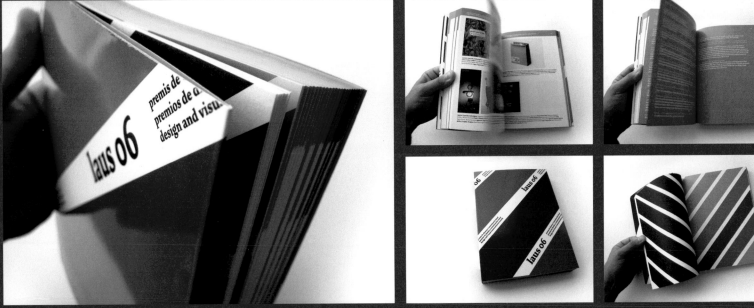

**Marc Atlan**
Ad campaign
Photo by
David Sims,
Still-life by
Albert Giordan
Client:
Tom Ford for
Yves Saint
Laurent

YVES SAINT LAURENT

SPRING LOOK 2002

BARNEYS NEW YORK  SAKS FIFTH AVENUE  NEIMAN MARCUS  BERGDORF GOODMAN  SEPHORA  WWW.YSL.COM

154

**Stina Persson**
Poster

Client:
Sturegallerian
department store

Technique:
watercolor
and Photoshop

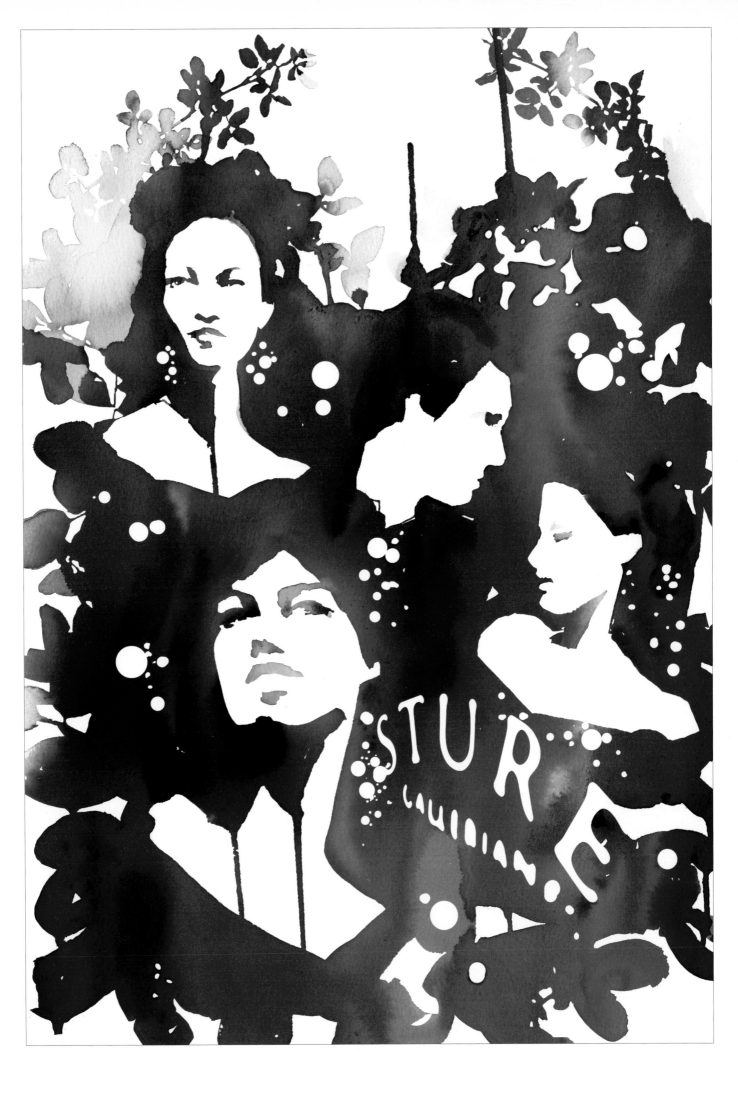

1

**Boris Brumnjak**
Client: F.U.N. at Weekend
Format: 10 x 15 cm

2

**Karen Willey**
Invitation card for Tomas Adolf's exhibition
Printed by Calff & Meischke
Client: BijlmAir/CBK Zuidoost
Format: 21 x 14.8 cm

2

Here
Here
Here
Before
Again
Again

BijlmAIR/Artist in Residence Bijlmer
Centrum Beeldende Kunst Zuidoost
Bijlmerdreef 119
1102 BP Amsterdam
020-6911322
www.cbkzuidoost.nl

**TPG Post**
Port betaald
Port payé
Pays-Bas

BijlmAIR nodigt u van harte uit voor de
eindpresentatie van het project Here, before
and again van de kunstenaar Tomas Adolfs
op donderdag 29 juni om 17:00 uur in het
Infocentrum van Stadsdeel Zuidoost, Anton
de Komplein 150. De opening wordt ver-
richt door Jelle Bouwhuis, curator Stedelijk
Museum Bureau Amsterdam. De tentoon-
stelling is te zien van 29 juni tot 28 juli.

K Willey
Van Der Hoopstraat 116-iii
1051 VN AMSTERDAM

20720

Here, before and again
Nog maar 40 jaar geleden begon de bouw
van de Bijlmer zoals we deze nu kennen.
Voor die tijd bestond dit gebied voorname-
lijk uit weilanden en boerderijen. Op een
aantal namen van pleinen, parken en flats
na, is er bijna niets dat nog verwijst naar
de geschiedenis van deze plek.

Tomas Adolfs wil de inwoners en bezoekers
van de Bijlmer in aanraking brengen met
de geschiedenis van deze plek. Hij daagt
hen uit vanuit een andere invalshoek over
deze plek na te denken. Adolfs wil de van-
zelfsprekendheid van de Bijlmer, zoals deze
nu wordt ervaren, wegnemen. Hij doet dit
door middel van een installatie, te zien in
het Infocentrum van het Stadsdeel Zuid-
oost. Met de installatie geeft hij een fictieve
opzet voor een vernieuwing van de Bijlmer.
De installatie heeft de vorm van een archi-
tectonische presentatie en is gebaseerd
op beeldmateriaal van de Bijlmer van voor
1960 en beelden van nu.

Tomas Adolfs (Enschede, 1977) volgde
de Gerrit Rietveld Academie in Amsterdam
en studeerde af in 2005. Adolfs maakt
beelden van vederlicht piepschuim. Hij
reconstrueert gebruiksvoorwerpen, op ware
grote en bouwt modellen van bestaande of
gefantaseerde gebouwen. Hij speelt in zijn
beelden met schaal, verhouding, ruimte,
kleur en volume.

BijlmAIR is een project van Centrum
Beeldende Kunst Zuidoost en Stedelijk
Museum Bureau Amsterdam. Twee keer
per jaar worden jonge kunstenaars uit-
genodigd om in een atelier in Amsterdam
Zuidoost te wonen en te werken. Tijdens
dit verblijf maakt de kunstenaar werk dat
reflecteert op dit multiculturele stadsdeel.

De kandidaten voor BijlmAIR worden
geselecteerd in samenwerking met de
volgende kunstopleidingen: de Rietveld
Academie en het Sandberg Instituut in
Amsterdam, de Academie voor Beeldende
Kunst en Vormgeving Arnhem, de Academie
voor Beeldende Kunst en Vormgeving
Enschede en het Dutch Art Institute
in Enschede, en de Willem de Kooning
Academie en het Piet Zwart Institute in
Rotterdam.

Routebeschrijving
Openbaar vervoer: metro richting Gein:
uitstappen station Bijlmer, loop winkel-
centrum de Amsterdamse Poort in. Volg
borden stadsdeel kantoor Zuidoost, Anton
de Komplein 150.
Auto: afslag Amsterdamse Poort, parkeren
in parkeergarages rond het winkelcentrum
Amsterdamse Poort.

ontwerp Karen Willey, druk Calff & Meischke

**1**
**Ludovic Balland**
Poster, silkscreen, warm red and Pantone 258 U
Client: Ausstellungsraum Klingental Basel
Format: 60 x 100 cm

**2**
**Projet Vercors, Pierre Marie**
Poster for a theatre piece written and
performed by la Troupe du Vieux-Theatre
Client: Thomas Adam-Garnung
Format: 30 x 40 cm

**3**
**Fons Hickmann / m23,**
**Viola Schmieskors, Markus Büsges,**
**Fons Hickmann**
Poster for the "Münchner Opernfestspiele"
Client: Bayerische Staatsoper
Format: 120 x 84 cm

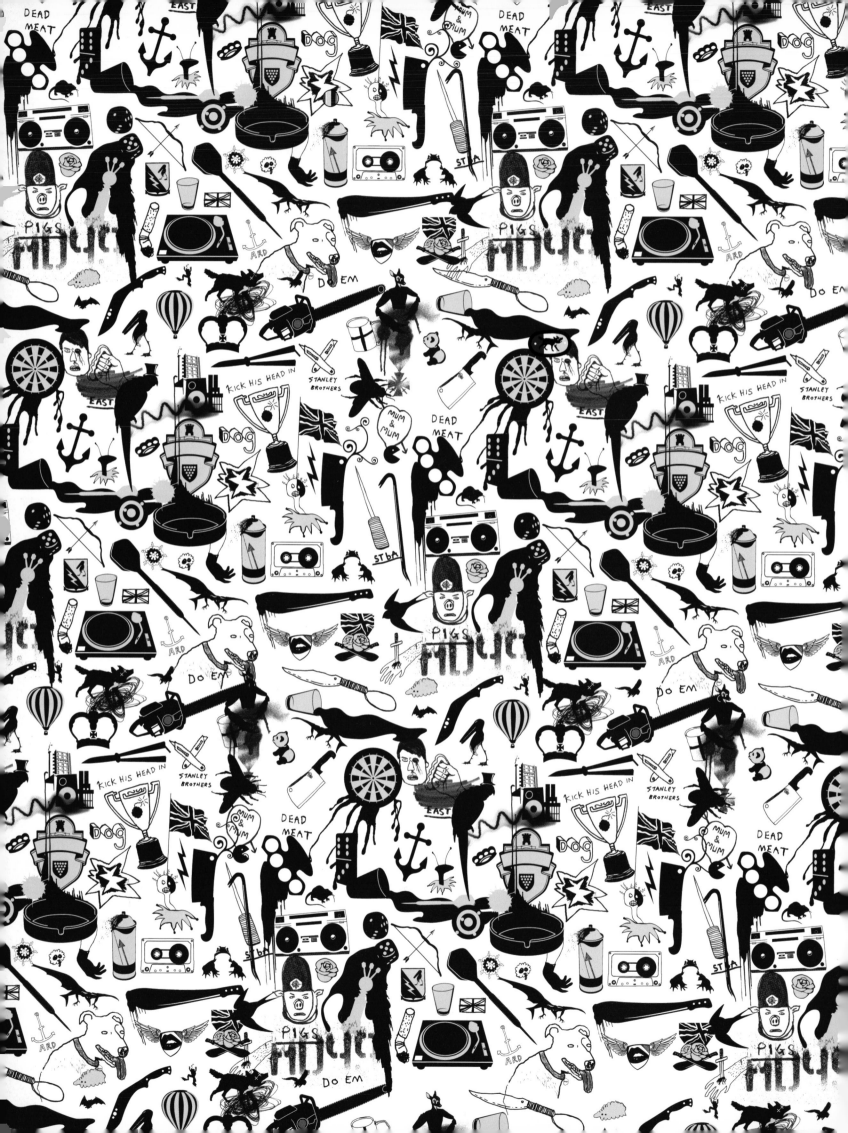

(opposite page)
**Vault49**
Apparel graphic design
Collaboration with Daryl Waller
Client: Artful Dodger

**Stout / Kramer**
"Good Intensions"
Book
Client: Fonds BKVB, Amsterdam

07

tation that the 'breakthroughs' will occur again. And Klasema impertinently annexes space for his utopian community spirit. Under everchanging circumstances, he lets people share in his free position. Each time he tries to endure the shared freedom, until the freedom 'is filled up' with reality and it's time to look out for new freedom.

In short, these artists exercise a paradoxal position: they anticipate an objective that cannot be determined. It is a matter of open intentions: taking it no further than having good intentions. The artists refuse to, and are unable to, forcibly realize or accomplish their objectives. If so, then the naturalness would disappear, their good intentions would transform into objectives, their tactics into strategies. Giving careful consideration to good intentions, that's what it's about, in the hope – or, for some, like Cerpac, in the conviction – that good will naturally come about.

No wonder that some art critics felt uncomfortable. In order to be a success, intentions have to be visible in a concrete, visible artwork or a clear, preconceived concept. In art, intentions alone are not enough, is the general opinion. Which is understandable, if 'good intentions' are supposed to make up for the fact that a project has failed. However, if the artist has specialized in good intentions, and gives careful consideration to the development of an anticipatory position, then we must take him seriously and try to develop ways to discuss the quality of this position.

Good Intentions
Judging the Art of Encounter

Erik Hagoort

Foundation for Visual Arts,
Design and Architecture

Essay 001

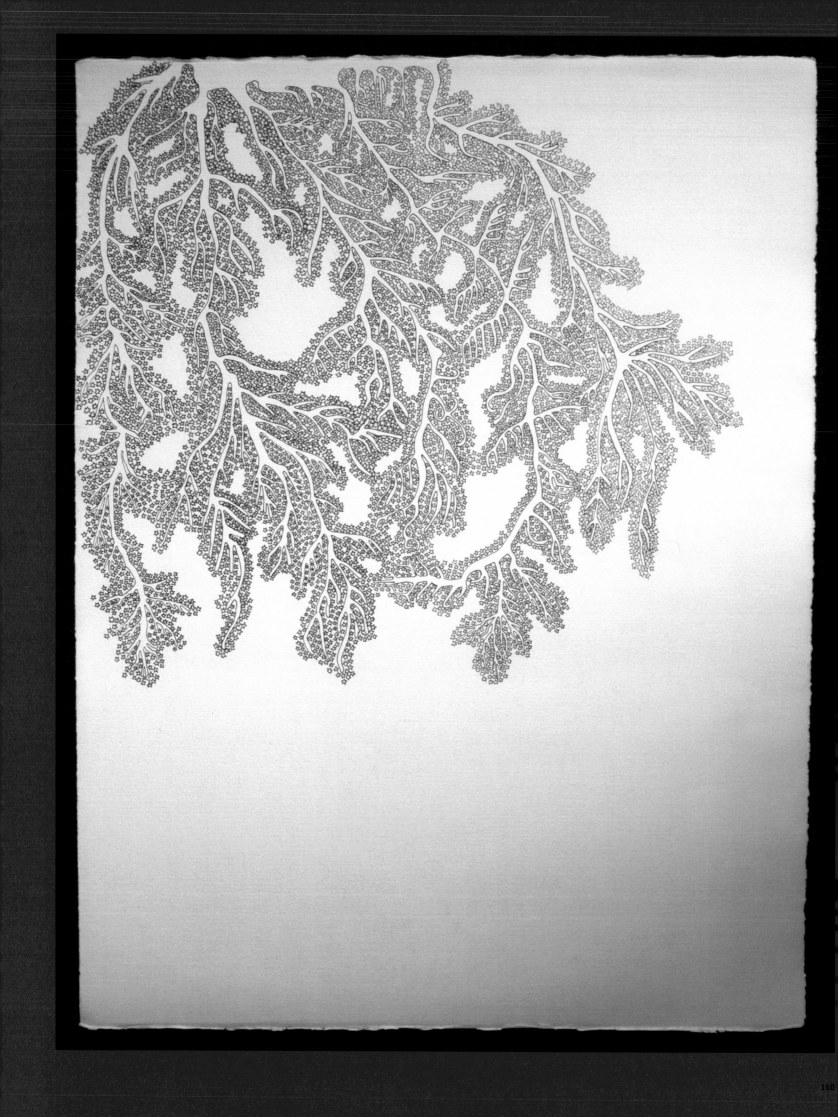

**1**
**Studio Thomson**
Invitation for a Garrard event entitled
"A Kaleidoscope of Colour"
Client: Garrard
Format: 42 x 29.7 cm

**2**
**Dan Funderburgh**
"Decorative Noose".
One colour screen print for solo show at
Servicio Ejecutivo Gallery, Brooklyn.
Format: 21 x 28 cm

(opposite page)
**Arnika Müll**
"Wurzeln und Sterne",
Fineliner on paper
Format: 50 x 65 cm

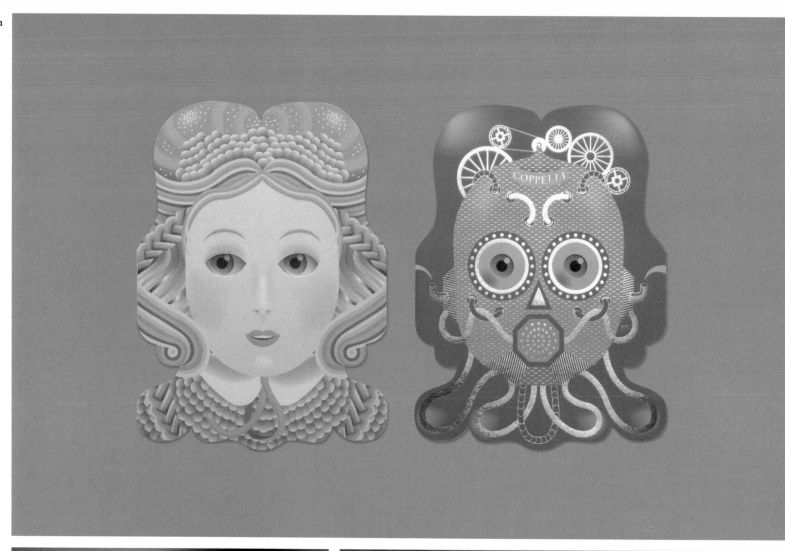

**1**
**Pierre Marie**
Invitation for a charity event at the
National Opera of Paris called "Reve d'Enfants".
Client: AROP
Format: 15 x 20 cm

**2**
**Pierre Marie**
Sabine Morandini edited that little book as an
extension to her website.
Client: Sabine Morandini
Format: 15 x 20 cm

**3**
**Superbüro / Barbara Ehrbar**
Floor painting in a design second-hand store
Client: Loft 26
Format: 70 x 50 cm

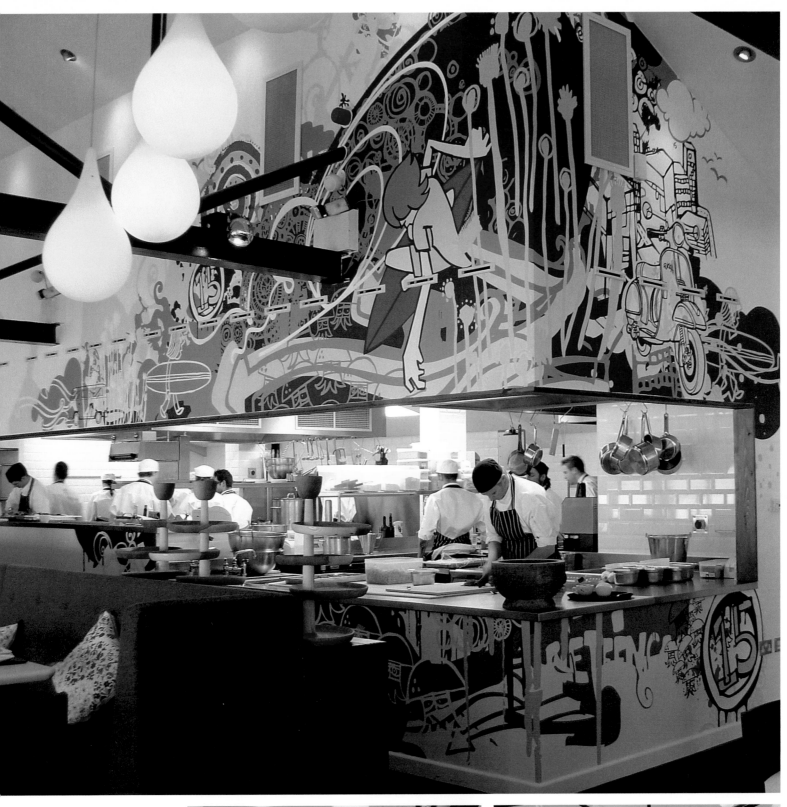

**A-Side Studio**
Mural for Jamie Olivers
Fifteen restaurant
Client: Fifteen

1

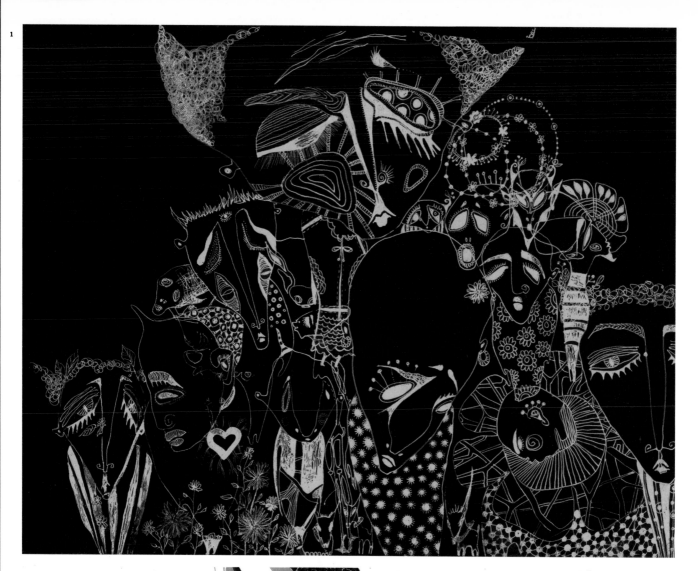

2

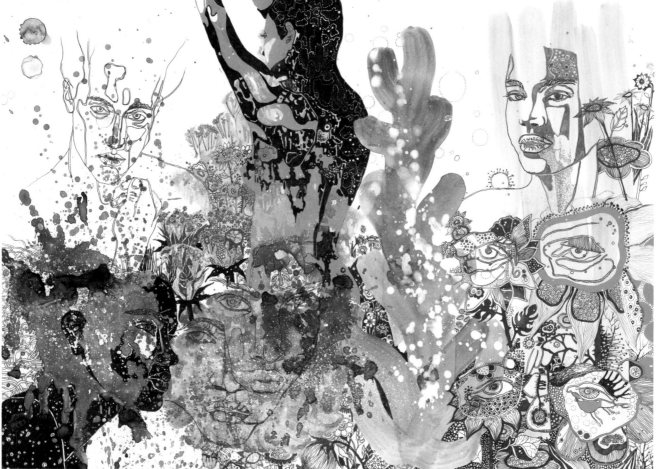

1
**Sonya Suhariyan**
"Violet", handdrawn
Format: 30 x 40 cm

2
**Sonya Suhariyan**
"Melancholy", handdrawn
Format: 30 x 40 cm

(opposite page)
**Bodara,**
**Büro für Gebrauchsgrafik,**
**Tobias Peier**
Designs for shirt series
Client: Pö-tit

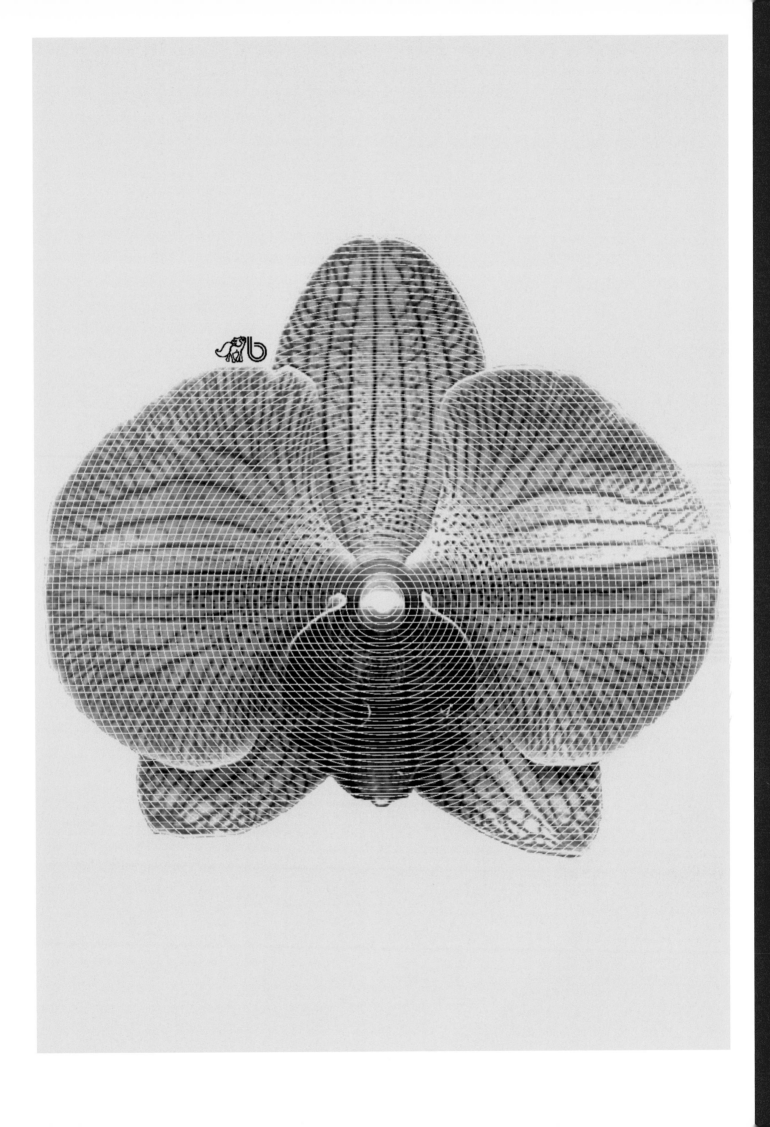

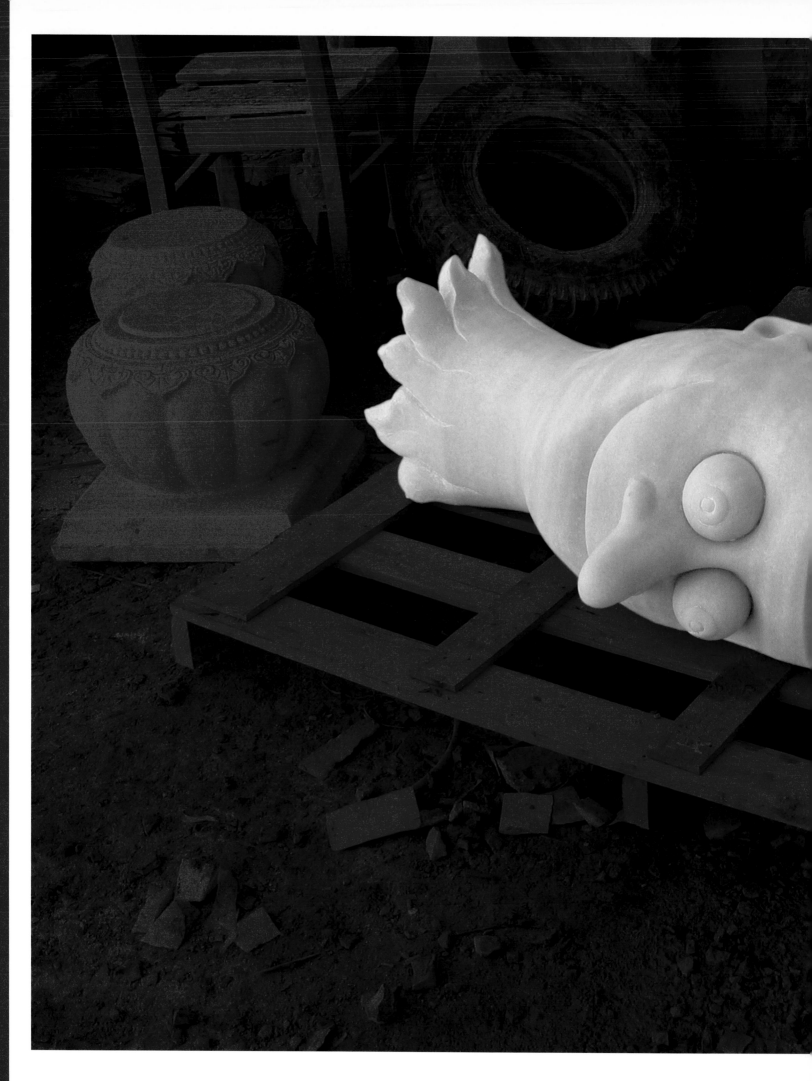

**Jes Brinch**
"Head"
Courtesy of V1 Gallery

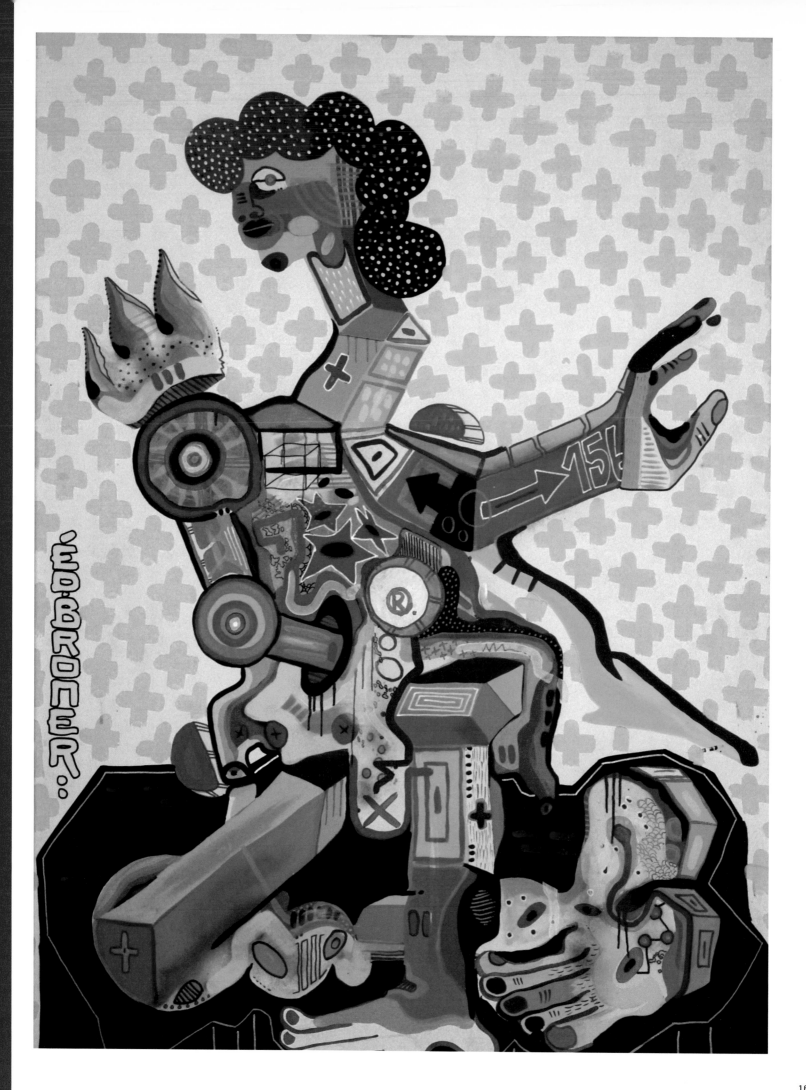

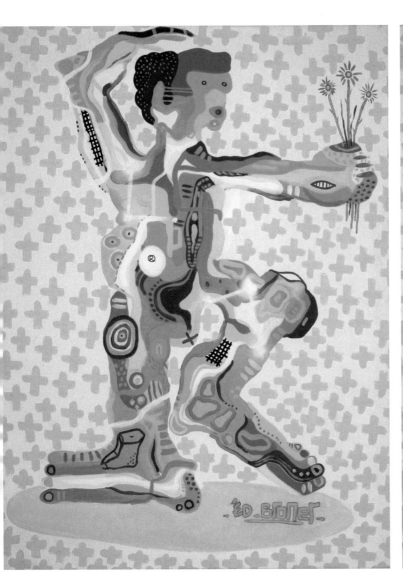

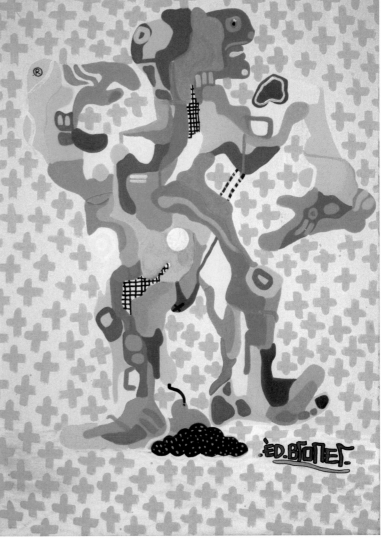

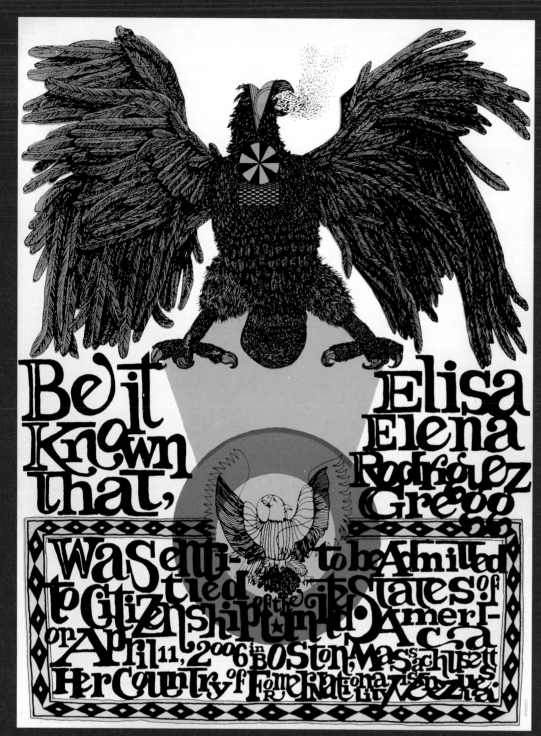

**1**
**Seripop**
A poster commemorating the
newly-acquired American citizenship
of one of our friends.
Photo by Yannick Grandmont
Client: Richard Gregg
Format: 45 x 65 cm

**2**
**Seripop**
Show poster for Japanese band
Boredoms; the show was in Chicago.
Client: the Empty Bottle
Format: 45 x 65 cm

**1**
**Benjamin Güdel**
Illustration for the report "Über das Leben
der Neandertaler" ("About the Life of the
Neanderthal")
Client: Die Weltwoche

**2**
**Benjamin Güdel**
Print campaign
AD: Oliver Drewes, Work in Progress, Düsseldorf

2

**1**
**Chris Bolton, Rami Niemi,**
**Jesse Auersalo, Nina Merikallio**
Radio Slave "Creature of the Night"
Client: Eskimo Recordings

**2**
**Chris Haughton**
"4 characters"

**Kenzo Minami**
"3"

# Brown

## "Brown, all love completely forgotten"

That is what Baroque poet Martin Opitz said some four hundred years ago. And he is still right. It's tough for brown. The blackened brother of yellow, orange and red is often interpreted negatively. Many people, besides the brown-shirted Fascists (who did their dirty work in Italy, however, as the Blackshirts) could be made responsible for brown's bad reputation. Even the Romans discredited brown as the colour of the uncultivated and shouted insults of "pullati" (brown-clothed) to the poor. With the Christians, the situation was naturally even worse, and the colour brown was unceremoniously designated as laziness, one of the seven deadly sins. Consequently, the colour tone appears at most in the realm of the humbly endured brown monk's habit. Even nature seems to participate in the universal diss of brown. Or it may even be providing the basis for the widespread disapproval: everything that decomposes turns a brownish-earthy tone. It is the colour of the spoiled or unpalatable – consequently the fear of death and decay is the motor for its rejection. Even Knecht Ruprecht, who traditionally punishes bad children, wore a brown coat before the colour was used for a caffeinated, brown (sic) beverage that became popular around the globe. In the 20th century, the aforementioned "brown piles" (as Hitler's paramilitary organisation, the SA, called themselves in one of their songs) provided it with a conceivably bad image. After the war, although suntans could be considered a sign for a positive revival, no other colour but brown was characteristic for the grumpy lowbrows who spent life in their slippers, crouching on a sofa while they doggedly rejected any refreshing change. In this context, even the interior decors in brown/orange, which were enjoying ever more popularity in the seventies, were of little help. The Anglo-Saxon says, "I'm browned off", when something bores him. The personification of mediocrity is Charlie Brown...

But fans of brown shouldn't get too worked up just yet. The colour's rehabilitation is in full swing and can be supported with the same weighty contemporary and historic evidence that those who spurn it have used. Brown is not only omnipresent but is above all a partner who, in context, is convincing and can develop its full potential. A team player! The combination of brown and light blue is, for instance, not only a secret long-term hit in Scandinavia, where they cultivate a cleverly creative and very effective handling of brown tones. And there aren't any fears of contact to the good, old earth tone in the USA either. Or would anyone want to seriously suggest that the legendary Eames House was the wrong colour? Onward we go. Brown creates a perfect environment: it is the colour of rustic material; it provides a natural feeling of security. A piece of crispy, roasted meat has the most intensive flavour when it is brown. Dough that is baked brown looks just as mouth-watering as coffee, cocoa and chocolate. And when it comes to presenting soul and songs sung bursting with life, no colourfully named combo can beat the R & B legend Hot Chocolate.

Cultural history has so many good things to say about brown. Bruno (brown one) and Brunhilde were popular names. Ludwig XVI loved the couleurs de puce (the colours of the flea). Goethe disliked colourful clothing; he preferred grey, black and – exactly – brown. All of the sketches from his journey to Italy were done in sepia, the artists' brown, which is made from the ink of octopus. In the 19th century, the brown substance, which had been taken from the remains of abducted Egyptian mummies, was ground up and offered for sale as artists' pigment! By 1925, the colour was sold under the heading "Mummy Brown". For those who think that's too old-fashioned and not rock 'n' roll enough, may I suggest, in conclusion, that they refer to "Brown Sugar", the mega-hit by the Rolling Stones. Written by Mick Jagger, the grand master of semanticambiguity, this song allows many interpretations. Both positive (drugs and women) as well as negative (drugs and women). So, let's finally integrate brown according to its eclectic potential, and then the positive associations and applications will automatically follow.

Text by **Ole Wagner**

Ole Wagner lives as a lingo-libertine, freelance writer and online editor for Die Gestalten Verlag in Hamburg and Berlin.

**Ralph Schraivogel,**
**Yves Netzhammer**
Stamps
Client: Choco Suisse

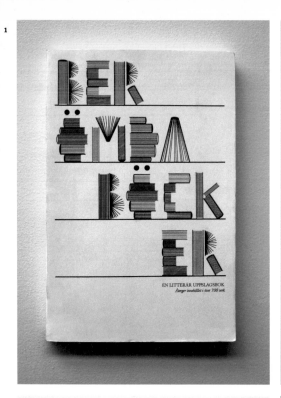

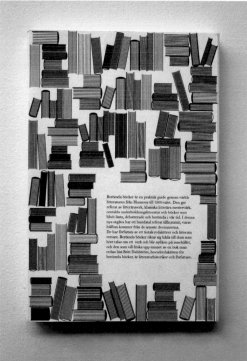

**1**
**Bygg studio,**
**Hanna Nilsson & Sofia Østerhus**
Book Club font promotion.
Book

**2**
**//DIY**
Nike Choco Sneakers

**3**
**Loveworn, Mario Hugo**
A new collaborative art project with my eight year old brother, Alejandro.

(opposite page)
**Jürg and Urs Lehni, Rafael Koch**
"Monetäre Situation, global"
Poster design
Client: F.I.R.M.A. (Cécile Wick and Peter Radelfinger)

2

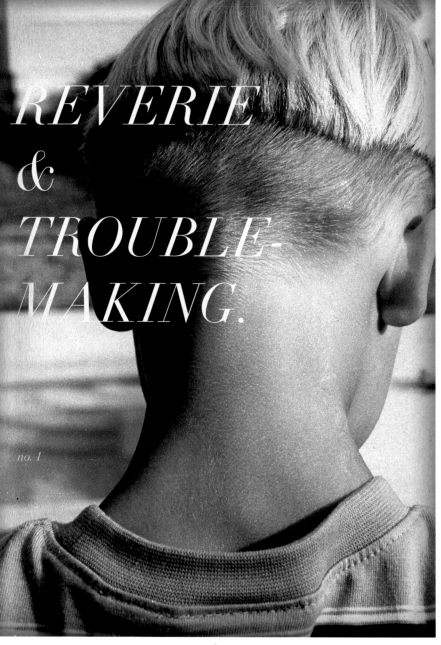

3

16.06.05 — 17.07.05

IAN ANÜLL
SONJA FELDMEIER
F.I.R.M.A.
PIER GERING
MARIANNE HALTER
THOMAS HUBER
TATJANA MARUSIC
CHARLES MOSER
GUIDO NUSSBAUM
RELAX
VENICE SPESCHA
INGEBORG STROBL

GELD

GALERIE
HANS-TRUDEL-HAUS
OBERE HALDE 36
5401 BADEN
056 222 64 18
WWW.TRUDELHAUS.CH

AUSSTELLUNG

MI      14 — 20
DO/FR  14 — 18:30
SA/SO  11 — 16

DIE STIFTUNG HANS-TRUDEL-HAUS WIRD UNTERSTÜTZT DURCH DAS AARGAUER KURATORIUM UND DIE STADT BADEN

2

**1**
**Arko**
"Resonance", illustration

**2**
**Bianca Strauch**
LP cover
Client: Kompakt

**3**
**Noumeda Carbone**
"Mirror#1",
Ink, pencil, gold pigment, ecoline, Photoshop
Published on Kult Magazine
Format: 27 x 40 cm

(opposite page)
**1, 4**
**Jason Munn,**
**The Small Stakes**
Posters for Bonnie "Prince" Billy
and Mark Kozelek

**2**
**Jason Munn,**
**The Small Stakes**
Poster for Mark Kozelek

**3**
**Jason Munn,**
**The Small Stakes**
Poster for José González

3

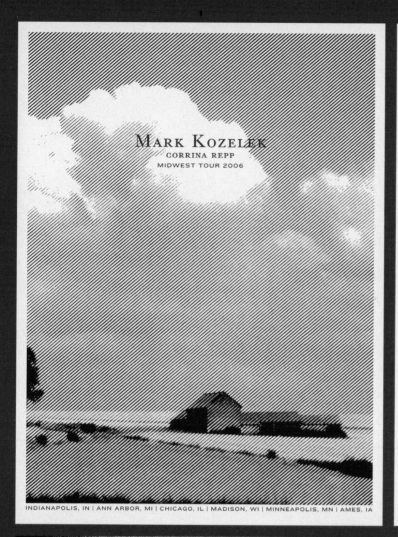

MARK KOZELEK
CORRINA REPP
MIDWEST TOUR 2006

INDIANAPOLIS, IN | ANN ARBOR, MI | CHICAGO, IL | MADISON, WI | MINNEAPOLIS, MN | AMES, IA

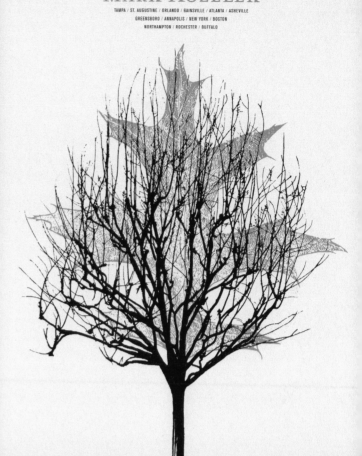

EAST COAST TOUR / MAY 2006
MARK KOZELEK
TAMPA / ST. AUGUSTINE / ORLANDO / GAINSVILLE / ATLANTA / ASHEVILLE
GREENSBORO / ANNAPOLIS / NEW YORK / BOSTON
NORTHAMPTON / ROCHESTER / BUFFALO

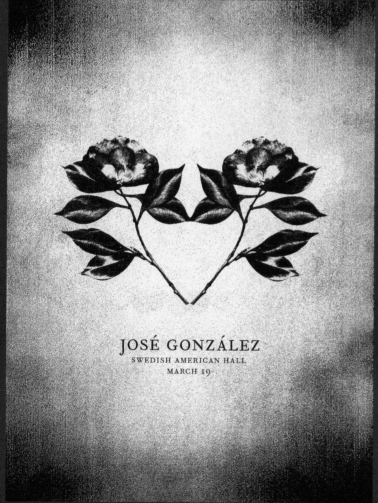

JOSÉ GONZÁLEZ
SWEDISH AMERICAN HALL
MARCH 19

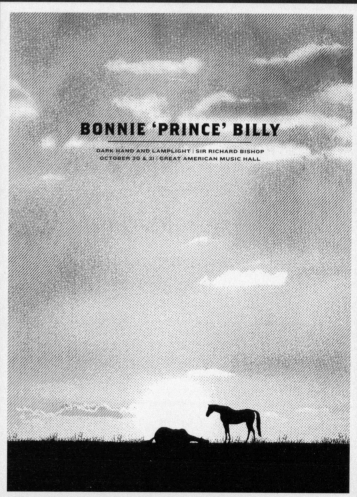

BONNIE 'PRINCE' BILLY
DARK HAND AND LAMPLIGHT | SIR RICHARD BISHOP
OCTOBER 30 & 31 / GREAT AMERICAN MUSIC HALL

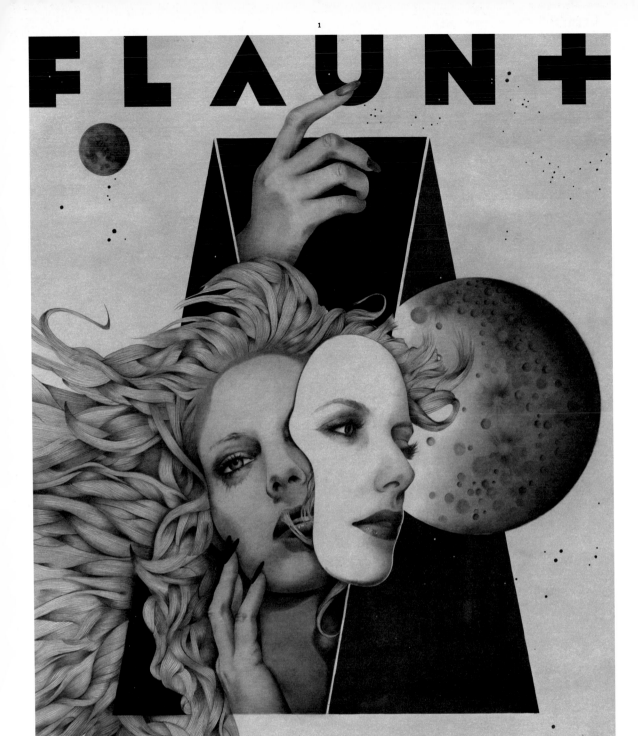

**1**
**Loveworn, Mario Hugo**
Cover for Flaunt Magazine.
Graphite, china ink and gouache
on acetone stained paper
Client: Flaunt Magazine

**2**
**Loveworn, Mario Hugo**
A piece for a book celebrating
D&G's 10th Anniversary
Graphite, china ink and gouache
on torn book pages
Client: Dolce & Gabbana /
Giovanni Bianco

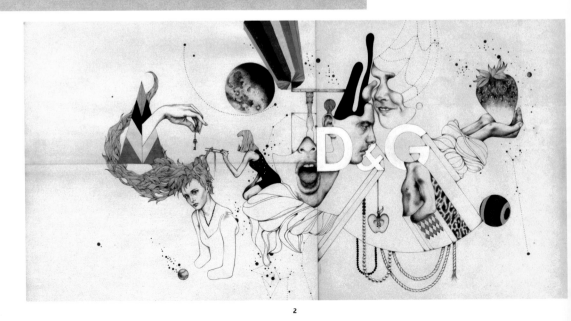

3

ng bodily injury with
drunken condition.' Would you
was that Maximov and that he
Tchitchikov made his journey,
g of the twenties, so that the
n thrashed then, he couldn't,
t to imagine what Kalganov
nt was genuine. Mitya foll

hey did thrash him!" he cried
t they thrashed me exactly
Maximov.
u mean? Either they thrashed
k is it, *panie?*" the Pole, wi
with a bored expression. The
y. Neither of them had a watch
k? Let other people talk. Mu
u're bored?" Grushenka flew
of finding fault. Something se
on Mitya's mind. This time
le irritability.
't oppose it. I didn't say anythi
n. Come, tell us your story
Why are you all silent?"
ing to tell, it's all so foolis
with evident satisfaction, m
by way of allegory in Gog
a meaning. Nozdryov was rea
ov had quite a different name was
ardi really was called Fenardi,
ussian, and Mamsel Fenardi
little legs in tights, and she h litt
les, and she kept turning round
ars but for four minutes only, an

re you beaten for?" cried Kalgano
answered Maximov.
" cried Mitya.
French writer, Piron. We were
us, in a tavern at that very fair.
f all I began quoting epigrams.
a funny get-up!' and Boileau answers
querade, that is to the baths, he-he! A d they
selves, so I made haste to repeat another, very
hown to all educated people:

*, Sappho and Phaon are we!*
*one grief is weighing on me.*
*don't know your way to the sea!'*

THE SPECIAL CONTENTS OF THIS EDITION
© Copyright, 1966, by
Airmont Publishing Company, Inc.

PUBLISHED SIMULTANEOUSLY IN THE DOMINION OF CANADA
BY THE RYERSON PRESS, TORONTO

PRINTED IN THE UNITED STATES OF AMERICA
BY THE COLONIAL PRESS INC., CLINTON, MASSACHUSETTS

They're on th
And a
door behind t
you meant it.
Teenage
to do things the
drink when they
We're su
just as we are.
if you've shown

drink, it's
mix driv
ng to thi
ure in a

l please
ly are the

istillers
For reprints, please write: Advertising Dept. A, Seagram Distillers Co., 375

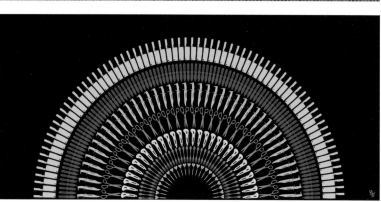

**1**
**Kate Sutton**
Cushion design, hand drawn
Client: Urban Outfitters

**2**
**Seldon Hunt**
3 CD box set for
Conrad Schnitzler
Client: Important Records

**3**
**Dan Funderburgh**
"Gravity's Rainbow"
Format: 68 x 42 cm

**1**
**ZIP Design, David Bowden**
Soul Heaven Blaze Presents…
Series of CD and vinyl
compilations
Client: Defected Records
Format: 31.4 x 31.4 cm

**2**
**March Castle**
An excerpt from one of
my sketchbooks detailing
fragments of memories and
overheard speech
Format: 50 x 9.58 cm

**1**
**Bo Lundberg**
This was just something that popped up in my head and is pretty much improvised.
Format: 17.5 x 22 cm

**2**
**Bo Lundberg**
I just played around with shapes and colour.
Format: 21.5 x 28 cm

**3**
**Bo Lundberg, Chant Egenian**
A book was created that was distributed to all Swedish girls at the age of thirteen.
Credit: Woo Agency
Client: Svensk Mjölk
Format: 15.7 x 20.5 cm

**4**
**Bo Lundberg**
I was asked to design a pattern for a coffee cup. Theme: hot.
Credit: Woo Agency
Client: Svensk Mjölk
Format: 15.7 x 20.5 cm

**5**
**Bo Lundberg**
This was for an exhibition I did in Stockholm. This motif was inspired by Japanese art.
Credit: Woo Agency
Format: 70 x 88.5 cm

**1**
**Bo Lundberg**
Personal work for one of two exhibitions I did in
Japan during Swedish Style in Tokyo.
Credit: Double Agent, Japan Dutch Uncle, UK
Format: 40 x 27.5 cm

**2**
**Didrik Rasmussen**
CD-cover for Norwegian rock band Syracus.
Fold-out booklet
Client: Duplicate Records / Suc-Yr-As Records
Format: 12 x 60 cm

(following spread)
**Dirk Rudolph**
Illustration for "POE Illustrated Tales of
Mystery and Imagination
Client: Die Gestalten Verlag

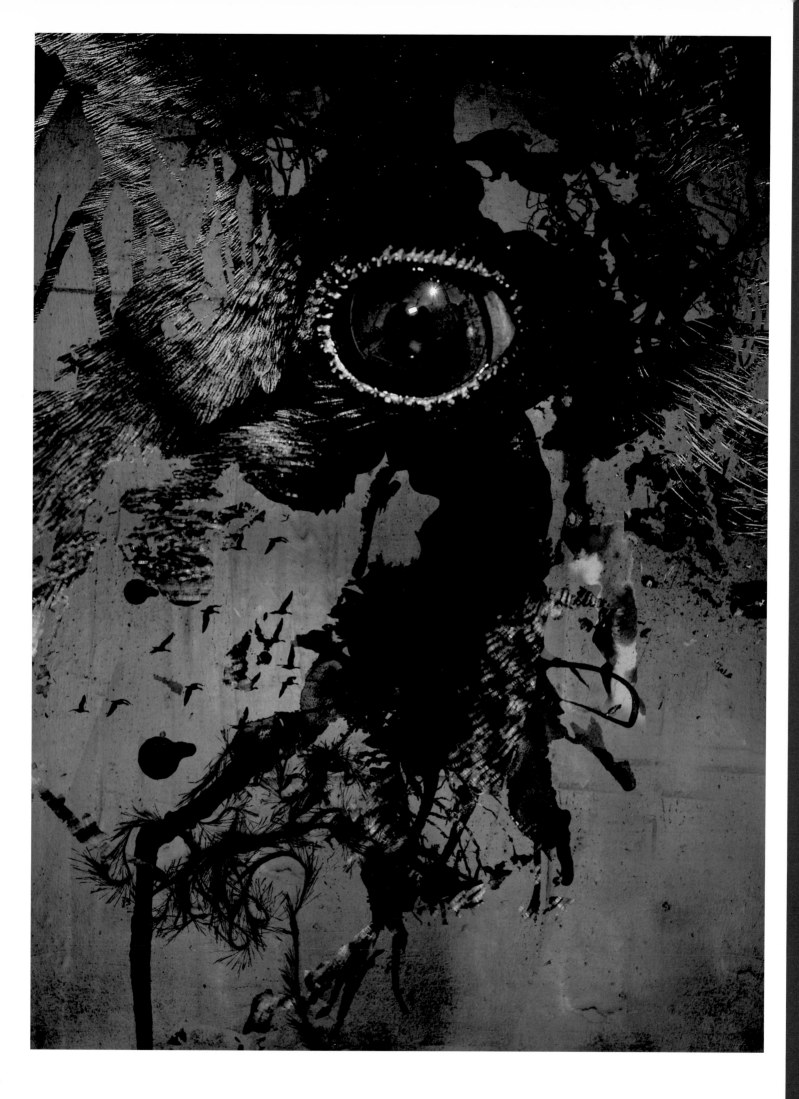

**Julia Ryser, Simona Brühlmeier**
"Laut Und Luise",
CD cover
Client: Laut und Leise

(following pages)
**Deanne Cheuk**
Wrapping paper design commission for the
American Institute of Graphic Arts
Client: AIGA
Format: 94 x 53 cm

**Elias & Saria**
Annie (Part of "Falling In Love")
Photo: Elias & Saria
Photography model: Annie Beust / Trumpmodels
Hair: Almog
Make-up: Edward Powell
Styling: Elias & Saria
Retouching: Elias & Saria
Format: 56 x 35.5 cm

(following spread)
**Homework, Jack Dahl**
Client: Cover magazine

**Ian Brown, Timo Hofmeijer**
Invite for Lost & Found
We came up with a way of
folding the poster down to A5
so that both the front and the
back are visible at once.
Client: Lost & Found
Format: 42 x 59.4 cm folded
to 14.8 x 21 cm

(opposite page)
**Kenzo Minami**
"Calling"
Limited edition print

**Julia Ryser**
"Der Mond tut nichts"
Final year project
HKB, Bern
Format: 4 books, 17.8 x 23 cm

(opposite page)
**Julia Ryser**
Final year project
HKB, Bern
Photography: Daniel Kaufmann

**RO&AD architecten**
Photography: Anita Huisman

(opposite page)
**Sagmeister Inc.**
Adobe Achievement Award
Art Direction: Stefan Sagmeister
Design: Matthias Ernstberger
Illustration: Matthias Ernstberger
Photography: Zane White
Production: Philipp Haemmerle
Client: Adobe Systems
Format: 70 x 91 cm

**Heine / Lenz / Zizka**
St. Moritz Design Summit
Client: Raymond Loewy Foundation

# Orange

## "How cool would a carrot-coloured interior have been in '2001: A Space Odyssey' instead of an orange-coloured one?"

Orange is a modern colour and it is therefore retro in the post-post-post-modern era. But let's start at the beginning. Europe was initially introduced to the orange fruit from Asia during the Middle Ages, and it was first documented as a term for colour in a report about small talk at the Court of Henry VIII in the year 1512. Before that, it was referred to in Old English as "geoluhread", which meant and was even pronounced "yellow-red". And why is it called orange and not carrot? Because the apparently so deeply rooted orange-coloured European vegetable is even younger – it was first produced in the 17th century as a hybridisation between yellow and black varieties, in The Netherlands, of course.

If orange had been called carrot, would it have become the domineering fashion colour back in the sixties? How cool would a carrot-coloured interior have been in "2001: A Space Odyssey" instead of an orange-coloured one? Or would the cheeky vitality of this colour have asserted itself anyhow in the Swinging Sixties? Whatever the case, at the time everything was orange – from wallpaper to bedding and underwear, and on to bean-bag and plastic chairs, televisions, telephones or alarm clocks. The grand triumphal procession of the colour goes hand in hand with the triumphal procession of plastic.

And so, avant-garde soon became mainstream and the time came when public transportation companies considered combinations of orange with yellow, shit-brown and/or grass green to be particularly mood-elevating and implemented them to design the interiors of entire subway trains. Orange became synonymous with cheap, fashionable, throwaway products. In the eighties it was neither popular with the environmentally-conscious nor with flamboyant New Wave fans, who preferred cooler neon colours.

It is probably not a coincidence that orange experienced its revival in a new era of autocratic departure: it was the favourite colour of the dot-coms. It not only brilliantly illuminated the screen.

Even off line, the New Economy companies presented themselves in orange, preferably together with bright blue – a questionable combination in regard to taste, which one would hardly choose if standing in front of a clothes closet. Many dot-coms went down the tube; orange and blue are still in the Web. Even the paper manufacturer Zanders has the colour "Dot-com Orange" in stock in their Chromolux product line.

Today, orange is completely back in vogue, riding the sixties retro-wave that has been rolling for years now. At the same time, direct banks, telecommunication companies, cheap airlines and political parties like Germany's CDU have been helping themselves to the signal power of the colour, which is characterised as being friendly, reliable and active. The perhaps most interesting new interpretation can be found in publications, for which the term Print 2.0 is becoming established. These are premium print products, which are happy to exist in contrast to our digital era by relying on elaborate haptics and using raw materials like cardboard or designs or typography that have been silk-screened in neon orange. (Years ago, the magazine "Wired" was a pioneer in the use of haptics and bright orange.)

One dimensional allocations don't function with any colour anyhow, especially not in a global world. Therefore, everyone must answer the question for themselves, as to whether they associate orange more with an advertisement for soda pop or fresh juice, with Agent Orange or marigolds, with Dutch soccer fans or with a beech tree forest in autumn, with sale tags or Buddhist monks, with the Orange Revolution in the Ukraine or the orange glow of the sexual chakra, with the blinking orange light of an alert signal or with the setting sun.

Text by **Claudia Gerdes**

Claudia Gerdes is a freelance author and editor of the design magazine PAGE. She lives and works in Hamburg.

**Boris Hoppek**
TV documentation about colours
Client: tv3 colors en serie

1

PLAY

*Party*

2

STORE

A
Z

3

**1**
**Vance Wellenstein, Matt Rezac**
Proposals for RAID
Client: Midway Contemporary Art
Format: 41.9 x 60.3 cm

**2**
**Ludovic Balland**
Invitation
Client: Vitra Design Museum
Format: 21 x 50 cm

**3**
**A-Side Studio**
Promotional poster / flyer
Client: ProjectBase

**4**
**Boris Brumnjak**
Client: Institut für Neue Musik, Berlin
Format: 21 x 29.7 cm

SOCIAL
SYSTEMS

1

(pages 206 and 207)

**1**
**o Lundberg**
aper cut
elf Promotion
ormat: 26,5 x 34 cm

**, 3**
**o Lundberg, Alison Oliver**
lustration
ormat: 25 x 31 cm

**o Lundberg, Kelly Hyatt**
Wrapping paper
lient: Beaumonde
ormat: 50.5 x 69 cm

**o Lundberg**
he International Traveller"
elf promotion
ormat: 26.5 x 32,5 cm

**an Funderburgh**
attern based on Japanese
amily crests for a select T-shirt
lient: Threadless

**1**
**Neubauberlin**
Book
Publisher: Die Gestalten Verlag

**2**
**Didrik Rasmussen**
Homage to the colour orange
Personal project
Format: 330 x 480 cm

**3**
**Kummer & Herrman**
Book cover
Photo: Mick Salomons
Client: Mondriaan Foundation
Format: 16.5 x 22.0 x 2.2 cm

2

3

3

3

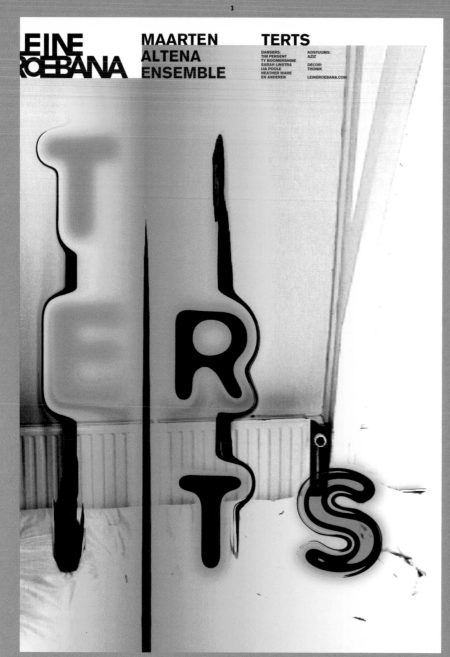

EINE
ROEBANA

MAARTEN
ALTENA
ENSEMBLE

TERTS

DANSERS:
TIM PERSENT
TY BOOMERSHINE
SARAH LINSTRA
LIA POOLE
HEATHER WARE
EN ANDEREN

KOSTUUMS:
AZIZ

DECOR:
THONIK

LEINEROEBANA.COM

**1**
**Koeweiden Postma**
Poster for a dance performance called "Terts"
Client: Leine & Roebana
Format: 84.1 x 118.9 cm

**2, 3**
**Marc Atlan**
Catalogue, displays & collaterals
Client: James Perse

**4**
**Marc Atlan**
Cibachrome in light box
Client: Mu Foundation, The Netherlands

FALL 2006
JAMES PERSE LOS ANGELES

FALL 2006
JAMES PERSE LOS ANGELES

THE GREAT
REFUSAL

**A Practice for Everyday Life**
Exhibition catalogue
"Daniel Buren – Intervention II
Works In Situ"
Client: Modern Art Oxford

(following pages)
**Mixer, Marco Sieber**
Free work
Format: 30 x 40 cm

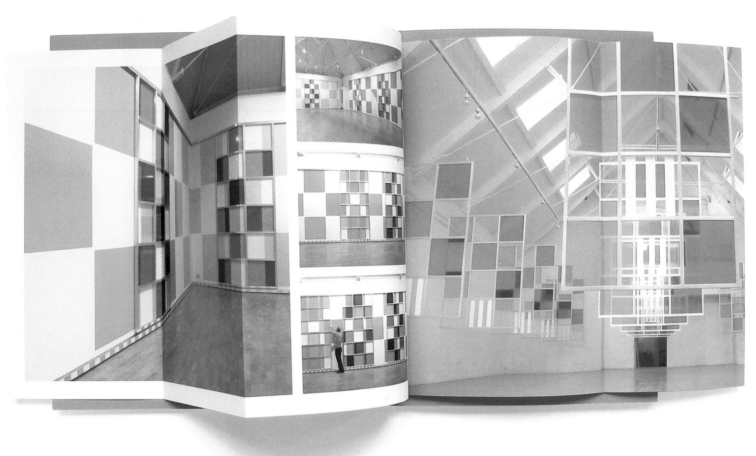

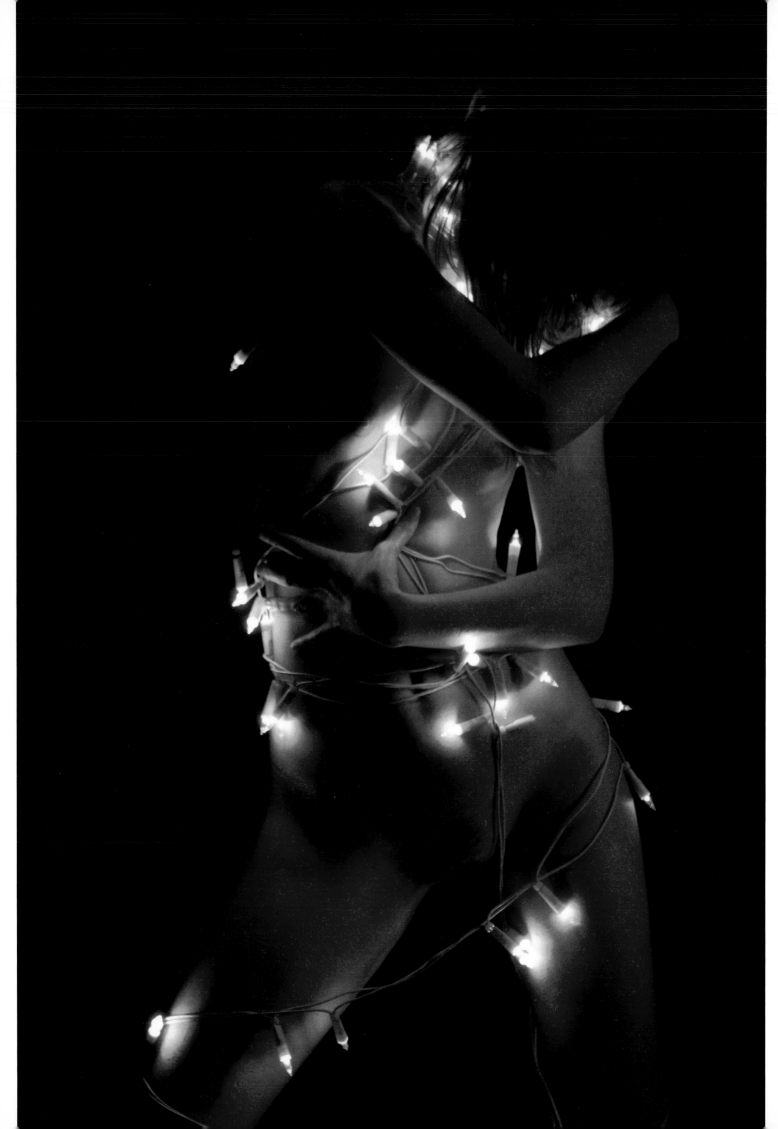

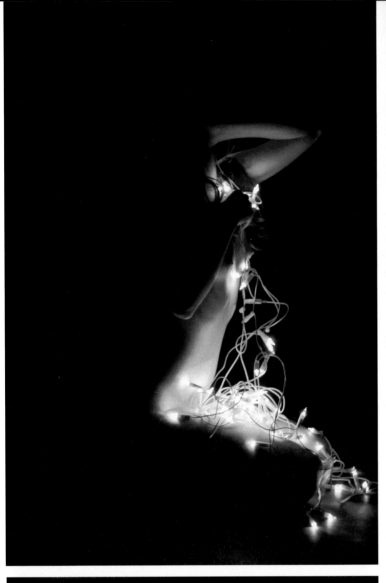
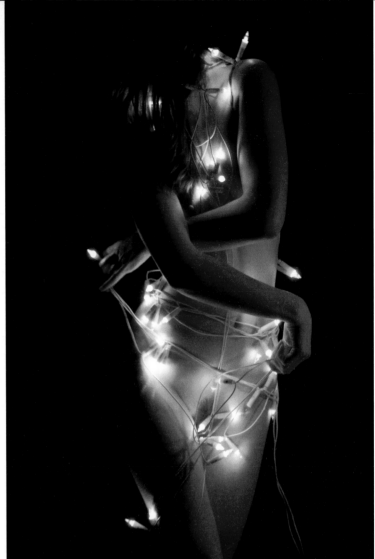
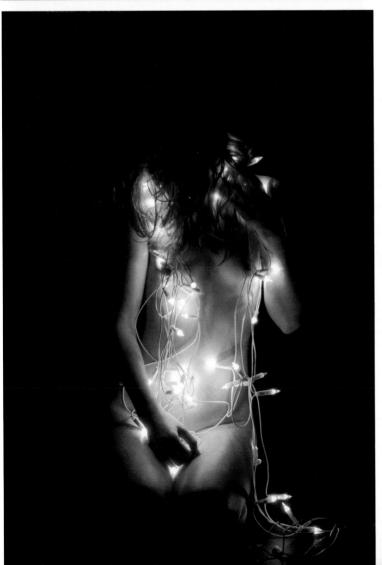

**Florentijn Hofman**
Credit: Kooyman Publicity
Client: Nighttown /LLIK
Photographer: Frank Hanswijk

**Newskooldisplay™ / Johannes Schroth**
Street art installation on Mulakstrasse in
Berlin-Mitte. It consists of 4 different isles, which
all sport at least some chairs, a table and
decoration. All are painted shocking orange.
Credit: KHC Crew, Martin Bütow and Wassif
Client: Haeberlein + Maurer / Aemkei

# Black

## "Go against the conformity."

I have a tendency to pick something I am not quite fond of. A lot of the colours I ended up using for my work naturally (or unnaturally) have often been colours I did not like, or even despised. This, to me, is quite logical since, it satisfies my strong desire for challenge and also my love for the gap caused by the unusual and unexpected combination of things, creating something unexpected (naturally), causing the unforeseeable effect. And it is for the fear of choosing something you are fond of. The conformity and ease of choosing what you like and you know well go against the idea of my work itself and bore me from the start – and that is death to our work. So I suppose it is a fail-safe when potential ingredients, which might trigger those dangers, are eliminated at the very first stage of the design process.

For me, using the colour black came about in the same fashion, but with another layer of twist. This is appropriate because of its uniqueness and tricky stance among colours – starting with the whole discussion of if it should be considered as a colour in the first place. It's a void of colours and all the colours in one simultaneously. It is outside of the boundary of colour and, at the same time, it is the entire boundary. It deserves something better (or worse) than simple loathing and the reflexive rejection of choosing it.

One of the most crucial reasons why I started using black, and for some period of time I forced myself to use only black and white, is because I always had seen conformity and ease in it – and its dangerous and addictive nature. It was not conformity I wanted by choosing it, but it was for the fear of comfort it provides. I chose it because of my twisted liking of the hatred I have for myself liking it. It is the complete reverse of the fail-safe, which is just another type of fail-safe. I also saw black as a means of measuring my own ability, as the ultimate test as a designer. I stripped away all of the things I could rely on to see the reflection of my capability on its surface.

If it's something I like, think I know well and can already foresee the capacity of it and my capacity with it, it must take so much more for me to go beyond it, go above my understanding of its capacity and go beyond my conception of its nature. I have to go outside of my own preconceived idea of design, myself, and my own habitual and formulated thinking process simply with my own will, effort, and ability. To fight against and go above the banality and power of black, and our own dependency and laziness is quite challenging.

I suppose this is something one should reach after using all of the colours in the world. But I was young (well, it was just 5 or so years ago, but still), and my irrelevant ego claimed that I could handle it. I felt defeated the first time around and banned myself from using it for a while until I felt ready for another challenge. It's almost like comparing two types of people who wear black their whole lives. One wears it just because it's safe, and the other, who tried all the colours in the world, settled on wearing black. You definitely see the difference. Here again, we see black as the void or black as the mixture of all the pigments of colours. All of the colours the person tried before are now reflected upon the black surface.

So I come back to black every so often, to see the progress I made since I touched black previously. To see how many more colours I have mixed into my black since the last time.

Text by **Kenzo Minami**

Originally from Hyogo, Japan, Kenzo now lives and works in New York City. As an artist, Kenzo has been featured in many international publications and has shown work at renowned venues. His work and designs have been commissioned by companies such as Mercedes-Benz, VH1, Nike, Adidas, Reebok, Converse, Kidrobot and the Tribeca Grand Hotel, among others. Kenzo also has his own garment project line. www.kenzominami.com

**Christina Baeriswyl**
"The killer in me is the killer in you"; these
photographs are the key to the solution of the riddle.

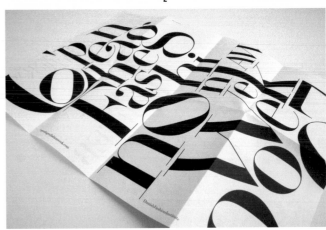

1

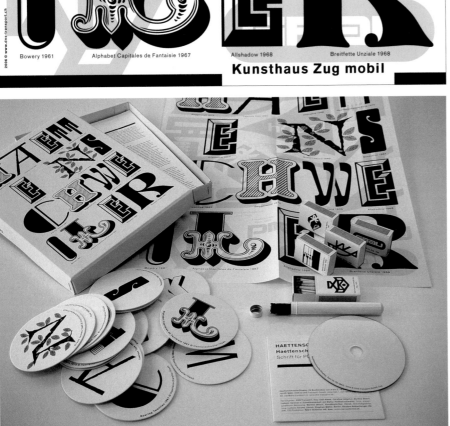

**1**
**DNS-Transport GmbH**
Client: Kunsthaus Zug

**2**
**Homework / Jack Dahl**
Poster invitation
Client: Copenhagen Fashion Institute

**3**
**Homework / Jack Dahl**
Promotion poster series
Client: 2BE (Better Eating)

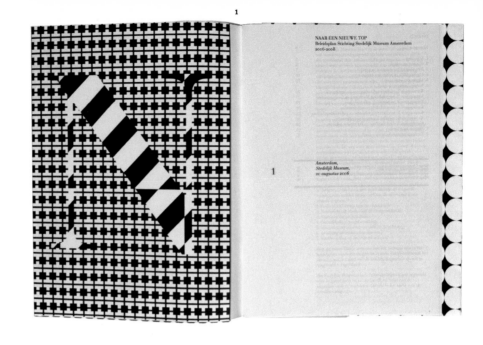

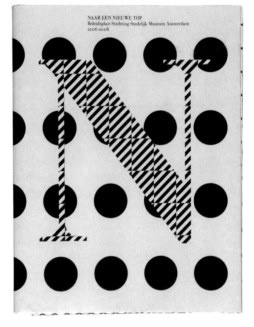

**1**
**TM / Richard Niessen, Esther de Vries**
Business plan
Client: Stedelijk Museum Amsterdam

**2**
**Mario Hugo, Loveworn**
Screen logo
Client: Accept & Proceed

**3**
**Newsgroup**
Flyer
Client: Crackhouse Warming Party

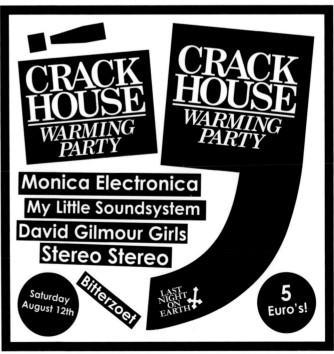

**2**
**Gabor Palotai**
The Swedish Architecture and Design Yearbook 2001
Client: Arvinius Publisher
Format: 70 x 100 cm

**3**
**Gabor Palotai**
Poster, silkscreen
Client: The Royal Coin Cabinet, Stockholm
Format: 70 x 100 cm

**4**
**Gabor Palotai**
Poster, silkscreen
Client: The National Museum of Science
and Technology
Format: 70 x 100 cm

**5**
**Gabor Palotai**
The Swedish Architecture and Design Yearbook 2001
Poster, silkscreen
Client: Arvinius Publisher
Format: 70 x 100 cm

1. Reihe: **Seltene Platten**
Samstags 14 Uhr
19. 2. 2000 Bruce Haak, The Electric Luzifer, 1968 Moog Sounds
26. 2. 2000 Silver Apples Spectrum, Spaceman 3

**Labor für Soziale und Ästhetische Entwicklung**
Berger Kirche, Bergerstrasse Ecke Wallstrasse, Düsseldorf
In Zusammenarbeit mit Hitsville

**Liebesdinge**   Das Publikum wird um Leihgaben für die Ausstellung gebeten   7. - 21. Juli in der Berger Kirche Bergerstrasse 18a
Annahme bis 6. Juli, Montag bis Freitag 15 - 18 Uhr ..... ...... .......... Labor für Soziale und Ästhetische Entwicklung

**Ian Brown**
50 Posters,
all screen-printed in
4 runs; black, and three
colour-gradients and
are all unique, in the
sense that the under-
lying pattern is never
the same twice.
Screenprinted by Ian
Brown and Kees Maas
Client: Museum
De Paviljoens, Almere,
The Netherlands
Format: 60 x 90 cm

PIÈCE

AFRICAINE

De et Mise en scène Catherine Anne
Musique Fabienne Pralon

20  21  22  23 mars'07 au Théâtre en Bois
      19h00
20h00         20h00

Le Centre Dramatique de Thionville-Lorraine est subventionné par le Ministère
de la Culture et de la Communication – DRAC Lorraine,
la Ville de Thionville, la Région Lorraine et le Département de la Moselle

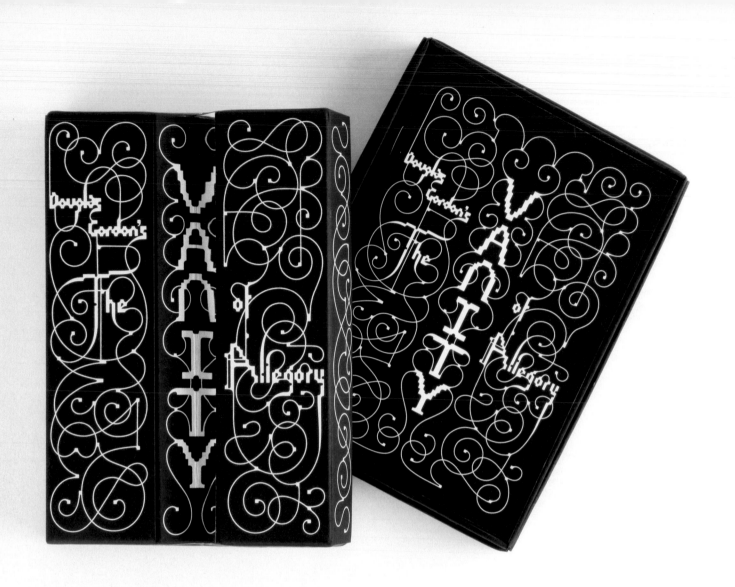

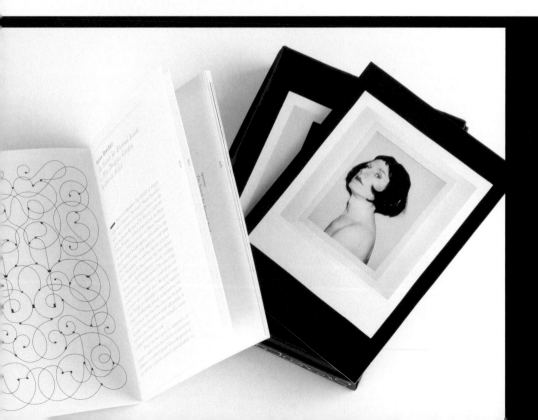

**Sagmeister Inc.**
Douglas Gordons' entire
exhibition "The Vanity of
Allegory" at the Guggenheim
Museum in Berlin is packaged
as postcards into a portable
box. The cover incorporates a
slanted mirror thus creating a
vain, reflected typography.
Art direction: Stefan Sagmeister
Design: Matthias Ernstberger
Typography: Marian Bantjes
Photography: various
Production: Lara Fieldbinder and
Melissa Secundino
Writer: Nancy Spector
Client: The Guggenheim
Museum, Berlin
Format 11.5 x 16.0 x 4.5 cm

**Jonas Vögeli, Matthias Michel**
Editor: Gerd Folkers, Rainer Egloff, Matthias Michel
Cover: Arni Siebdruck
Programming special edition: Jamie Ward, Stijn Ossevoort
Client: ETH Collegium Helveticum / Chronos Verlag
Format: 17 x 24 cm

**1**
**Jonas Vögeli**
Stationery:
unprinted letter (2 blacks),
printed letter
(2 blacks + 1 black + 1 stamp)
Corporate Design:
Business card, letterhead 1 + 2,
envelope stamp, stamps,
word templates modular
system, printed with
3 different blacks (1 black,
1 reliefcolour black and
laserprinted black)
Client: Jens Studer Architekt

**2**
**round / Michaela Webb**
Gallery identity and stationery
Client: Anna Schwartz Gallery

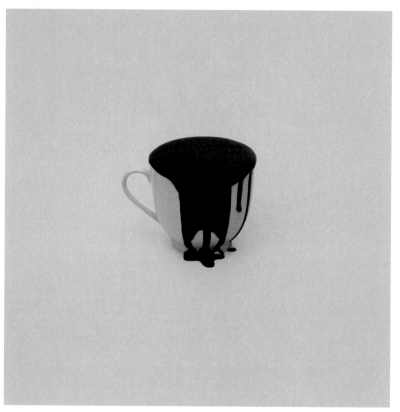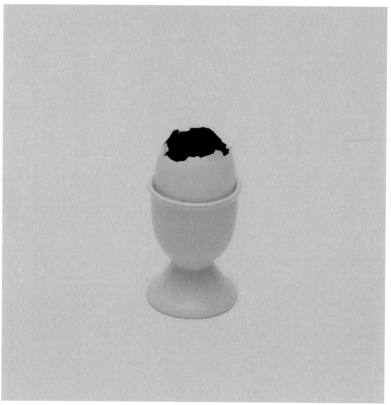

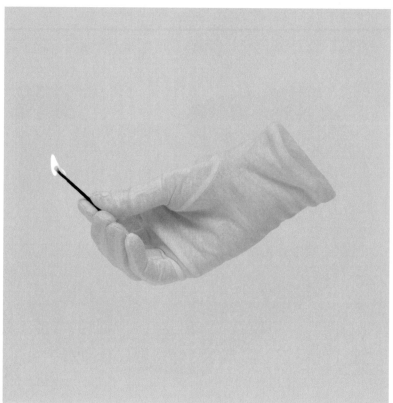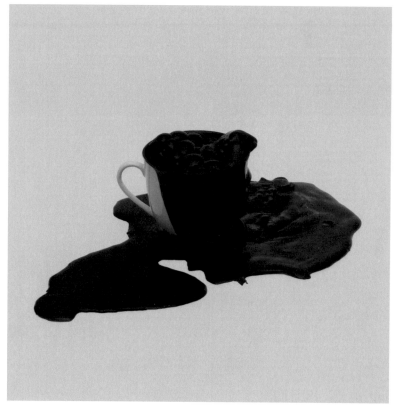

**James Musgrave, Anthony Sheret**
Artwork proposals for Simon Wilcox's new album "The Charm and The Strange"
3 narratives that represent evil taking control
Client: Simon Wilcox
Format: 12 x 12 cm

BECOMING ONESELF
four conversations on art
and institutional creativity today

Nicolas Bourriaud

Boris Veldhuijzen van Zanten

Branislav Dimitrijevic
Declan McGonagle

Oladélé Ajiboyé Bamgboyé
Barbara Vanderlinden

Charles Esche

Sean Snyder

BAK, basis voor actuele kunst, Utrecht

**1**

**Hans Gremmen**

The Black Hole: Scheeren and Kruithof worked as photographers on numerous projects that reflected the theme of "the black hole" on a very associative level. To document this project, Hans Gremmen decided to overprint half of the book with black. Pictures shimmer through and are sometimes, but not always, repeated in another place in the book.
Edited by Hans Gremmen, Jaap Scheeren and Anouk Kruithof
Client: Jaap Scheeren and Anouk Kruithof
Format: 17 x 24 cm

**2**

**Kummer & Herrman**

Book containing four conversations on art and institutional creativity today. Printed in black on the organisation's stationery material (Pantone 072). The "Becoming Oneself" photo inside the book was done by Mick Salomons.
Client: BAK, basis voor actuele kunst
Format: 21.0 x 29.7 cm.

**3**

**Spin / Tom Crabtree**

International jeweller Ileana Makri commissioned a complete identity along with discrete packaging for her unique range of up-market jewellery.
Client: Ileana Makri
Format: Various size jewellery boxes

**4**

**Surface / Markus Weisbeck**

The series "Art Propaganda Documents" publishes original text material, speeches, programs and manifestos that were crucial to cultural politics in the context of 20th century totalitarian movements. The graphical idea was to produce a "non-finished" or "damaged" book found in a second-hand market after a rainy day on the street. You don't know if there had been a cover or if this found copy is heavily damaged. The idea of the switch of background colour and type colour is a kind of copy protection, which makes it difficult to reproduce it on a cheap copier.
Client: Revolver Verlag
Format: 10.5 x 17.5 cm

OFFSET_one run_black                    OFFSET_two runs_black on black          INKJET_one run_black (g/s)              LASER_one run_black

LITHOGRAPHIC STONE_one run_black        LITHOGRAPHY STONE_two runs_black on black   SILKSCREEN_(oil based)_one run_black   SILKSCREEN_(oil based)_two runs_black on black

SILKSCREEN_(water based)_one run_black  SILKSCREEN_(water based)_two runs_black on black   SILKSCREEN_(water based)_one run_gloss black   SILKSCREEN_(oil based)_one run_UV black

INTAGLIO_(Aquatint)_one run_black       INTAGLIO_(hard ground)_one run_black

IN ORDER OF PRINT – Used & Mediaberg, Royal Bruhn Edition, WerkZeugberg, Amsterdam Graphisch Atelier, & Kees Maas. Thanks to Julia Born, René Put, Olivier Jean, Laurent Brunier, Freek Klie, & Lewi Fanous.
(concept/design/production – say brown, 20xx)

**1**
**Umbra + Dor**
typomoon 2006
Format: 32 x 68 cm

**2**
**Atelier BLVDR, François Canellas**
Cover for the magazine "Attitudes – espace
d'arts contemporain"
Client: Attitudes – espace d'arts
contemporains
Format: 23 x 32.5 cm

**1**

**2**

**Kenzo Minami**
"Fear of Words,
Words of Fear
(The Second)"
Limited edition
print

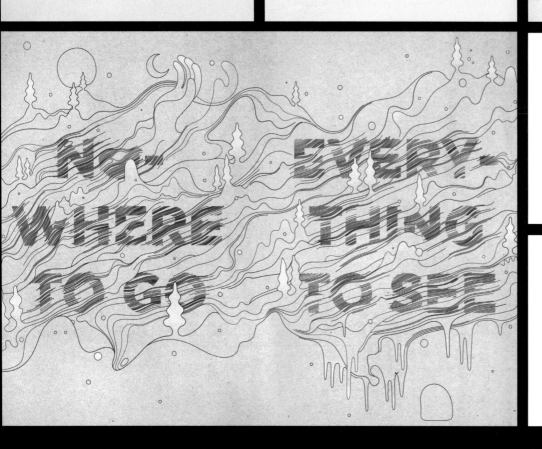

**1**
**Allon Kaye**
Hand-printed digipak packaging
Photographs by Martin Holtkamp

**2**
**Mario Hugo, Loveworn**
My contribution to 2007's "If You Could ..."

**3**
**Arko**
"Somewhere In Space"

**1**
**Jonas Vögeli**
LP cover
Front Cover: 4 colour cmyk generates black
Back Cover: 4 colour / black
Client: Saalschutz
Format: 31 x 31 cm

**2**
**Denastas & Chapus, Alexandre Chapus**
An exercise consisting of creating the visual identity
of an arts centre. By taking the cross as a starting
point, it was a matter of developing it with the
continuation of a whole vocabulary of forms and then
applying them to support the visual identity.

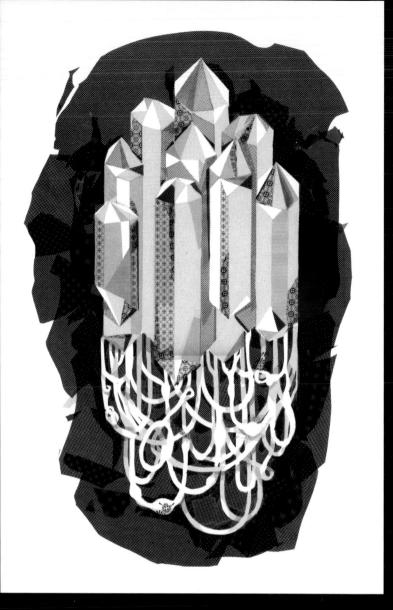

3

**1**
**Madame Paris**
"Dark Crystal", silkscreen poster
Client: Madame Paris &
Espace Basta
Format: 120 x 180 cm

**2**
**Madame Paris**
"Arsenal ", silkscreen poster
Client: Madame Paris &
Espace Basta
Format: 120 x 180 cm

**3**
**Pixelpunk**
Collages for a stream on the
webradio Radio Dadio
Client: Radio Dadio
Format: 25 x 30 cm

3

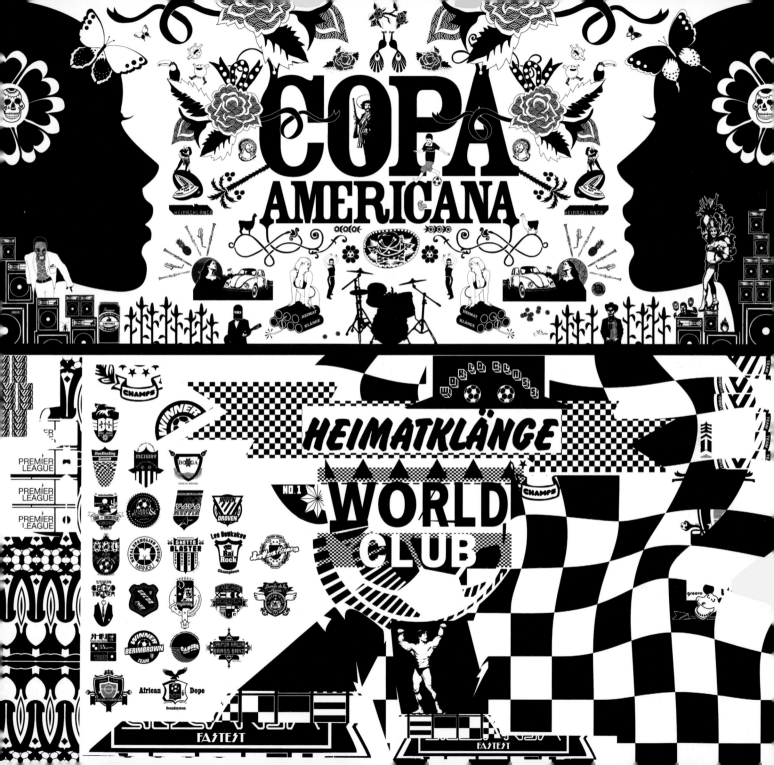

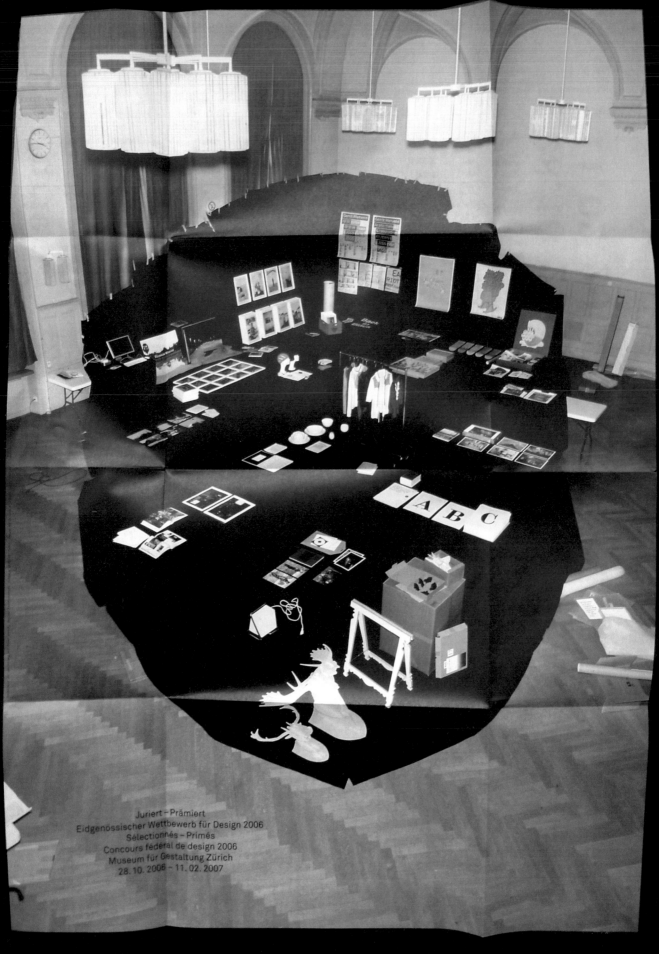

**Derrierelacolline,**
**Marie Lusa, Claudia Roethlisberger, Anne-marie Van Den Berg**
Invitation poster for the exhibition "Juriert-Prämiert Eidgenössischer Wettbewerb für Design 2006"
Photography: Koerner Union & Claudia Roethlisberger/Marie Lusa
Client: Swiss Federal Office of Culture & Museum für Gestaltung Zürich
Format: 45 x 60 cm

**1**
**Ian Brown, Selina Bütler**
1,000 DIN A1 posters printed
front and back on poster paper,
which was made especially for
"fly-postering". The paper was white
on one side and blue on the back
so as not to let the poster, on which
it has been glued, bleed through.
We printed text in super high gloss
black UV ink on the blue side and
super matt black on the white,
smooth side. The posters, as they
were printed, were not functional
until folded.
Printed at Wyber Zeefdruk,
Amsterdam
Client: Gerrit Rietveld Academie
Format: 59.4 x 84.1 cm

**2**
**Ludovic Balland**
"Blackpaper On Wall", signage
Client: Buchner Bründler Architekten

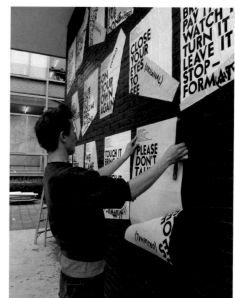

NIGHTWORKER
KLAKE

INTRO
SUBWAY
THE TRUTH
WHY WE LOVE
LOOKING OUTSIDE
CONCIOUS SONG
EBB AND FLOW
OUTRO

© KLAKE 2007
ALL RIGHTS RESERVED.
KLAKE@JMS.PL

ARTWORK BY FLEXN
WWW.FLEXN.DE
FLEXN@FLEXN.DE

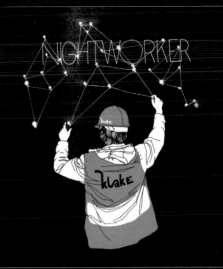

NIGHTWORKER

ONE DAY YOU'LL FIND HER TASTEST

GALAXY

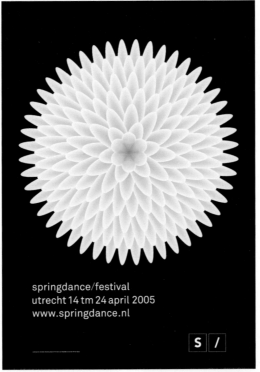

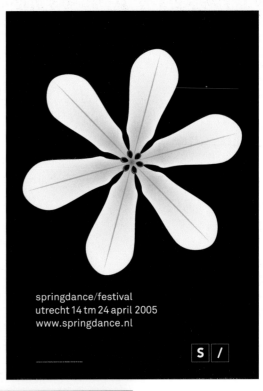

springdance/festival
utrecht 14 tm 24 april 2005
www.springdance.nl

springdance/festival
utrecht 14 tm 24 april 2005
www.springdance.nl

springdance/festival
utrecht 14 tm 24 april 2005
www.springdance.nl

(opposite page)
**1, 2**
**Flexn, Jakob Kanior**
CD Cover "Klake – Nightworker"
Client: Klake
Format: 12 x 12 cm

**3, 4, 5**
**Fichtre, Forbach Mathias**
Personal work, handdrawn

**1**
**Herman van Bostelen**
**with Kummer & Herrman**
Poster for Springdance Festival 2005
Client: Springdance
Format: 42 x 59.4 cm

**2**
**Fichtre, Forbach Mathias**
Personal work, handdrawn

FOTO
NOVÁ
SMR
ŠŤ

Katedra fotografie FAMU, Ateliér fotografie
VŠUP pod vedením Ivana Pinkavy
a Galerie Velryba si Vás dovolují pozvat na
zahájení výstavy Lukáše Prokůpka
a Kateřiny Bříčové
v úterý 03 04 2007 v 18 hodin,
Galerie Velryba, Opatovická 24, Praha 1
Výstava potrvá od 04 04 2007 do 05 05 2007
Otevřeno: po—pá 12—21 hod, so 11—21 hod

FOTO
NOVÁ
SMR
ŠŤ

FAMU, Department of Still Photography,
Academy of Arts and Design Prague
and Velryba Gallery would like
to invite you to the opening of the exhibition
of Lukáš Prokůpek and Kateřina Bříčová
PHOTON WHIRLWIND
on Tuesday, April 3, 2007 at 6 p.m.
Velryba Gallery, Opatovická 24, Prague 1.
The exhibition will last from April 5, 2007
to May 5, 2007
Open: Mo—Fri 12—21, Sa 11—21

FAMU

**1**
**Borsellino & Co., Piero Borsellino**
For the first issue of T4Xi Magazine the image of
a black tape was chosen to symbolize the power
of media
Photo: Karsten Handke
Client: T4XI Network.
Format: 21 x 27 cm

**2**
**Advance design, Petr Bosák,**
**Robert Jansa**
Every exhibition provides an opportunity to review
one's own work – it creates a cut in an artist's
career. Ornaments were used only for the sake of
refinement and to detract attention.
Poster for the exhibition of Lukás Prokupek.
Client: Lukás Prokupek / Academy of Art, Design
and Architecture in Prague
Format: 42 x 59.4 cm

**3**
**re-p, Nik Thoenen, Maia Gusberti,**
**Lorenz Tschopp**
Exhibition Poster Serigraphie.
Client: Künstlerhaus Wien
Format: 84.1 x 118.9 cm

**Ondrej Jób**
173kPa. The composition with Ribbon typeface (173)
and Papier typeface (kPa), crystal illustration and a
photograph
Format: 12 x 12 cm

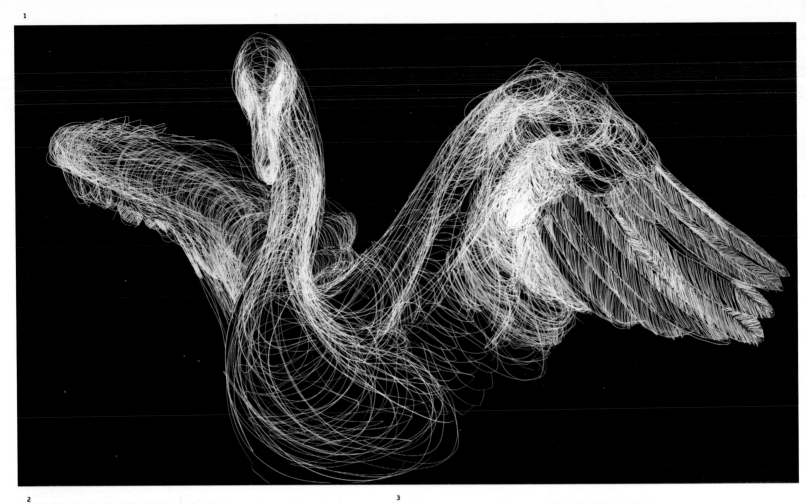

1

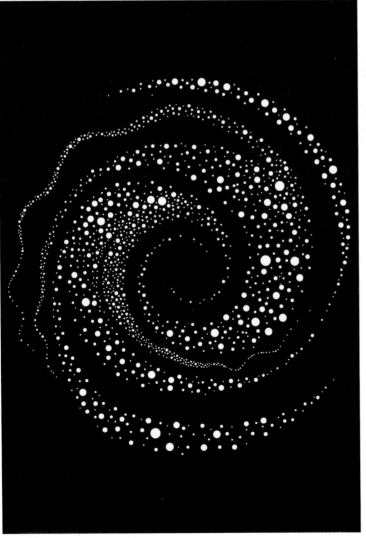

2

3

4

J'AI DANSÉ AVEC TOI,
SUR UN MORCEAU DE
HIP-HOP. SERRÉS, NOUS
NOUS SOMMES EMBRASSÉS.
LE MOMENT VIBRE EN MOI.
IL N`Y A RIEN DE PLUS BEAU.

**1**
**Marcus James**
Swan drawing backdrop for Camilla
Staerk show spring summer 2005,
Original drawing graphite pencil
on paper
Client: Camilla Staerk
Format: 12 x 5 m

**2**
**Rinzen**
Poster Design for Rinzen's
"In the Milky Night" exhibition
Format: 69 x 99 cm

**3, 4, 5**
**Fichtre, Forbach Mathias**
Personal work, handdrawn

(opposite page)
**1, 2**
**Madame Paris**
Poster-programmes, Le Bourg
Client: Le Bourg, Lausanne
Format: 66 x 51 cm

**3**
**ZIP Design,**
**David Bowden, Chrissie Abbott**
CD Album and single and promotional items
Illustration: Chrissie Abbott
Client: The Sanderson Pitch
Format: 12 x 12 cm

**4**
**Madame Paris**
Dandelions LP, digipack and CD
Client: Seychall-Mills
Format: 12.5 x 12.5 cm

**5**
**Mario Hugo, Loveworn**
A personal project inspired by textile designs

**Umbra + Dor,
Dieter Feseke,
Anja Kähler**
Poster for a
jazz concert
Photography:
Dagmar Gebers
Client: Deutsches
Theater Berlin
Format: 84 x 120 cm

JAZZ IN DER KAMMER
TRISTANO 317
AKI TAKASE
18. NOVEMBER 2001 · 23 UHR

D T

KAMMERSPIELE

Non-Format

**2**
**Jiminie Ha**
Poster for visiting critic,
Armand Mevis of
Mevis van Deursen.
Format: 60.96 x 91.31 cm

**3**
**Mario Hugo, Loveworn**
China ink stains masked into
Non-Format's geometric
typography creates something
almost celestial in nature –
the '68' mimicking the phases
of the moon
Geometric Typography by
Non-Format
Client: Hanne Hukkleberg /
Propeller Recordings

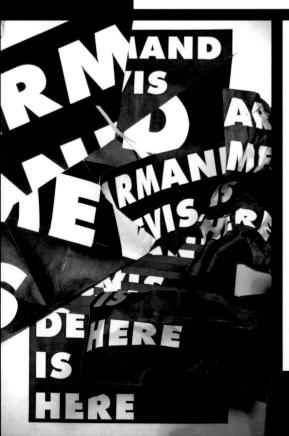

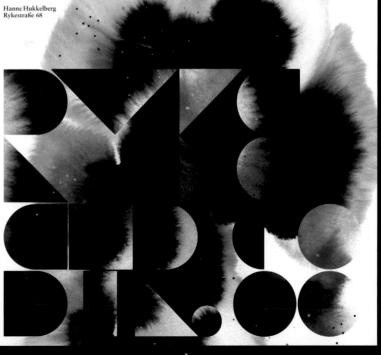

Hanne Hukkelberg
Rykestraße 68

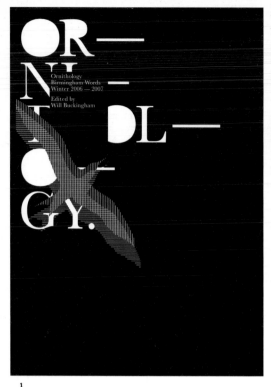

ORNI—TOL—OGY.

Ornithology
Birmingham Words
Winter 2006 — 2007

Edited by
Will Buckingham

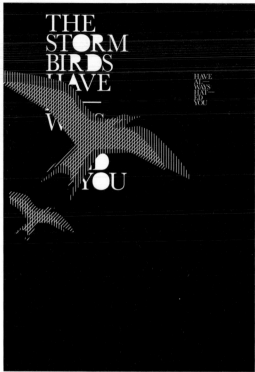

THE STORM BIRDS HAVE —W— —YOU

HAVE AL— WAYS HAT— ED YOU

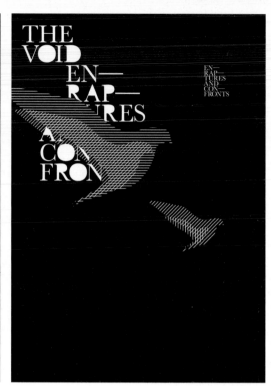

THE VOID EN— RAP— —RES A CON FRON

EN— RAP— TURES AND CON— FRONTS

1

2

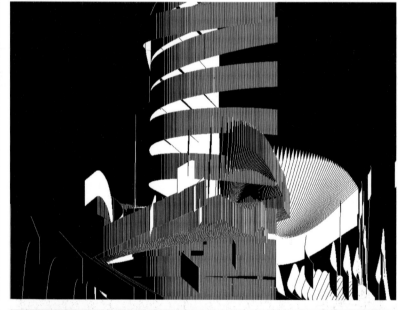

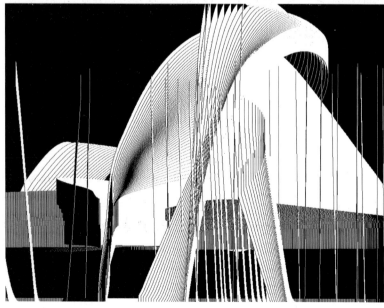

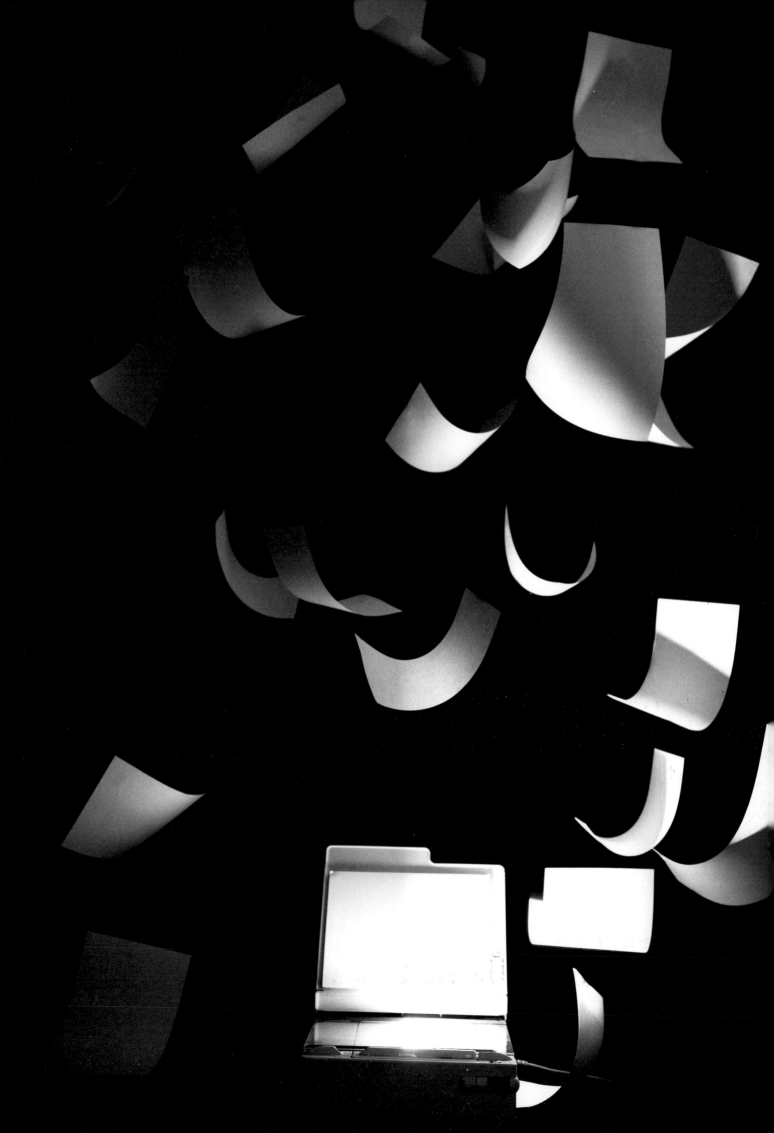

(opposite page)
**1**
**The Graphic**
**Aware,**
**Andy Rouse**
Publication
design for a
collection of
poetry based
on the theme
of 'Ornithology'.
Credit:
Will Buckingham
Client:
Birmingham
Words
Format:
21 x 29.7 cm

**2**
**LIA**
Online project:
ItsBlackItsWhite.
org
An interactive,
online
software-art
project
Format:
34.68 x 26.01 cm

**Petter**
**Törnqvist,**
**1:2:3**
Photo from
catalogue
for fashion
designer Emma
Borgström
Photography:
Annika
Aschberg
Client: Emma
Borgström

**1**
**Jiminie Ha**
"This Conversation …" poster,
Black and white laser prints, folded and scanned
Format: 56.44 x 74.59 cm

**2**
**Jiminie Ha**
"Check This Out" poster,
Black and white laser prints, folded and scanned
Format: 60.96 x 86.36 cm

**3**
**Jiminie Ha**
"Stitch" typeface inspired by a jacket
Format: 81.28 x 121.92 cm

(opposite page)
**round / Michaela Webb,**
**Ryan Ward, Suzy Tuxen, Kate Mansell**
"Now is New" exhibition poster

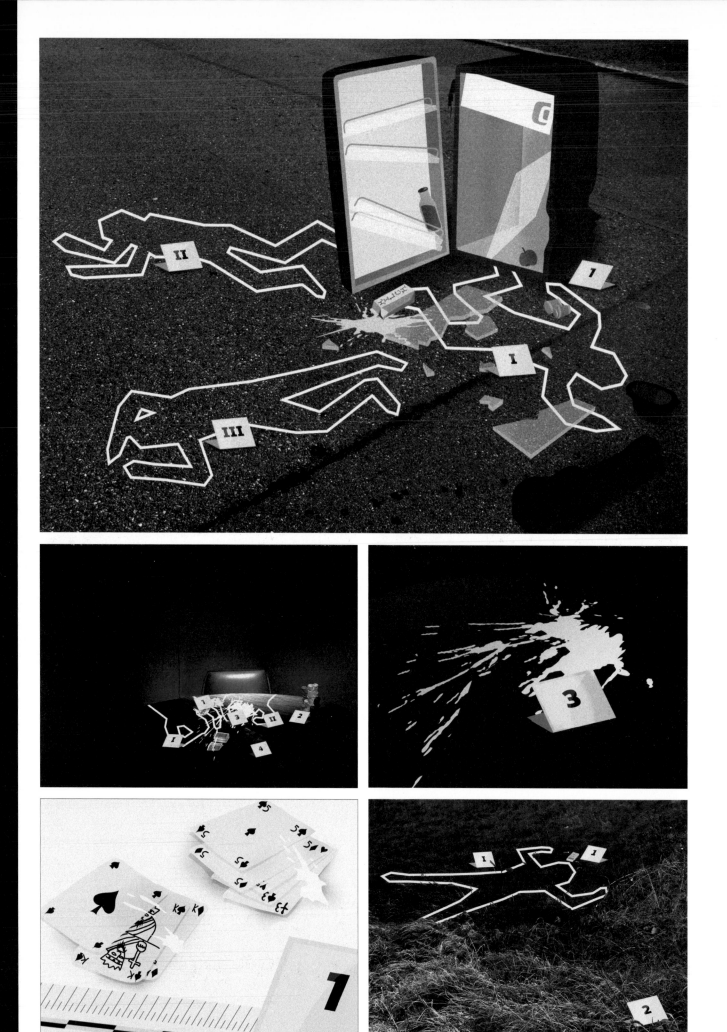

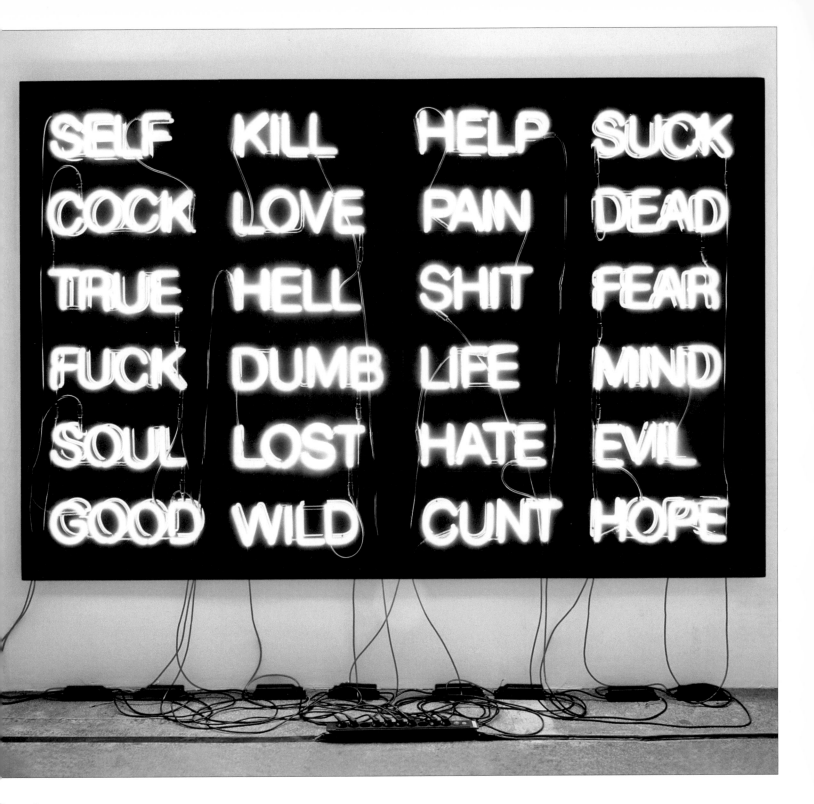

**Kasper Sonne**
"Four letter words"
Materials: neon, cords, converters, painted mdf
V1 Gallery

(opposite page)
**Christina Baeriswyl**
"The killer in me is the killer in you";
These photographs are the key to the
solution of the riddle.

253

**Bernd Preiml**

(opposite page)
**Christian
Riis Ruggaber**
Untitled I-III,
[RAL 6005], 2005, C-Print

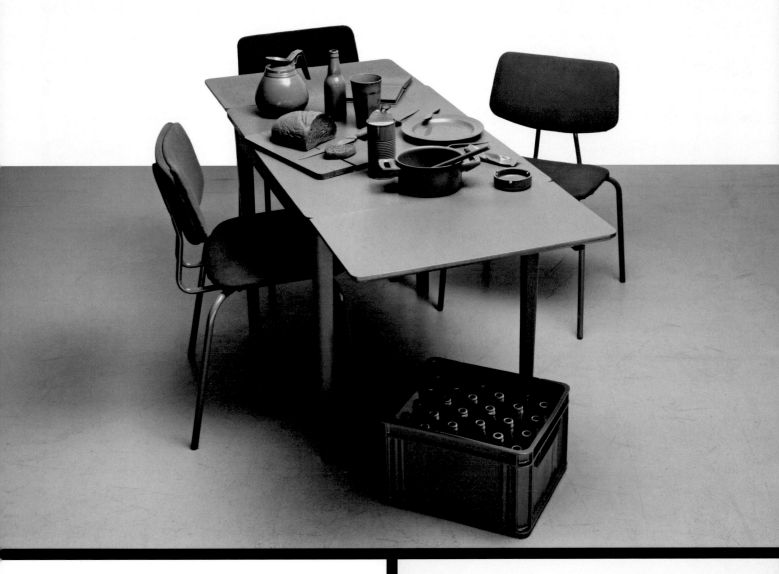

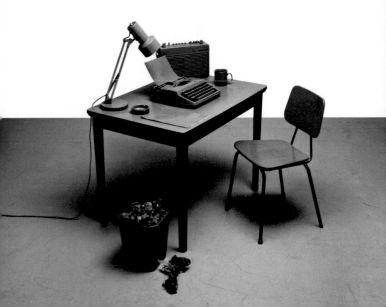

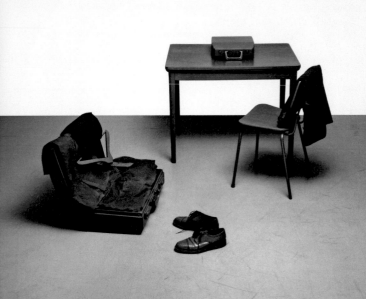

**Discodoener,**
**Marcus Fischer**
Client: Fischercasting
Credit: Lilly / BrodyModels
Format: 60 x 45 cm

(opposite page)
**Fulguro,**
**Yves Fidalgo, Cédric**
**Decroux**
Contribution for
"Local Studies", book on
Joël Tettamanti, photographer
Client: etc publications

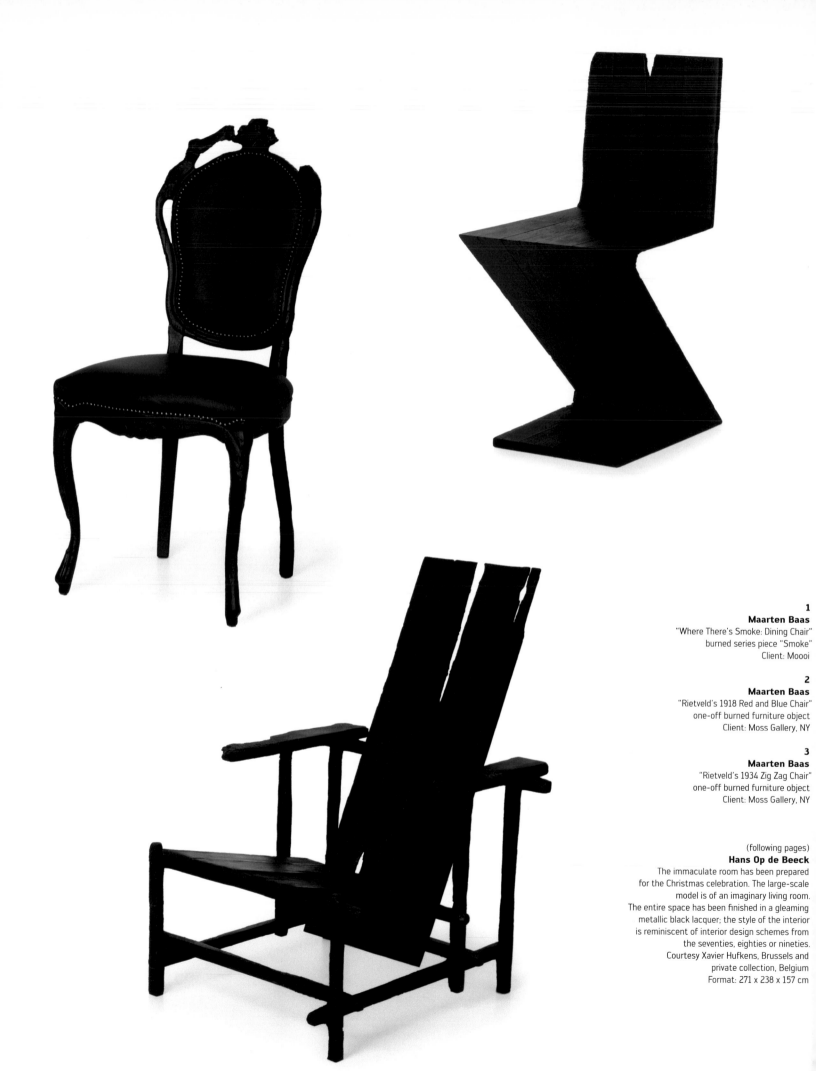

**1**
**Maarten Baas**
"Where There's Smoke: Dining Chair"
burned series piece "Smoke"
Client: Moooi

**2**
**Maarten Baas**
"Rietveld's 1918 Red and Blue Chair"
one-off burned furniture object
Client: Moss Gallery, NY

**3**
**Maarten Baas**
"Rietveld's 1934 Zig Zag Chair"
one-off burned furniture object
Client: Moss Gallery, NY

(following pages)
**Hans Op de Beeck**
The immaculate room has been prepared
for the Christmas celebration. The large-scale
model is of an imaginary living room.
The entire space has been finished in a gleaming
metallic black lacquer; the style of the interior
is reminiscent of interior design schemes from
the seventies, eighties or nineties.
Courtesy Xavier Hufkens, Brussels and
private collection, Belgium
Format: 271 x 238 x 157 cm

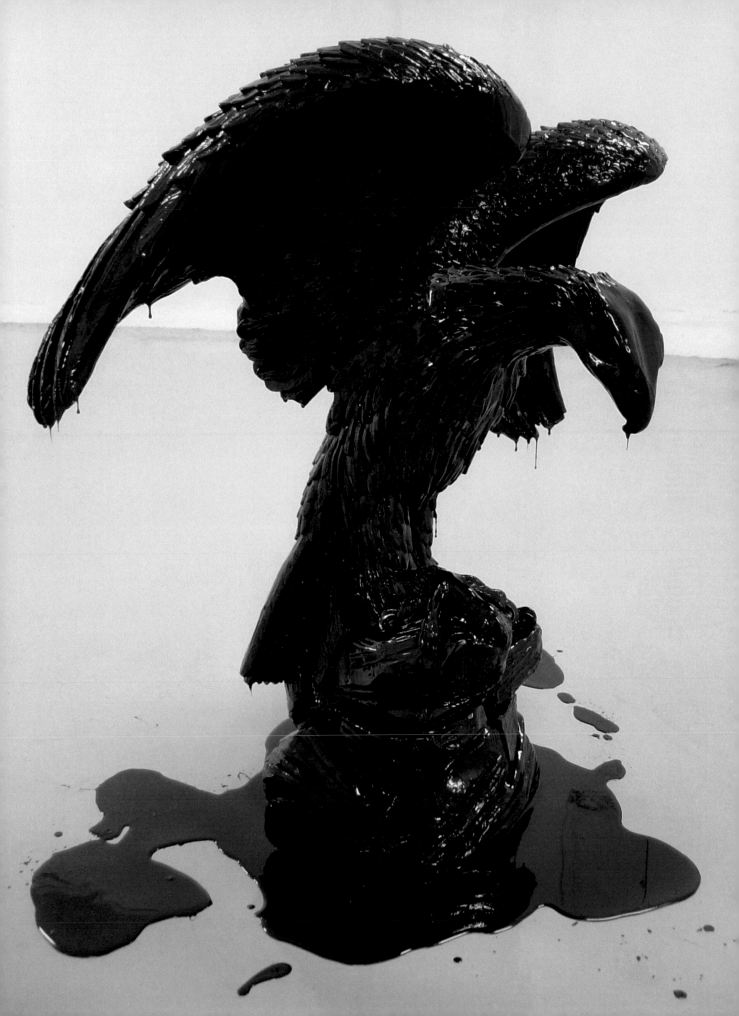

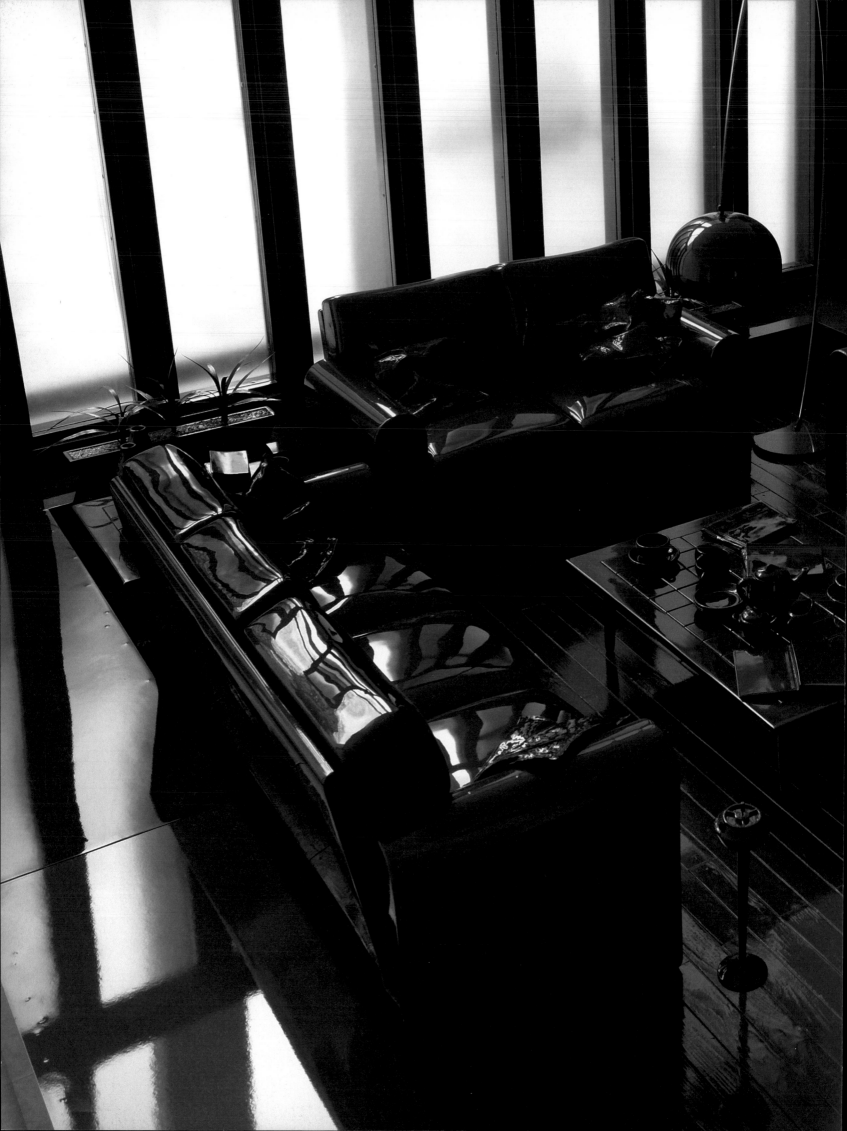

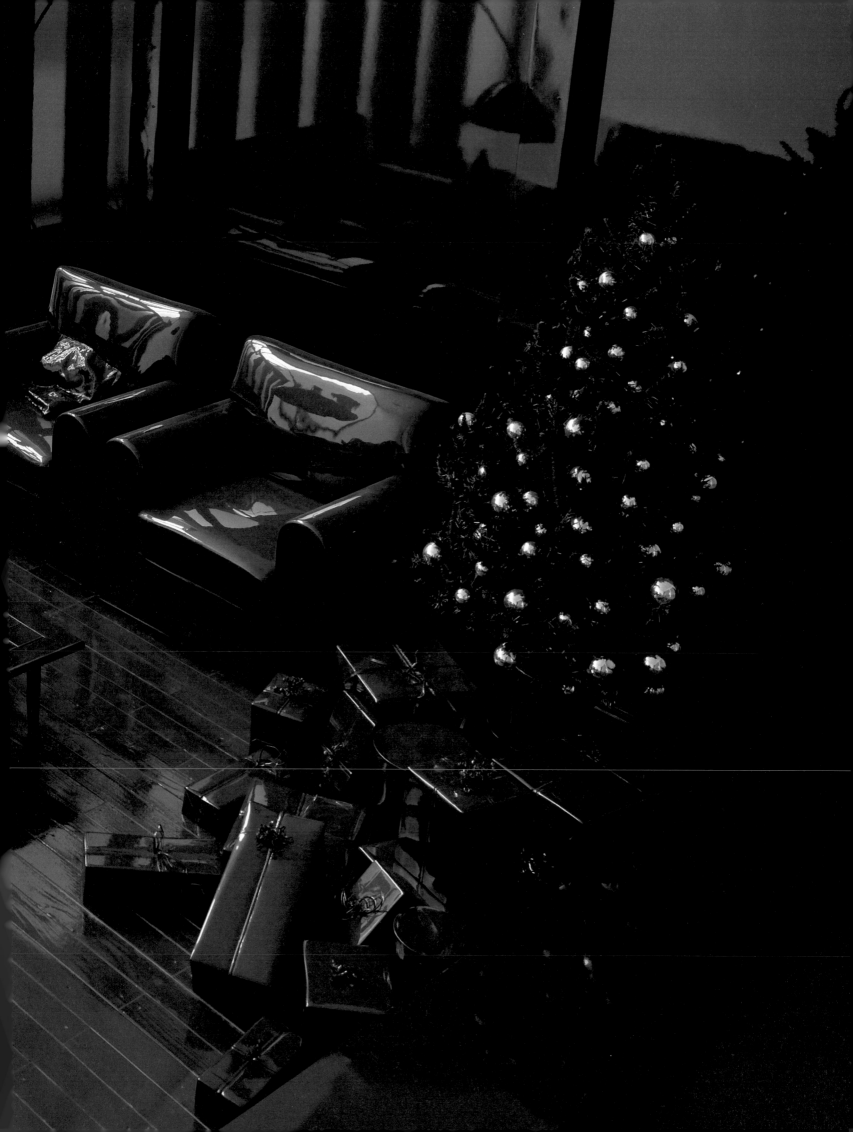

# White

## "White is so (in)essential, that it has never really gone out of style."

The endless struggle for white wash; the snow that gets trampled on and filthied right after it falls; the festively set dining table covered in white linen, which is governed by chaos and gummy leftovers after the feast; our soul, whose blossom-pure, childlike innocence is eaten away by dark stains over the course of a lifetime. White is a nearly superhuman colour, an ideal that is hard to come by and even harder to hold. It is the colour of perishability, emptiness and vagueness (that's why it is readily used by cheap, generic brands). But it also signifies luxury, because it is characteristic of dealing extravagantly with space and for social circles where one doesn't get one's hands dirty (and is therefore willingly used by high-end cosmetic brands).

White is so (in)essential, that it has never really gone out of style. But presently, a particularly powerful white wave is rolling in, which is making itself – in part, asynchronously – noticeable in fashion, product, interior and graphic design. Last year, fashion designers once again declared white to be the season's trend colour. Dior even presented white suitcases – surely highly practical for VIPs. More interesting is the longer-term implementation of white in entertainment electronics. The masculine, still very mechanical appearance of black in the nineties was followed by the more androgynous, technical silver, which represents the mainstream in today's media markets. In contrast, iPod-white represented the avant-garde. The little white earplugs became the badge for the pioneers of the global-digital lifestyle, for the slick technology, which is seamlessly integrated in the lives of its users. Now, Apple has bid farewell to white. The new products are in aluminium or black, matching the iPhone. After bondie blue and white, is Apple bringing back black as the next cult colour?

At automobile trade fairs, white has really only just arrived and the most sensational innovations were presented in white in 2007. New high-tech varnishes and pigments, sparkly or pearl finishes, golden sheen, silk-matt or mirror surfaces are being implemented – preferably in combination. Fair visitors report on haptic experiences and their desire to stroke the vehicles.

Can one even speak about white as a fashion colour in the print world? In any case, following the complex or even chaotic layouts a la David Carson, tranquillity and order have already been restored there some years ago, and with them – at least in the more sophisticated publications – the clear white space. Usability is also the great ideal of Web 2.0 design; consequently, white backgrounds and the generous handling of space that suit large, legible fonts are prevalent.

Today's greatest luxury is being relieved of information overkill and general overstimulation. White space in media arranges for that, just as the white rooms in interior design do. That's why luxury boutiques and design hotels willingly celebrate themselves as expensive oases of simplicity – a currently much sworn upon catchphrase. The longing for clarity in confusing times, for emptiness in a world that is bursting at the seams enables white to unfold its healing powers even in wellness areas. But at the same time, an overly antiseptic cleanness has its threatening components: take, for instance, fully automated production plants, where machines produce machines. The white rooms that are currently so cool foreshadow a future where the thing-world achieves such perfection that it no longer needs humans. Indeed, where they are an interfering factor.

Text by **Claudia Gerdes**

Claudia Gerdes is a freelance author and editor of the design magazine PAGE. She lives and works in Hamburg.

**Kasper Sonne**
"Nine Letter Words"
Materials: PVC, vinyl with print
Client: V1 Gallery
Format: 5.75 x 5.75 x 5.75 cm

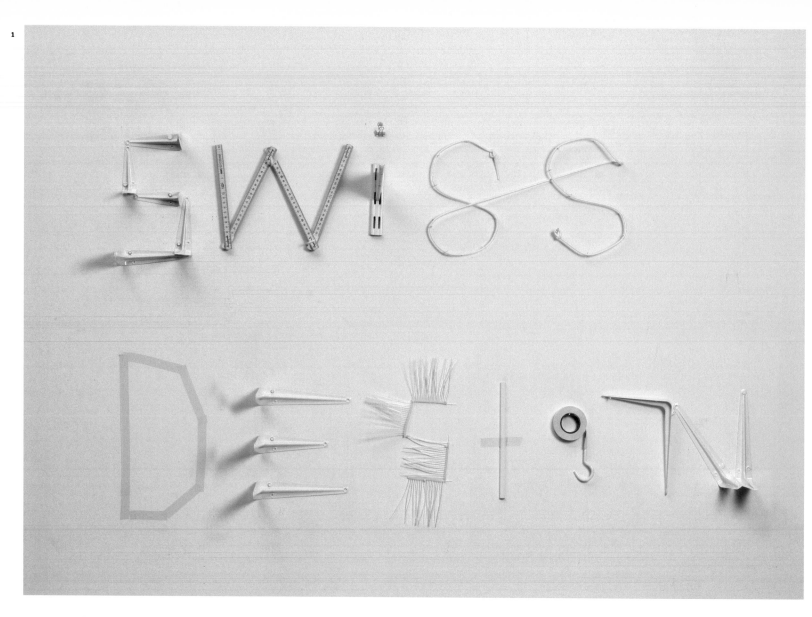

**1**
**Fulguro, Yves Fidalgo / Cédric Decroux**
Research for the exhibition design
"Swiss Federal Design Competition 2007"
Photo: Fulguro
Client: Swiss Office for Culture

**2**
**Airside**
A joint venture project with EMI Music to produce screenprints of famous song lyrics they hold the rights to. Each design is hand screenprinted at K2 onto thick art paper, and signed and numbered.
Client: Airside / EMI Music Publishing
Format: 70 x 100 cm

**3**
**Studio Thomson**
Invite inspired by the collections main influences which were Louis XIV and the film "2001 – A Space Odyssey"
Client: Preen by Thornton Bregazzi
Format: 21 x 14.85 cm

**1, 2, 3**
**Fulguro,**
**Yves Fidalgo /**
**Cédric Decroux**
Research for the exhibition
design "Swiss Federal
Design Competition 2007"
Photo: Fulguro
Client: Swiss Office for
Culture

**4**
**Dani Navarro**
Client: Mercè Amat
Format: 11 cm

**5**
**Kasper Sonne**
Title: Once remembered,
twice forgotten
Materials: Inkjet print
on paper (longevity
approximately 100 years),
framed
V1 Gallery
Format: 21 x 29.7 cm,
40.9 x 31 cm framed

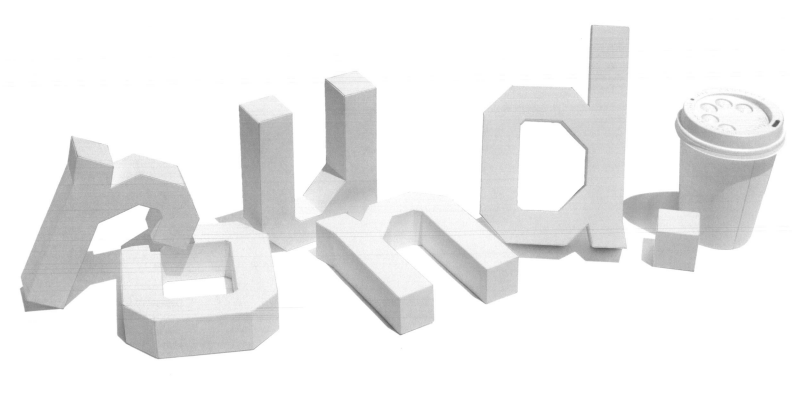

**round / Michaela Webb,
Ryan Ward, Suzy Tuxen**
Typeface and identity designed
for the studio
Photography: Paul Barbera

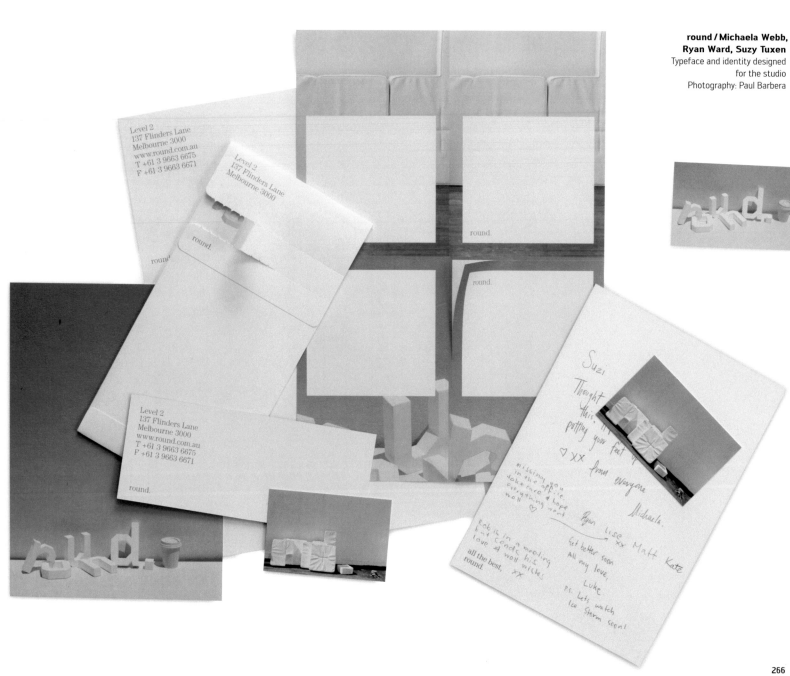

266

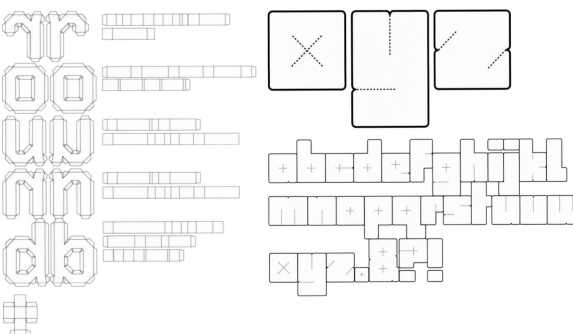

**round / Michaela Webb,
Ryan Ward, Suzy Tuxen**
Typeface and identity designed
for the studio
Photography: Paul Barbera

**Heine / Lenz / Zizka**
iPray

1

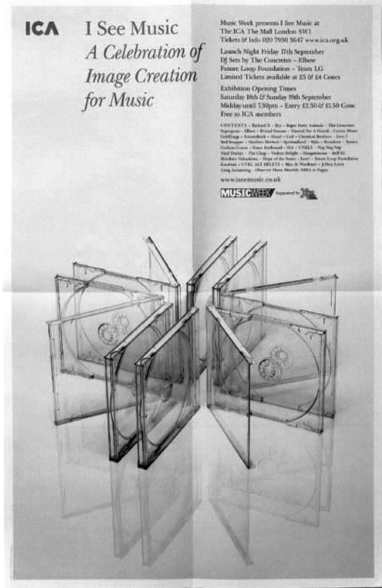

2

3

**1, 2**
**Studio Thomson**
Campaign to advertise the best in music
packaging design. CD and DVD cases
photographed on perspex
Photography: Lewis Mulatero
Client: Ballistic
Format: 42 x 59.4 cm

**3**
**Augustin Scott de Martinville,**
**Adrien Rovero**
Swarovski Crystal Tape, Prototype
© ECAL

1

4

3

2

**1**
**Christian Riis Ruggaber**
untitled I, [Albula], C-Print

**2**
**Christian Riis Ruggaber**
untitled II, [Albula], C-Print

**3**
**Christian Riis Ruggaber**
untitled III, [Albula], C-Print

**4**
**Christian Riis Ruggaber**
untitled, [SIG], C-Print
Client: SIG Visual Language

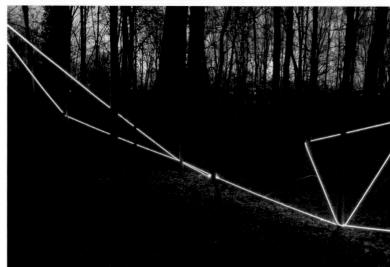

**Martin Hesselmeier**
Space Lines
Four-part photographic work
Lambda prints on di-bond
This series of exposures consisting of four images succesively
immerse the viewer in a new manner of perceiving the structure of
space. The components of the exposure time shift spatial
perception within one and the same image. Thus the structure of
the space is redefined by the lines.
Format: 50 x 70 cm

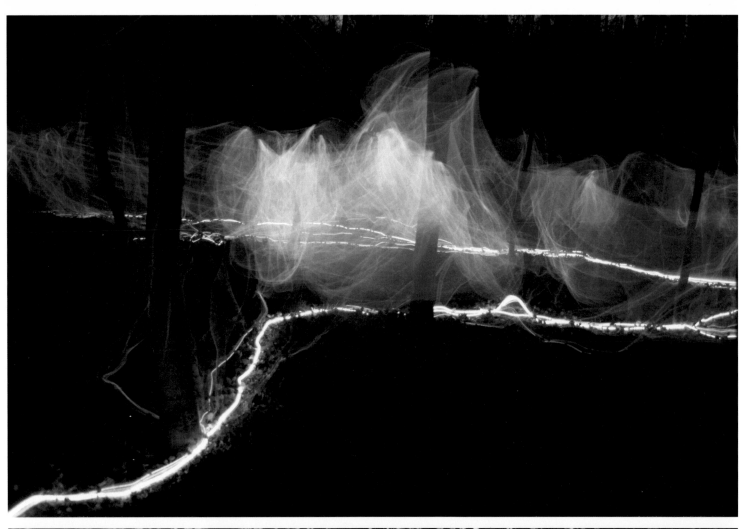

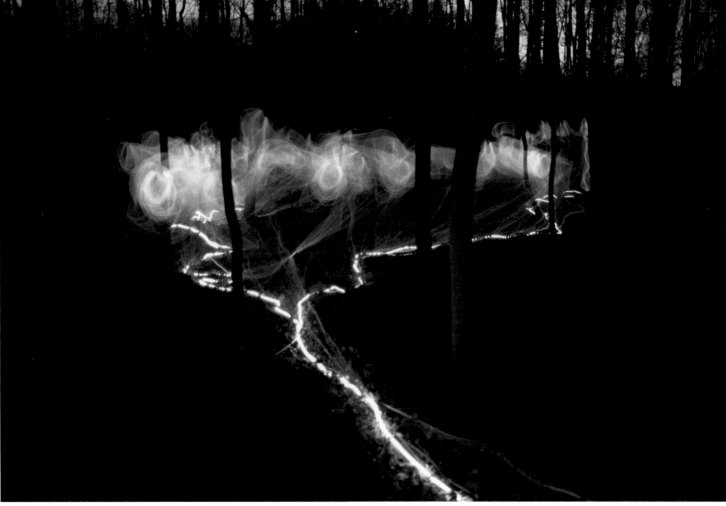

**Burdifilek**
Holt Renfrew Personal Shopping Suites
Photographer: Ben Rahn / A Frame
Client: Holt Renfrew

(opposite page)
**Burdifilek**
Holt Renfrew Designer Collection Floor
Photographer: Ben Rahn / A Frame
Client: Holt Renfrew

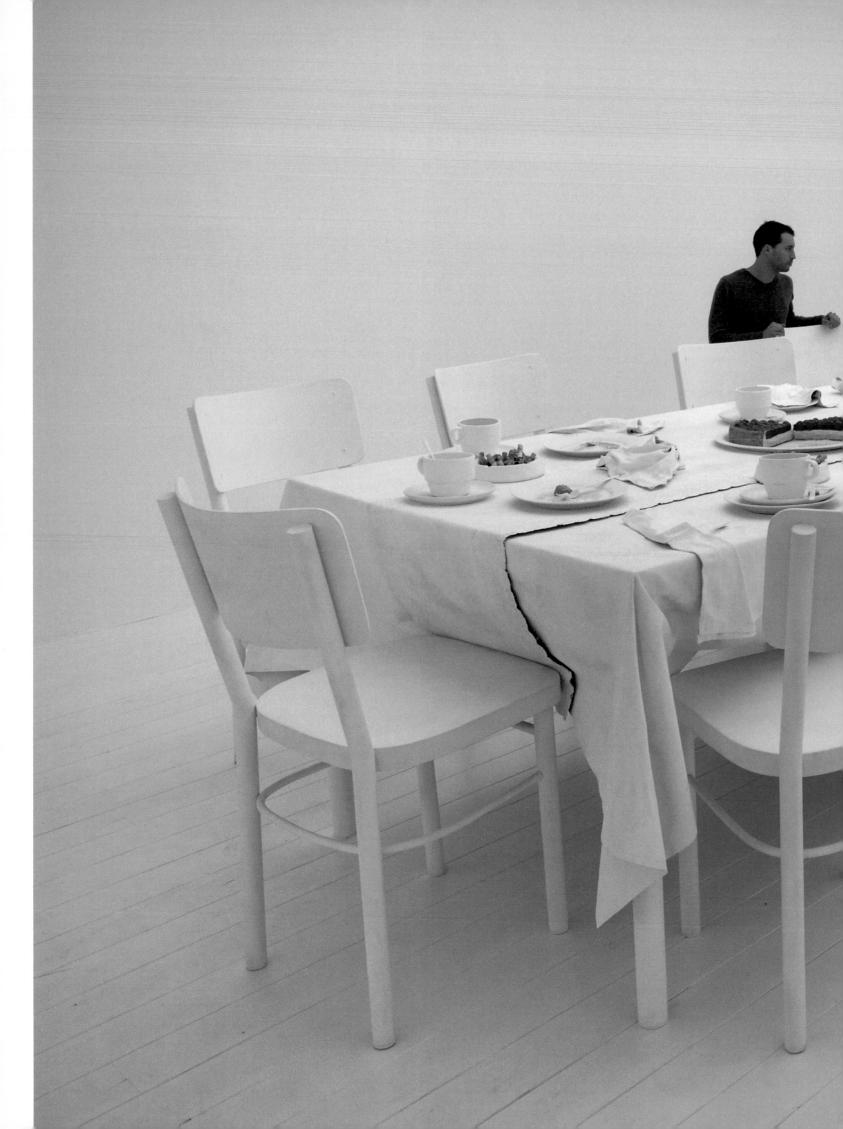

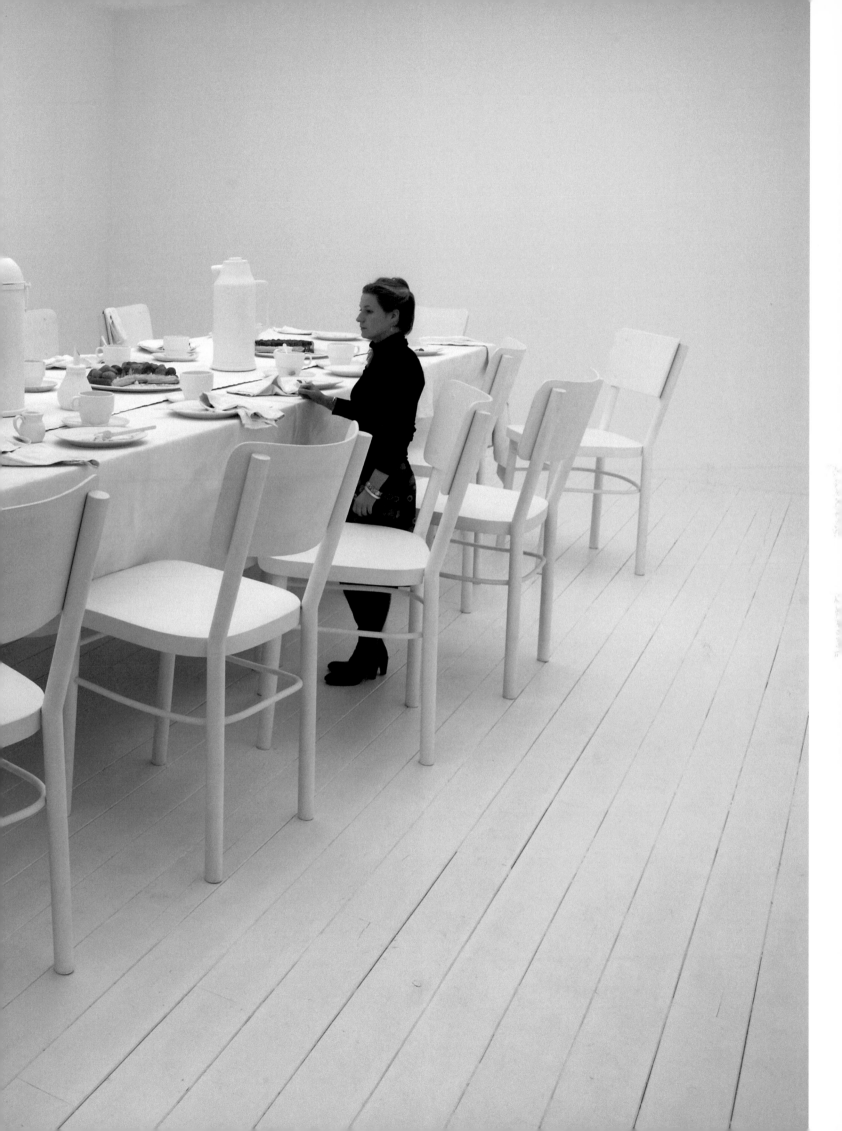

**Fulguro,**
**Yves Fidalgo / Cédric Decroux**
Research for the exhibition design
"Swiss Federal Design Competition 2007"
Photo: Fulguro
Client: Swiss Office for Culture

(previous pages)
**Hans Op de beeck**
The sculptural installation of an abandoned
table setting has been built to the scale of
1.5:1, thus shrinking the spectator to the
average height of a seven-year old child.
The entire work is immaculately painted
white in contrast to the remnants of cake,
coffee, and cigarettes, which have been
crafted in detail to look hyper-real. The
overall effect makes the whole setting
resemble a memory or dream image.
Courtesy Xavier Hufkens, Brussels, Galerie
Krinzinger, Vienna, Galerie Ron Mandos,
Amsterdam and private collection, Korea
Format: 300 x 800 x 170 cm

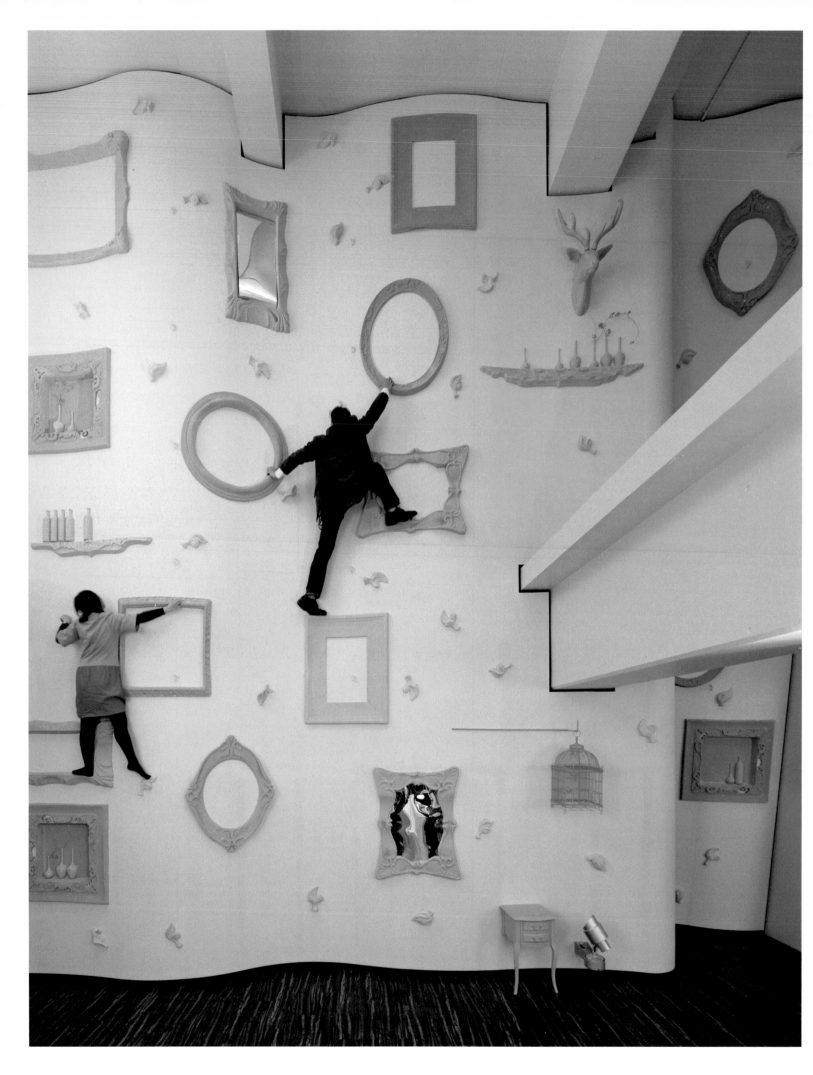

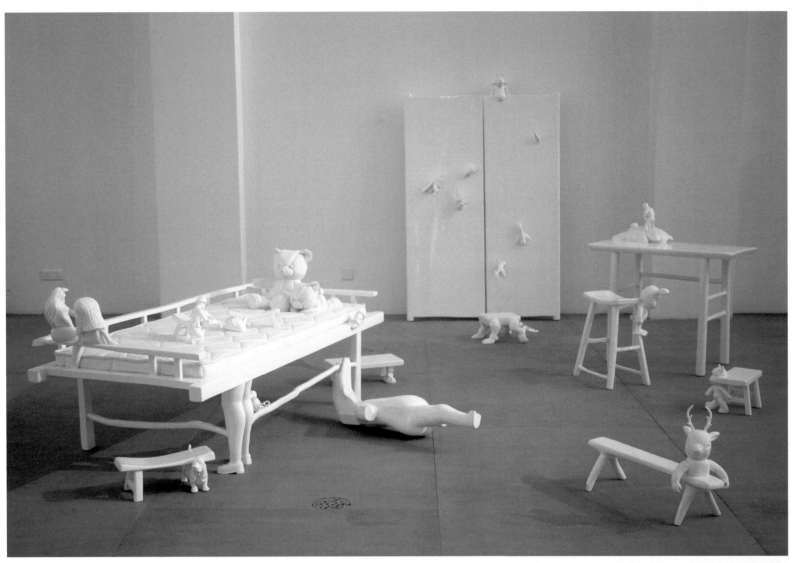

**1**
**WOKmedia,**
**Julie Mathias and Wolfgang Kaeppner**
New versions of our Made in China series of
furniture.

**2**
**WOKmedia,**
**Julie Mathias and Wolfgang Kaeppner**
BOO-HOO (stool)
Format: 19 x 25 x 50 cm

**3**
**WOKmedia,**
**Julie Mathias and Wolfgang Kaeppner**
ZZZ (stool) and SNAP (table)

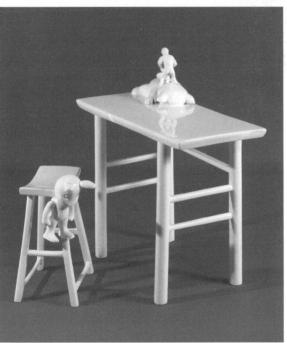

**4**
**WOKmedia,**
**Julie Mathias and Wolfgang Kaeppner**
BOW-WOW (stool)
Format: 19 x 25 x 50 cm

(opposite page)
**Nendo: Oki Sato**
Illoiha Omotesand
© Daici Ano

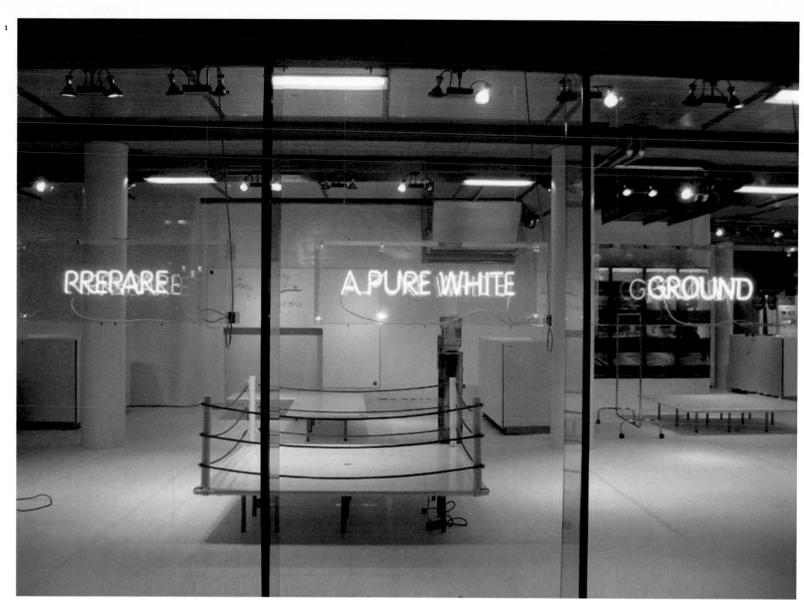

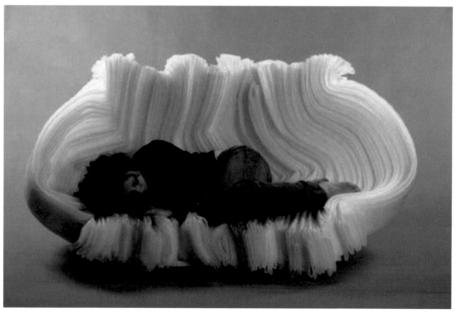

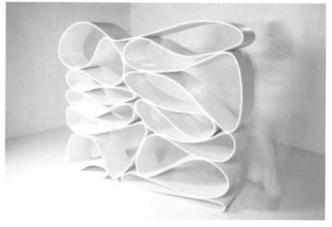

**1**
**Newskooldisplay™**
Production: Cookies
adidas Originals Store Berlin

**2**
**Edouard Simoëns**
Photography: Milamem Abderamane-Dillah

**3**
**Luca Nichetto**
"Neverending "
Photography: Sabine Schweigert
Client: Andreoli
Format: 200 x 170 x 38 cm

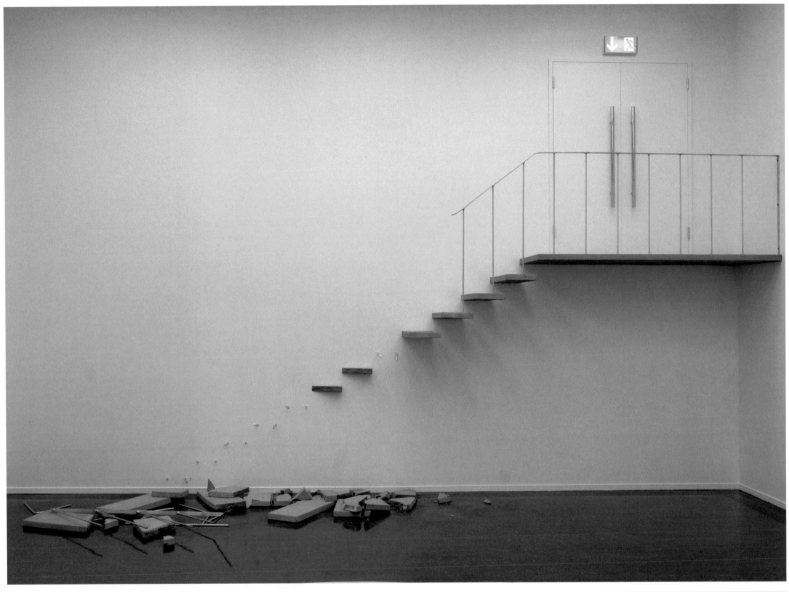

**1**
**Elmgreen & Dragset**
"Social mobility Fig. 1" (administration)
Aluminium, wood, isopor, iron, concrete
Exhibited at: "The Welfare Show",
Bergen Kunsthall
Photography: Thor Brødreskift
Format: 430 x 700 x 200 cm

**2**
**Elmgreen & Dragset**
"Taking Place"
Site specific project
Exhibited at: Kunsthalle Zürich
Photography: Carla Åhlander / Burkhard Meltzer

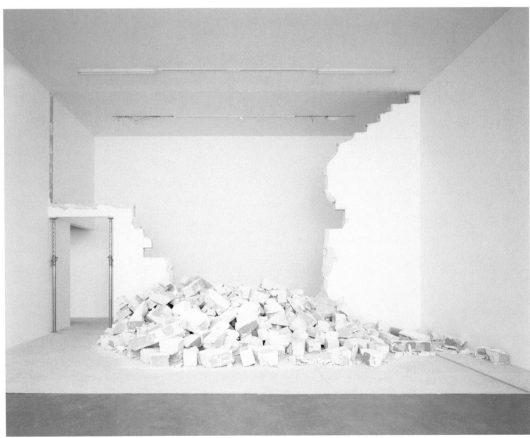

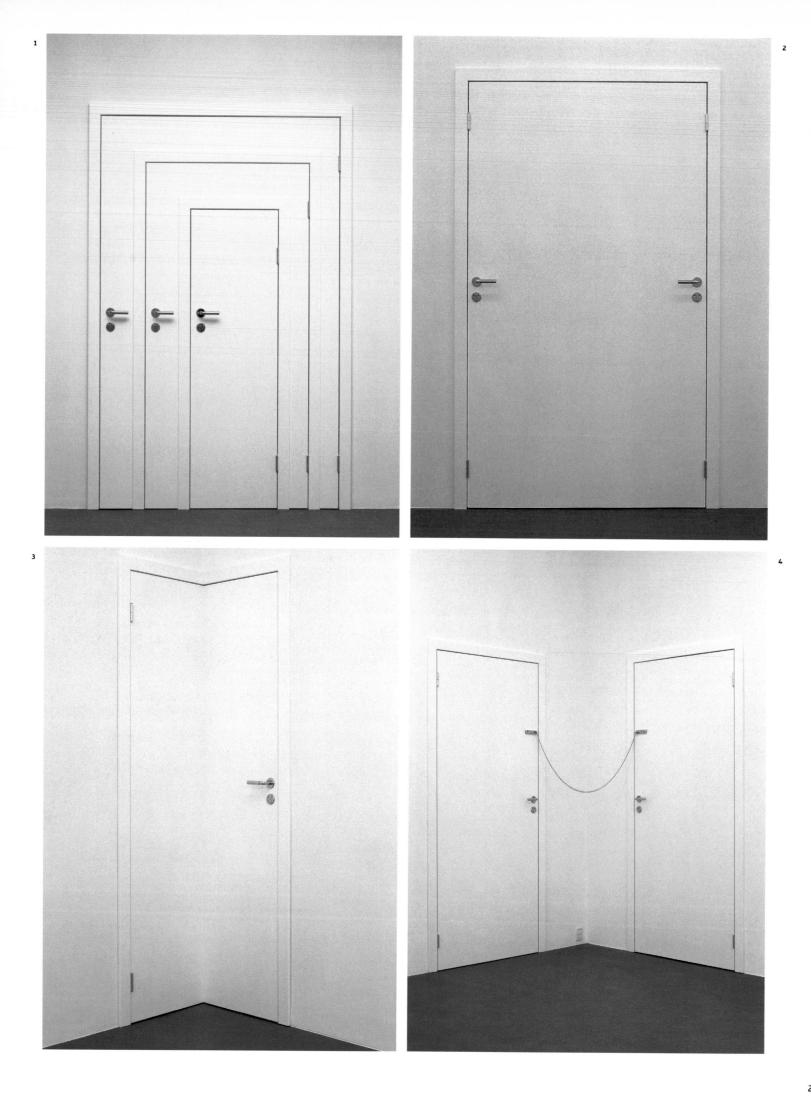

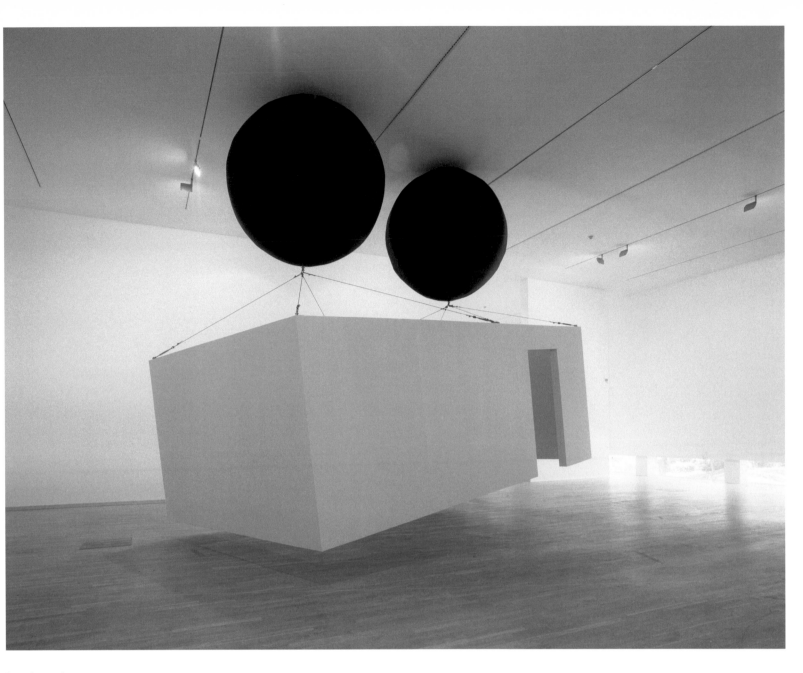

(opposite page)

**1**
**Elmgreen & Dragset**
"Powerless Structures, Fig. 133"
Wood, paint, door handles
Courtesy: Galleri Nicolai Wallner
Photography: Bent Ryberg
Dimensions: ca. 217.5 x 146.8 cm

**2**
**Elmgreen & Dragset**
"Powerless Structures, Fig. 123"
Wood, paint, hinges, door handles, key holes
Exhibited at: Art Forum Berlin, 2000;
Galleri Nicolai Wallner, 2001;
Centre for Architecture, Rotterdam, 2002
Courtesy: Galleri Nicolai Wallner,
Photography: Bent Ryberg
Format: 217.5 x 133.5 cm

**3**
**Elmgreen & Dragset**
"Powerless Structures, Fig 129"
MDF, wood, paint, door handle
Exhibited at: Galleri Nicolai Wallner, 2001;
Pontevedra Biennale, 2002
Courtesy: Galleri Nicolai Wallner,
Photography: Bent Ryberg
Format: 217.5 x 57 x 57 cm

**4**
**Elmgreen & Dragset**
"Powerless Structures, Fig. 122"
Two fake doors cornered, with safety chain
leading from one door to another
Wood, door handles, hinges, safety locks, chain
Exhibited at: "The works shown in this space…",
Neugerriemschneider, Berlin 2000;
Galleri Nicolai Wallner, 2001
Courtesy: Galleri Nicolai Wallner,
Photography: Neugerriemschneider
Format: each door 217.5 x 103.5 cm

**Elmgreen & Dragset**
"Elevated Gallery/Powerless Structures, Fig. 146"
wood, paint, cables, vinyl, office, furniture
Exhibited at: „A Space Defined by its own Accessibility"
Statens Museum for Kunst, Copenhagen, 2001;
Hamburger Bahnhof, Berlin, 2003
Courtesy: Galerie Klosterfelde,
Photography: SMK Foto / Andreas Szlavik
Format: 530 x 575 x 340 cm

**Limadeltaromeo,
LDR, Lorenz Tschopp, Dorian Minnig, Reto Bürkli**
"Anthology in White" is a collection of photography
dealing with the use of white. The work is an
examination of the colour white at moments of transition
referred to in such phrases as "to whitewash"
or "tabula rasa" (a blank slate). Here, white
does not indicate the unknown, but rather stands
for something that hasn't been formulated
yet or can't be described exactly.

# Special Colours

## Special colours for the sake of effect.

I was asked to write a short text about special colours. What are special colours? Fluorescent colours, silver, gold and white. I use them a lot in my work. Why do I do that? Maybe it's just for the sake of effect. To make my work look more precious. The glitter throws dust in the viewers' eyes to hide the weak ideas behind the work. It's my only chance of survival.

But maybe there is another reason... I like the alchemy of the printing process. Not knowing the exact outcome of overprinted layers of ink makes the design process more exciting. The use of special colours contributes to this excitement: one ink can glance off the other, they can be extremely covering or translucent.

I make my documents on the computer in separate layers, and I choose the colours just before printing. I am always tempted to choose new combinations which I cannot predict.

Graphic designers produce "printed matter". The use of special colours emphasizes the materiality of the printed work. They are "not from this world". They do not disappear in the design work; they are shouting for attention. The special colours assist me with my goal to produce work that is not referring to something else and they take over completely. Actually, it's still for the sake of effect.

It's cheap. I am a poor designer.

Text by **Richard Niessen**

Richard Niessen graduated from the Gerrit Rietveld Academy in Amsterdam in 1996. He has mostly worked alone, but from 1999 to 2002 he worked with designer Harmen Liemburg under the name "GoldenMasters". Niessen is also a musician, and designed the packaging, typography and artwork for each of the albums by his band the Howtoplays. Inspired by the likes of Ettore Sottsass (founder of the Memphis group) and the Scottish-Italian sculptor Eduardo Paolozzi, artists who similarly seek out the tension between structure and going overboard, Niessen developed his own systematic approach to design. He chose the name Typographic Masonry (TM) in 2002, after hearing the term used to describe the work of one of his major influences, Dutch designer and architect Hendrik Th. Wijdeveld. www.tm-online.nl

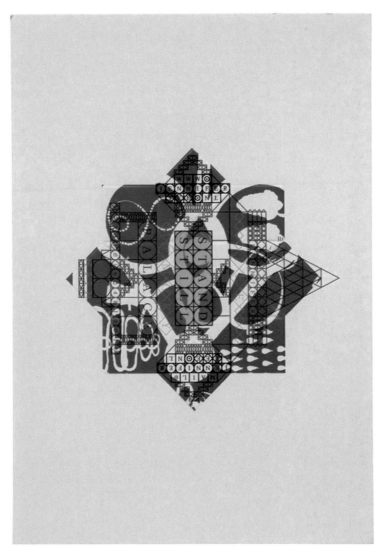

**Richard Niessen / TM**
Arabesque stationeries
for Jennifer Tee

1

2

1
**Jannetje in't Veld, Toon Koehorst**
Client: Frame magazine
Format: 23 x 29.7 cm

2
**Studio Laucke**
The Colour Envelope
Wooden stirrers in the original paint colours
Client: Akzo Nobel Decorative Coatings
Format: 19 x 24 cm

**Studio Laucke / Dirk Laucke, Marc Karpstein**
The Colour Envelope
Annual book about colour trends
Poster featuring original paint colours
Client: Akzo Nobel Decorative Coatings
Format: book 18 x 24 cm, poster 59.4 x 84.1 cm

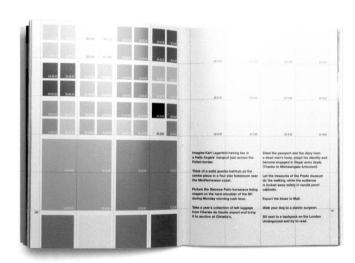

**Koeweiden Postma**
Annual report for the Ramadan Festival 2006.
Photography: Leonard Faustle and Leo Erken
Client: Stichting Samenbinding / Mexit
Format: 24 x 30 cm

(opposite page)
**Mint**
**Collective of independent designers**
Prospectus for the Zwolle Academy of the Arts.
The book is printed in black and one colour.
By using a special printing technique populair
in the sixties, in which different colored inks
are mixed on the press, a unpredictable and
coulourfull endresult is created.
Client: CABK
Format: 16 x 23 cm

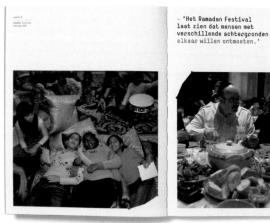

1

(opposite page)
**Christen Visuelle Gestaltung /
Andrea Züllig, Susanne Egli**
Design for the monthly programme overview
One huge colour gradient embraces
the whole season
Client: TMGZ
Theater und Musikgesellschaft Zug
Format: 89.5 x 128 cm

1

1

1

**1**

**Hans Gremmen**
Zeeuws Imago
"Zeeuws Imago" is a compelation of essays about
the identity of Zeeland; a province in the south-west
of the Netherlands. The essays are structured in
four different topics. Every topic has its own colour.
The book is bound in Japanese style and the colours
are printed on the inside of the paper.
Client: Zeeuws Museum
Format: 15 x 21 cm

**2**

**Hans Gremmen**
Book Hotel Maria
Hotel Mariakapel is an exhibition space wich invites
artists to work in residence on a project wich can
result in a exhibition. The "Book Hotel Maria" is
a reversed timeline about the history of Hotel
Mariakapel. It contains overviews of all projects and
exhibitions shown between 2006 and 2003.
The cover shows the logo of Hotel Mariakapel:
a flag wich is based on the traditional maritime flag
of the Netherlands, but then printed in anarchistic
colours.
Client: Hotel Mariakapel
Format: 16 x 22 cm

2

**Poster 1**

15./16.09.06 | 20.00 h Theater Casino Zug
# MUMMENSCHANZ
«3 x 1!» – RETROSPEKTIVE AUF 33 JAHRE

29.09.06 | 20.00h Theater Casino Zug
# DANCING MAN
SARDAR DANSETEATER – MUSICAL HOMMAGE AN BOB FOSSE

28.10.06 | 20.00 h Theater Casino Zug
# MOZART GMBH
MOZART WERKE GMBH – FRANZ WITTENBRINK – THEATER ESSEN / EURO STUDIO

22.09.06 | 20.00 h Theater Casino Zug | 24.09.06 | 10.30h Theater Casino Zug
HARMONIE UND DISSONANZ | DESPONDS / DOBLER
CHOR- UND SINFONIEKONZERT «SCHÖNBERG UND SEINE LEHRER» | APERITIVO – JAHRESZEITEN IN JAZZ

05.10.06 | 19.30 h Theater Casino Zug
MOTION TRIO | SENIORENORCHESTER LUZERN
SCHWIIZER CHUCHI GOES GLOBAL | MUSIKALISCHER BILDERBOGEN – JOSEF MEIER / DIRIGENT

24.10.06 | 20.00 h Theater Casino Zug
DER RAUB DER SABINERINNEN | DJANGO ASÜL
MIT ALEXANDER MAY ALS THEATERDIREKTOR STRIESE | HARDLINER – SOLO COMEDY

WWW.TMGZ.CH
Zuger Kantonalbank Hauptsponsor
tmgz

**Poster 2**

01.11.06 | 17.00h Theater Casino Zug
# SCHERBAKOV
KONSTANTIN SCHERBAKOV (KLAVIER) – GEDENKTAGE MOZART / SCHOSTAKOWITSCH / SCHUMANN

09.11.06 | 20.00 h Theater Casino Zug
# MOSKAUER OPER
DIE LUSTIGEN WEIBER VON WINDSOR – MOSKAUER KAMMEROPER

02.11.06 | 20.00 h Theater Casino Zug
# DOLDINGER
KLAUS DOLDINGER'S PASSPORT – 70TH BIRTHDAY

24.10.06 | 20.00 h Theater Casino Zug | 05.11.06 | 17.00h Theater Casino Zug
DER RAUB DER SABINERINNEN | KEISER & LÄUBLI
MIT ALEXANDER MAY ALS THEATERDIREKTOR STRIESE | 101 TEXTE AUS 40 JAHREN CABARET

26.10.06 | 20.00h Theater Casino Zug | 07.11.06 | 20.00h Maria Opferung Zug
DJANGO ASÜL | SCHNEEBERGER / DÜNKI
HARDLINER – SOLO COMEDY | RÉSONANCE – MOZART / SCHUBERT / SCHUMANN

28.10.06 | 20.00 h Theater Casino Zug | 24.10.06 | 15.00 h Theater Casino Zug
MOZART WERKE GMBH | SENIORENORCHESTER
FRANZ WITTENBRINK – THEATER ESSEN / EURO STUDIO | LUZERN – MUSIKALISCHER BILDERBOGEN

www.tmgz.ch
Zuger Kantonalbank Hauptsponsor
tmgz

**Poster 3**

16./17./18.11.06 | 20.00h Theater Casino Zug
# URSUS & NADESCHKIN
«WELTREKORD»

29.11.06 | 20.00 h Theater Casino Zug
# CHICAGO BLUES
FESTIVAL 2006 – WAYNE BAKER BROOKS BAND & TRUDY LYNN & DONALD KINSEY

24.11.06 | 20.00 h Theater Casino Zug
# COOKIN'
KÜCHENSOUND – THE BROADWAY ASIA COMPANY NEW YORK

08.12.06 | 20.00 h Kirche St. Michael | 27.11.06 | 20.00 Theater Casino Zug
THE HILLIARD ENSEMBLE | DAS LIED VON DER ERDE
«ARKHANGELOS» | SCHMID / LIPPERT / HOLLIGER – KAMMER-SOLISTEN ZUG

15.11.06 | 14.30 Theater Casino Zug | 07.12.06 | 20.00 Theater Casino Zug
DORNRÖSCHEN | BABY BABY, BALLA BALLA!
MÜNCHNER THEATER FÜR KINDER | ERICH VOCK / MAJA BRUNNER / REGULA IMBODEN

09.11.06 | 20.00 Theater Casino Zug
MOSKAUER KAMMEROPER
DIE LUSTIGEN WEIBER VON WINDSOR – NICOLAI

www.tmgz.ch
Zuger Kantonalbank Hauptsponsor
tmgz

**Poster 4**

16.03.07 | 20.00 h Theater Casino Zug
# DANCE OF LEGENDS
GETANZTE MYTHEN UND LEGENDEN – NESHKA ROBEVA, CHOREOGRAPHIE

09.03.07 | 20.00 h Theater Casino Zug
# MARK BRITTON
WILDLIFE | KABARETT FÜRS AUGE | ENGLISCHER HUMOR IN DEUTSCHER SPRACHE

03.03.07 | 20.00 Uhr Theater Casino Zug
# KRABAT
ODER DIE ERSCHAFFUNG DER WELT | BALLETTOPER / TANZTHEATER VON JURIJ BREZAN | SORBISCHES NATIONAL-ENSEMBLE BAUTZEN

01.03.07 | 20.00 Uhr Theater Casino Zug
KOMÖDIE IM DUNKELN
KOMÖDIE VON PETER SHAFFER (AUTOR VON AMADEUS)

11.03.07 | 10.30 Uhr Theater Casino Zug
KLAVIERDUO ADRIENNE SOÓS UND IVO HAAG
APERITIVO | WERKE VON SCHUBERT, KELTERBORN, BARTÓK

www.tmgz.ch
Zuger Kantonalbank Hauptsponsor
tmgz

**Poster 5**

08.12.06 | 20.00 Kirche St. Michael Zug
# THE HILLIARD ENSEMBLE
«ARKHANGELOS»

16.12.06 | 20.00 Theater Casino Zug
# SPARTACUS
CHATSCHATURJAN | BALLETT-THEATER DONETSK (UKRAINE)

24.12.06 | 14.30 Theater Casino Zug
WALDELINA WEIHNACHTSMÄRCHEN
GASTSPIELTHEATER ZÜRICH

12.12.06 | 20.00 Theater Casino Zug | 17.12.06 | 20.00 Theater Casino Zug
THE TAMING OF THE SHREW | GOSPEL GALA
SHAKESPEARE | AMERICAN DRAMA GROUP EUROPE | THE VICTORY GOSPEL SINGERS (CHICAGO)

17.12.06 | 11.00 Theater Casino Zug | 19./20.12.06 | Theater Casino Zug
THALMANN | SCHACHT | GYSLING | SING MIT UNS
FRANZ LISZT IN DER SCHWEIZ | APERITIVO | ZUGER SINFONIETTA UND 400 KINDER

www.tmgz.ch
Zuger Kantonalbank Hauptsponsor
tmgz

**Poster 6**

05.01.07 | 19.30 Theater Casino Zug
# HUJÄSSLER
DANIEL HÄUSLER | MARKUS FLÜCKIGER | RETO KAMER | SEPP HUBER | BASSMUSIKER: MAX LÄSSER, WALTER KEISER | ADRIAN HÄUSLER, BARBARA BETSCHART, DAVID SCHNEEBELI, SEVERIN SUTER | SCHWIIZER CHUCHI

17.01.07 | 20.00 Theater Casino Zug
# CARLOS NÚÑEZ
GALIZIEN / SPANIEN | THE NEW KING OF CELTS

19./20.01.07 | 20.00 Theater Casino Zug
# BUENA VISTA
CUBA'S GRANDFATHERS OF SON | REYNALDO CREAGH | MAESTRO RUBALCABA | PAPI OVIEDO | BAND UND TÄNZER

31.01.07 | 20.00 Theater Casino Zug
# ORCHESTRE DES PAYS DE SAVOIE
GRAZIELLA CONTRATTO | ESTHER HOPPE | HENRI DEMARQUETTE | PERCUSSION CLAVIERS DE LYON

21.01.07 | 17.00 Maria Opferung Zug | 24.01.07 | 20.00 Theater Casino Zug
KAMMER-SOLISTEN ZUG | GRAF VON LUXEMBURG
LASZLO SARY | NEUE ERNTE | URAUFFÜHRUNG | OPERETTENBÜHNE WIEN | HEINZ HELLBERG

01.02.07 | 20.00 Theater Casino Zug
FÜR EINE NACHT VOLLER SELIGKEIT
PETER KREUDER GALA | GUNTER EMMERLICH

www.tmgz.ch
Zuger Kantonalbank Hauptsponsor
tmgz

**Poster 7**

21.03.07 | 20.00 Uhr Theater Casino Zug
# ST. PATRICK'S DAY
CELEBRATION FESTIVAL 2007 | RACHEL HAIR & MICHAEL G. ROSE | THE MC BADES | CANTERAC

29.03.07 | 20.00 Uhr Theater Casino Zug
# ZAWINUL
JOE ZAWINUL & THE ZAWINUL SYNDICATE | 75TH BIRTHDAY | 30 YEARS SYNDICATE

25.03.07 | 17.00 Uhr Theater Casino Zug
# KLEEB | HAUSER
EINE REISE INS SCHWINGUNGSGEBIET | HILDEGARD KLEEB, KLAVIER | FRITZ HAUSER, SCHLAGZEUG, PERKUSSION

21.03.07 | 13.30 Uhr Theater Casino Zug | 12.04.07 | 20.00 Uhr Theater Casino Zug
DAS KLEINE GESPENST | DAKSHA SHETH
ZÜRCHER MÄRCHENBÜHNE MIT ERICH VOCK | DANCE COMPANY (INDIEN) | SARAPAGATI & BHUKHAM

13.04.07 | 19.30 Uhr Theater Casino Zug
HANK SHIZZOE & THE DIRECTORS
SCHWIIZER CHUCHI | HANK SHIZZOE | OLI HARTUNG | MICHEL POFFET | CHRISTOPH BECK

www.tmgz.ch
Zuger Kantonalbank Hauptsponsor
tmgz

**Poster 8**

13.04.07 | 19.30 Uhr Grosser Casinosaal
# HANK SHIZZOE & THE DIRECTORS
SCHWIIZER CHUCHI | HANK SHIZZOE (GUITAR, MANDOLIN, LAP STEEL GUITAR AND VOCAL) | THE DIRECTORS: OLI HARTUNG (GUITAR), MICHEL POFFET (BASS), CHRISTOPH BECK (DRUMS)

12.04.07 | 20.00 Uhr Theater Casino Zug
# DAKSHA SHETH
# DANCE COMPANY | INDIEN
PREMIERE | «SARAPAGATI» – THE WAY OF THE SERPENT | BHUKHAM | CIRCUS OF EARTH AND SKY

www.tmgz.ch
Zuger Kantonalbank Hauptsponsor
tmgz

**Poster 9**

24.05.07 | 20.00 Uhr Theater Casino Zug
# FESTIVAL SON CUBA 2007
DREI STUNDEN KUBANISCHE LIVE-MUSIK

11.05.07 | 20.00 Uhr Theater Casino Zug
# TEMPS FORT THÉÂTRE
MANO MÈNA | SINNESSPEKTAKEL MIT MASKEN

12.05.07 | 17.00 Uhr Klostergarten oder Institutskapelle Maria Opferung Zug
# AMORE! AMORE!
KONZERT ZUM MUTTERTAG | SOLISTEN DER TONHALLE ZÜRICH

05.05.07 | 20.00 Uhr Theater Casino Zug
EINES LANGEN TAGES REISE IN DIE NACHT
EUGENE O'NEILL | ANGELICA DOMRÖSE | HANS OTTO THEATER POTSDAM

PHILHARMONISCHES STAATSORCHESTER HALLE
MAHLER: 5. SINFONIE | MOZART: FAGOTTKONZERT | DAVID STAHL, DIRIGENT | STEFAN BÜHL, FAGOTT

www.tmgz.ch
Zuger Kantonalbank Hauptsponsor
tmgz

**Luna Maurer**

The Quarantine Series Book is printed with 21 pantone colors according to the overall housestyle concept of Quarantine Series: the daily changing color. The color is generated with a chaotic, deterministic algorythm.

Photograph: Maurice Scheltens
Client: Quarantine Series
Format: 21 x 29.7 cm

**Karen Willey**
Tubelight, free bi-monthly Dutch art review magazine
Printed by Robstolk
Client: Tubelight
Format: 21 x 29.7 cm

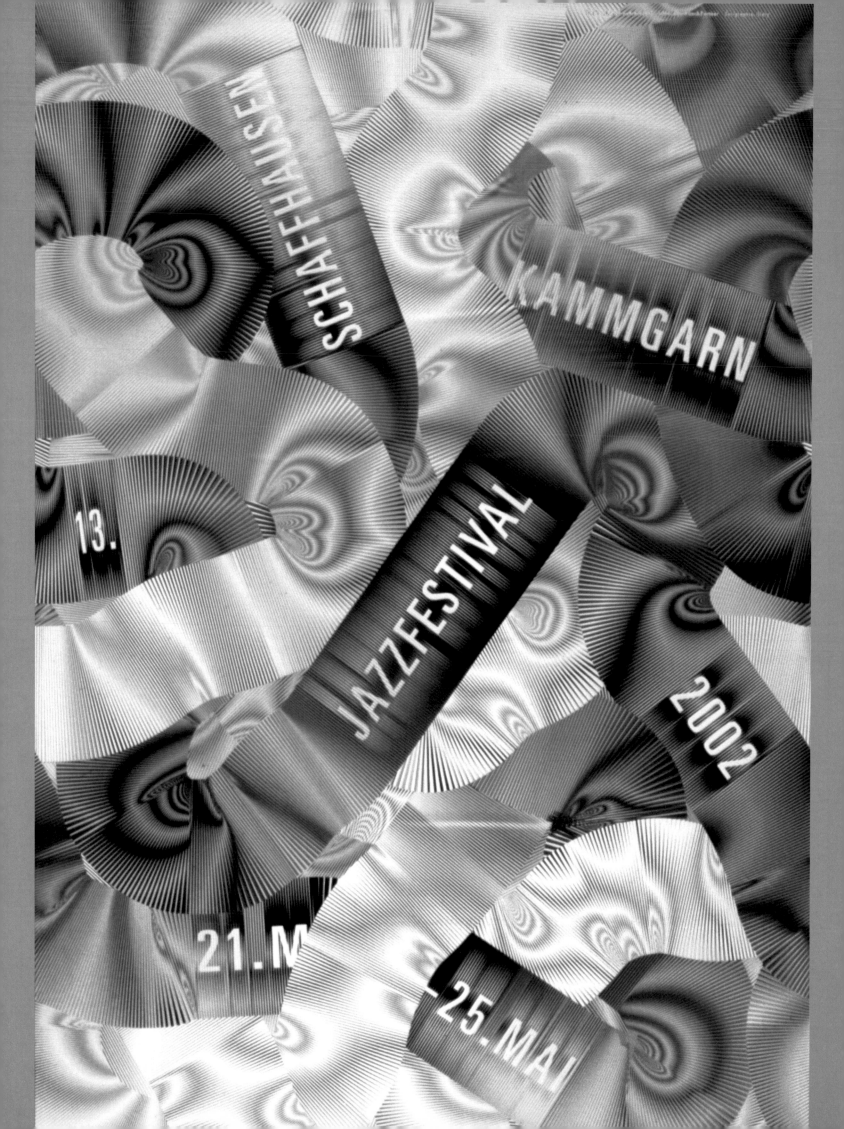

(opposite page)
**Ralph Schraivogel**

**1**

**Newfoundland**
**Kummer & Herrman and Herman van Bostelen**
Poster Springdance preview 2006
Printed in black and silver
Photo: Mick Salomons
Client: Springdance
Format 84 x 118.8 cm

**2**

**Newfoundland**
**Kummer & Herrman and Herman van Bostelen**
Brochure (interior) Springdance preview 2006
Printed in black and silver
Photo: Mick Salomons
Client: Springdance
Format: 21.0 x 29.7 cm

**3**
**Neeser & Müller**
Book about the last 15 years of "Festival Rümlingen"
Client: Festival Rümlingen and Christoph Merian Verlag
Format: 28 x 22 cm

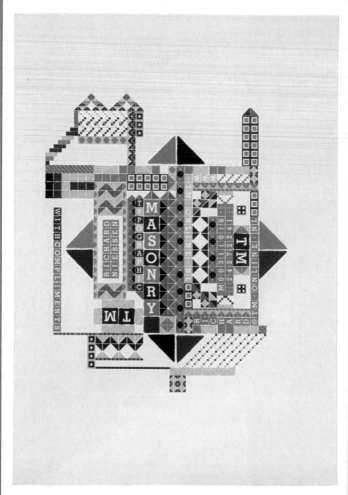

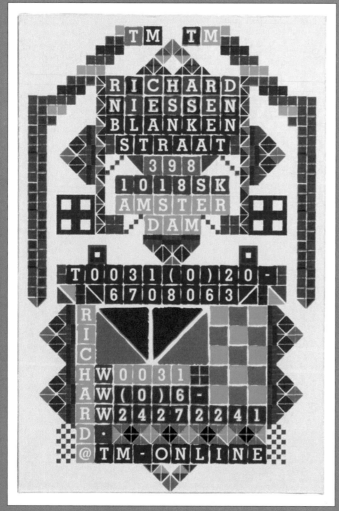

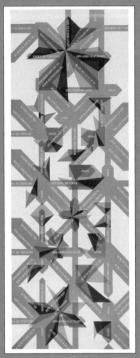
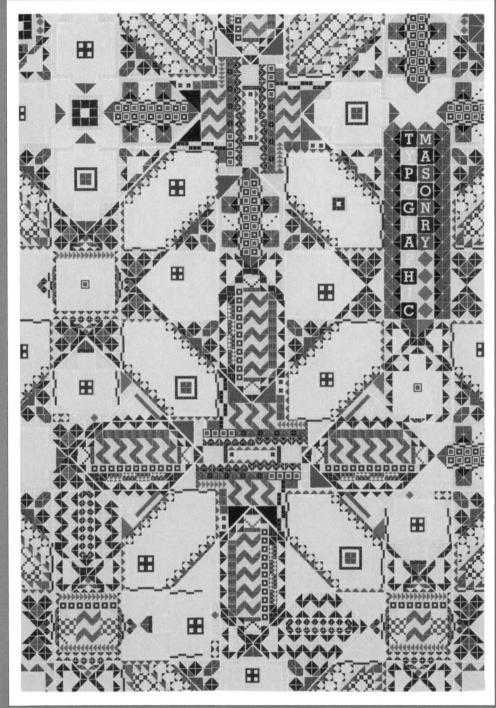
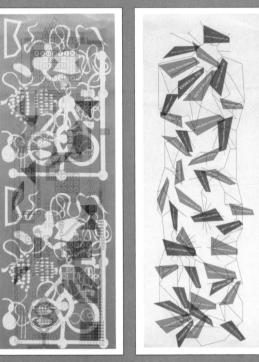
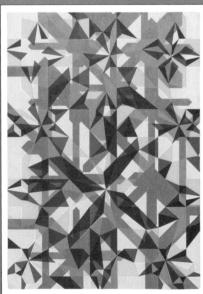

**TM / Richard Niessen**
Arabesque stationeries
for Richard Niessen,
Jennifer Tee,
Raoul de Thouars,
Joost Vermeulen and
Esther de Vries

(opposite page)
**Ludovic Balland**
Flyer
4 colour offset + black laserprint
client: Das Schiff
Format: 21 x 29.7 cm, folded 14.8 x 7 cm

(opposite page, below)
**TM / Richard Niessen**

**TM / Richard Niessen, Esther de Vries**
Client: Fonds BKVB, Amsterdam

**TM / Richard Niessen, Esther de Vries**
Self promotion

**1**
**Martin Woodtli**
Poster and card for design exhibition
4 colour silk-screen print
Client: Museum für Gestaltung Zürich
Format: 90.5 x 128 cm

**2**
**Lorenzo Geiger**
Poster for the concert of Matt Darriau's Paradox Trio
Client: Dachstock Reithalle Bern
Format: 42.0 x 52.5 cm

**3**
**Cybu Richli**
Paying homage to Lucerne's street philosopher Emil Manser
3 colour silkscreen print
Printer: Uldry, Hinterkappelen
Client: db-Verlag
Format: 128 x 90.5 cm

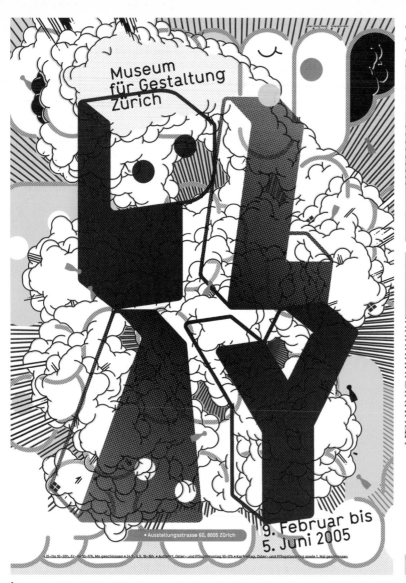
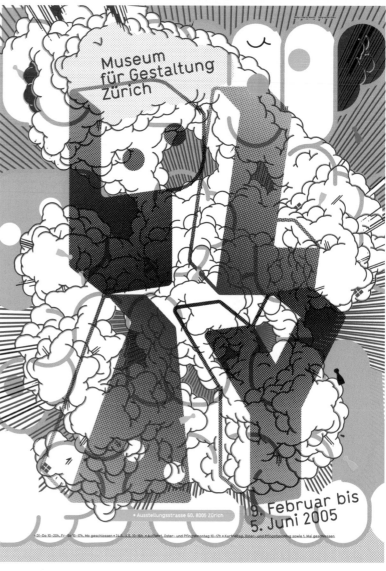

1

2

**1**
**Martin Woodtli**
Poster, 4 colour silkscreen print
Client: Museum für Gestaltung Zürich
Format 89.5 x 128 cm

**2**
**Welcometo.as,**
**Adam Machacek, Sébastien Bohner**
Series of invitation cards
Format: 14.8 x 21 cm

1

2

3

**1**
**Mixer / Erich Brechbühl**
Dust cover poster
Colour separations by DNS-Transport, Henning
Wagenbreth, Roland Wohler and Julia / Tina Worbs
Client: 100 beste Plakate e.V.
Format: 59.4 x 84.1 cm

**2**
**Mixer / Erich Brechbühl**
Exhibition poster
Colour separations by cyan, Märt Infanger, David
Lindemann / Matthias Wörle and Kleon Medugorac
Client: 100 beste Plakate e.V.
Format: 84.1 x 118.9 cm

**3**
**310k**
Book series
Client: De windroos gedichten
Format: 21 x 15 cm

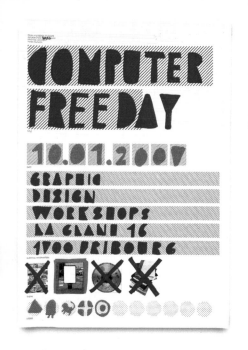
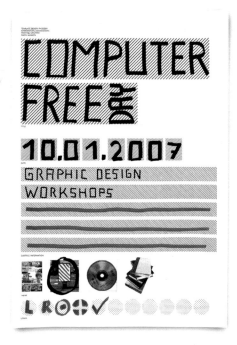
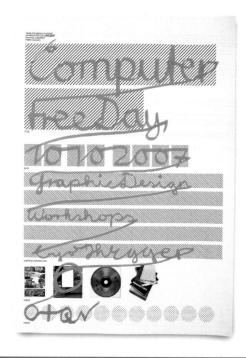

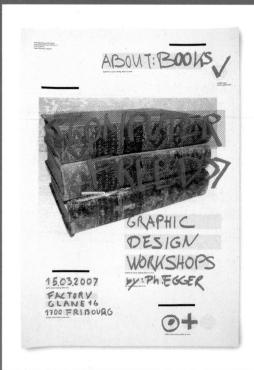
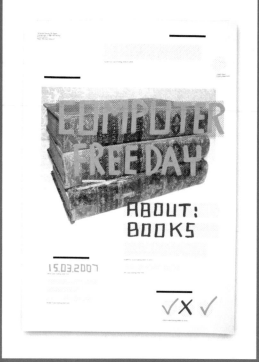
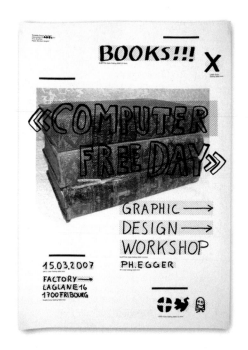

**Fageta**
Poster series for graphic design workshops
The template is made by us, then they are given
to invited designers who fill them out.
Format: 42 x 59.4cm

**1**
**Fageta, Coboi**
Black and white sticker set. The stickers are part of
the visual communication for the Bad Bonn Kilbi music
festival in Düdingen, Switzerland.
Screenprinting: Lowrider
Client: Tonverein Bad Bonn
Format: 5 cm height, different lenghts

1

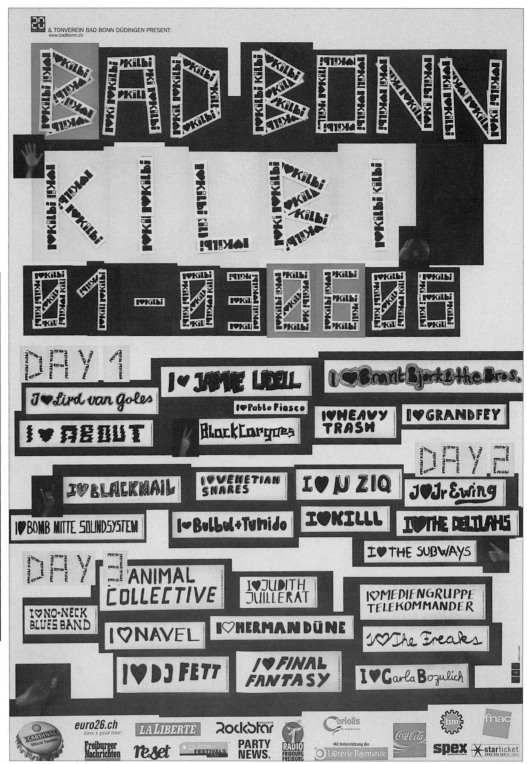

2

3

2
**Fageta, Coboi**
Poster design for the visual communication of the Bad Bonn
Kilbi music festival in Düdingen, Switzerland.
Offsetprint: Cricprint
Client: Tonverein Bad Bonn
Format: 42 x 59.4 cm

3
**Fageta, Coboi**
Cover of the booklet for the Bad Bonn
Kilbi music festival in Düdingen, Switzerland.
Offsetprint: Cricprint
Client: Tonverein Bad Bonn
Format: 14.8 x 21 cm

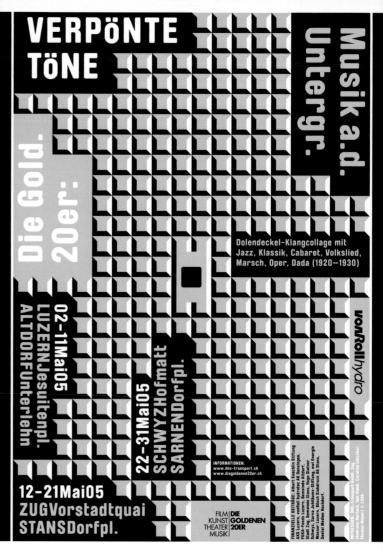

1

**1**
**DNS-Transport**
MEMENTO-MORI
4-colour (black, silver, red, flourescent green)

**2**
**DNS-Transport**
2-colour (black, gold)

**3**
**DNS-Transport**
DESASTRE-2001, red
3-colour (black, translucent black, red)

**4**
**DNS-Transport**
DESASTRE-2001, grey
3-colour (black, translucent black, metalgrey)

2

3

4

**1**
**André Baldinger**
Theatre poster using two complementary colours
which fit into the theme of the piece.
Client: Centre Dramatique de Thionville-Lorraine
Format: 40 x 56.5 cm

1

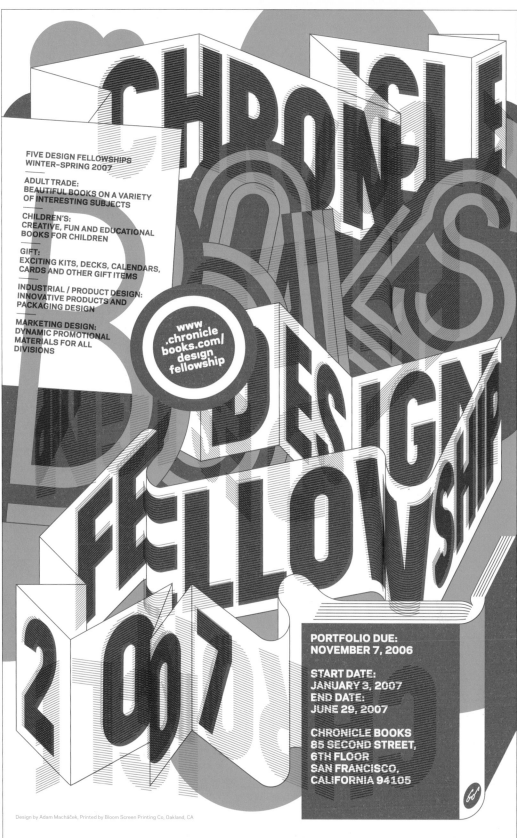

2

**2**
**Welcometo.as, Adam Machacek**
2-colour silkscreen poster to advertise the winter / spring 2007
session of Chronicle's Design Fellowship.
Client: Chronicle Books
Format: 35.6 x 56 cm

**3**
**André Baldinger**
Theatre invitation card
The use of the color blendings is part of the visual identity.
Client: Centre Dramatique de Thionville-Lorraine
Format: 14 x 21 cm

3

**2**
**Derrierelacolline, Anne-Lise Coste with Marie Lusa**
Exhibition poster
Client: Museum Tinguely, Basel
Format: 90.5 x 128 cm

**3**
**Derrierelacolline, Anne-Lise Coste with Marie Lusa**
Exhibition programme
Client: Museum Tinguely, Basel
Format: 42 x 58.9 cm

**4**
**Derrierelacolline, Marie Lusa**
Contribution to P. Parreno's artist book "Suicide in Vermillon Sands"
Client: Philippe Parreno
Format: 29.7 x 21 cm

2

3

4

4

5

(page, above)
e in't Veld, Toon Koehorst
pread
y Magazine, Hong Kong
7 x 38 cm

und pfeffer, Denny Backhaus, Per Törnberg
oster designs for the symposium "Transformations of
ace". Multiple variations of the logotype were created
encil, spray paint, ink, water and acrylic colours.
riations were then photographed to be reproduced as the
ers.
ohy: Anu Vahtra
edelijk Museum CS / LKPR
00 x 141.4 cm

5
Fageta

de for a young            Poster for a serie of antifolk
oup show at the          concerts at Bad Bonn,
e Morges, Switzerland.   Düdingen, Switzerland.
gn: Annina Mettler       Screen printing: Lowrider
hâteau de Morges         Client: Tonverein Bad Bonn
2 x 59.4 cm              Format: 42 x 59.4 cm

**1**
**75B**
"Game Over", poster
Format: 4 x 50 x 70.7 cm

**2**
**Roel Wouters**
A promotional poster for an
opera about white trash radio.
Not Printed.
Client: Jong Hollandia
Format: 42 x 29 cm

**3**
**75B**
"01", poster
Format: 16 x 70.7 x 141.1 cm

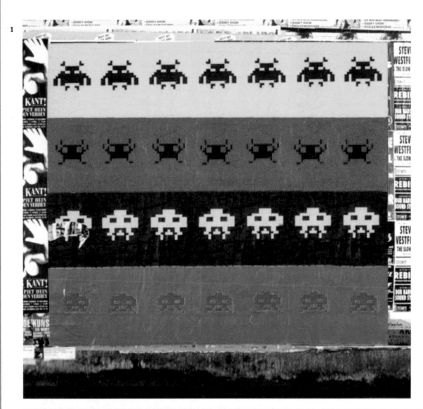

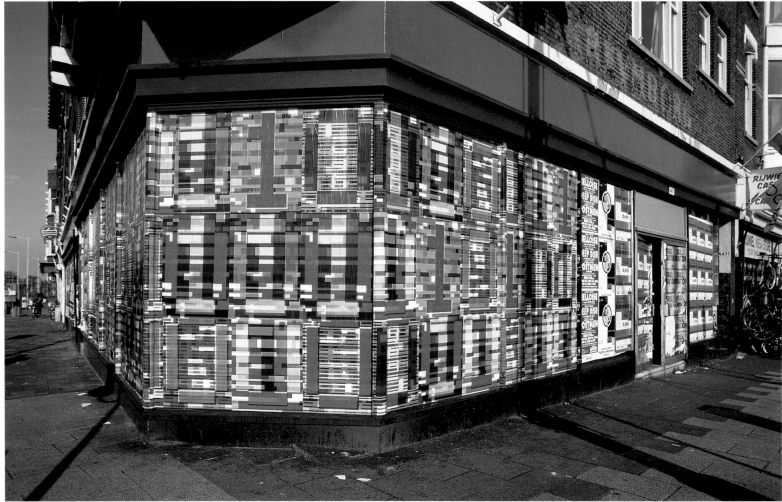

**1**
Roel Wouters
Promotional poster for a exhibition of the
chinese artist Yang Fudong
Client: Stedelijk Museum Amsterdam
Format: 120 x 175 cm

**2**
Raffinerie AG für Gestaltung
Plakat für Saisoneröffnung
Client: Theaterhaus Gessnerallee
Format: 89.5 x 128 cm

**3**
Wouters & Wouters, Roel Wouters
Series of flyers for a party called
Zeitgeist in a club called Sugarfactory
in place called Amsterdam.
Credit: Job Wouters
Client: MRKMLN
Format: 42 x 29 cm

**4**
Shahee Ilyas
Flags By Colours
Each sector of the pie-charts is
proportional to the area of the colour
on the respective flag.

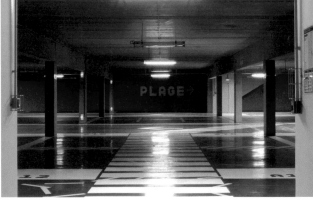

**Atelier Télescopique**
Signage system of a car park.
Client: Communauté Urbaine de Dunkerque

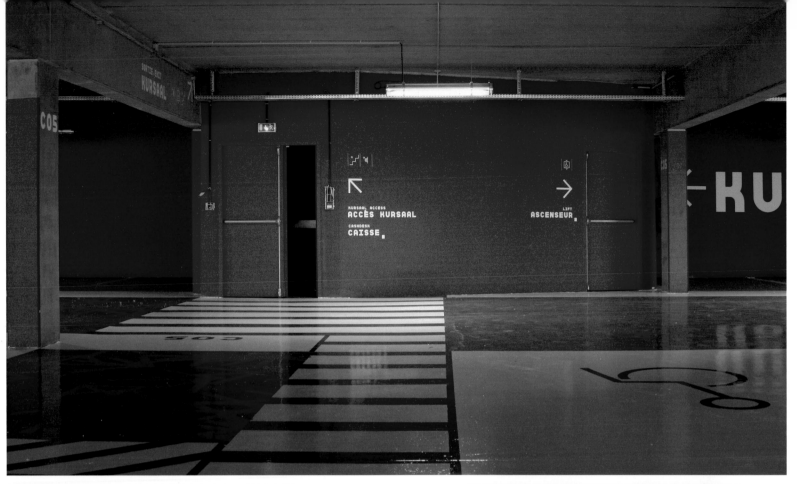

# Address Index

# Imprint

**Kelvin: Colour Today**

Edited by Robert Klanten, Boris Brumnjak and Sven Ehmann
Layout by Sabrina Grill, Hans Baltzer and Torge Peters for dgv
Cover image by Elias & Saria
Project management by Julian Sorge for dgv
Production management by Janni Milstrey for dgv
Proofreading by Helga Beck and Lina Kunimoto for dgv
Translations by Patricia Mehnert
Printed by Engelhardt und Bauer, Karlsruhe

Type faces: Engel by Soffi Beier, Blender by Nik Thoenen
Foundry: www.die-gestalten.de

Published by Die Gestalten Verlag, Berlin 2007
ISBN 978-3-89955-196-9

© Die Gestalten Verlag GmbH & Co. KG (dgv), Berlin 2007
All rights reserved. No part of this publication may be reproduced
or transmitted in any form or by any means, electronic or me-
chanical, including photocopy or any storage and retrieval system,
without permission in writing from the publisher.

Bibliographic information published by the Deutsche
Nationalbibliothek. The Deutsche Nationalbibliothek
lists this publication in the Deutsche Nationalbibliografie;
detailed bibliographic data is available on the internet at
http://dnb.d-nb.de.

For more information, please check: www.die-gestalten.de

Respect copyright, encourage creativity!

None of the content in this book was published in exchange for
payment by commercial parties or designers; dgv selected all
included work based solely on its artistic merit.